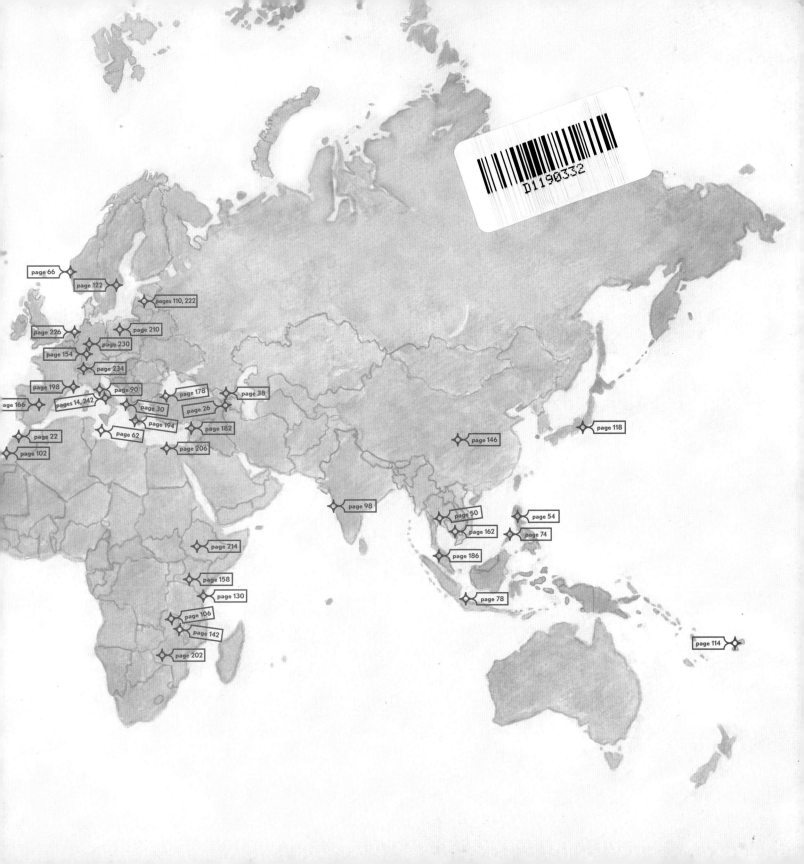

IN HER KITCHEN

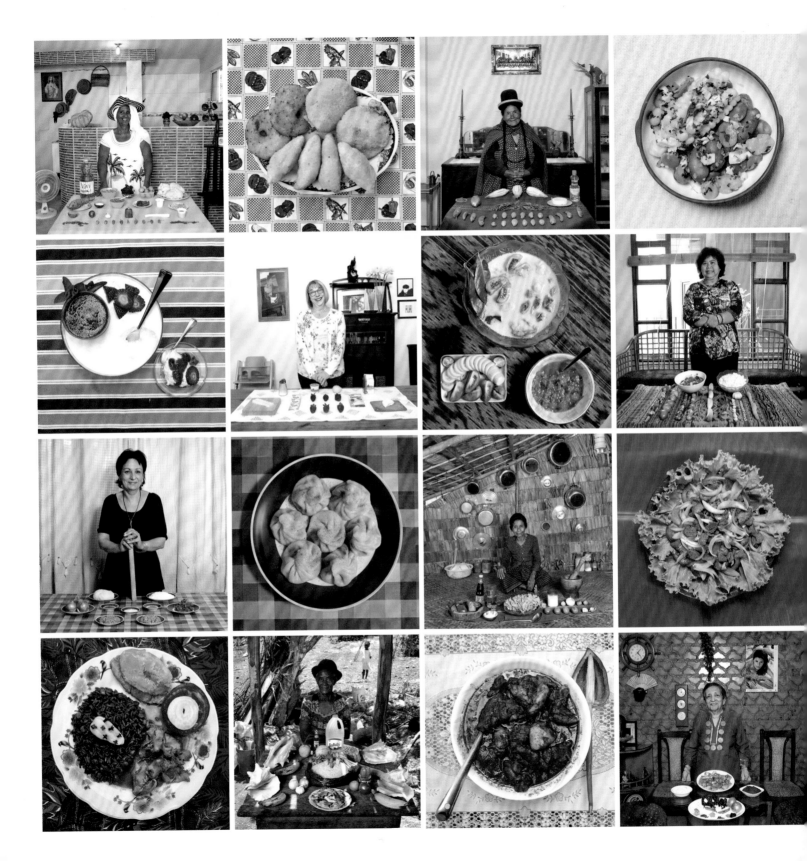

IN HER KITCHEN

STORIES AND RECIPES FROM GRANDMAS AROUND THE WORLD

Gabriele Galimberti

CLARKSON POTTER/PUBLISHERS
New York

Copyright © 2014 by Gabriele Galimberti

All rights reserved.

Published in the United States by Clarkson Potter/Publishers, an imprint of the
Crown Publishing Group, a division of Random House LLC, a Penguin Random
House Company, New York.

www.crownpublishing.com
www.clarksonpotter.com

CLARKSON POTTER is a trademark and POTTER with colophon is a registered
trademark of Random House LLC.

Selected photographs previously appeared on Slate.com's *Behold* blog
(May 2013).

Library of Congress Cataloging-in-Publication Data

Galimberti, Gabriele.

In her kitchen : stories and recipes from grandmas around the world /

photographs and text by Gabriele Galimberti.

pages cm

Includes index.

1. Cooking, International. 2. Galimberti, Gabriele—Travel. 3.

Grandmothers. I. Title.

TX725.A1G325 2014

641.59—dc23

2013050635

ISBN 978-0-8041-8555-4

eBook ISBN 978-0-8041-8556-1

Printed in China

Book design by Stephanie Huntwork
Cover design by Stephanie Huntwork
Cover photographs by Gabriele Galimberti
Endpaper map by Meighan Cavanaugh

10 9 8 7 6 5 4 3 2 1

First Edition

TO MY GRANDMA MARISA

Contents /

Introduction

If someone had told me, on the day I left my parents' house at age twenty-two, that I would end up traveling around the world, I wouldn't have believed it. I had rarely ventured far from home. Once a year, I went to the Tuscan coast with my family for fifteen days or so, and I had been to Venice and Apulia on school trips, but that was about it. I grew up in a little town, in the province of Arezzo, with a population of fewer than fifteen thousand. Its tiny historic center is enclosed within ancient walls, and a single medieval tower commands a view of the surrounding farmlands. Some of those fields belong to relatives of mine: my aunts and uncles, my cousins, my grandfather, my grandmother. That is where my family's roots lie, and there is not a family member who hasn't worked those lands—except for my mother, a schoolteacher, who was the first to break the tradition.

For generations, my family's ways were those of country folk, based on firm principles: patience; respect for others; and an unwavering commitment to protect and honor the natural environment. Ours was, therefore, also a heritage of passion for food—good food. I have clear memories of meals

at my great-grandparents' house, celebrating events that marked the turning of the seasons: the grape harvest and the first new wine; slaughtering the hog; killing a duck at feast times; the harvest of the cantaloupes and of the watermelons; the wild-boar and pheasant dinners at the opening of hunting season. I can still recall the yearly olive harvest and the delicious, slightly spicy taste of that fragrant, freshly pressed oil.

I remember the love with which my mother or grandmother prepared the lunches I took to school. Sometimes it was a simple sandwich, but more often it consisted of a meal, prepared in the early morning while I still slept. Spaghetti with tomato sauce, chicken with lemon, fresh vegetables—the same dishes they would have served me had I stayed at home. I was raised and nurtured by good country food, exquisitely prepared. That is how I ended up being a healthy six feet, two inches, taller than anyone in the generations that came before me.

Everyone in my family hoped I would become a surveyor like my father. But against my parents' wishes, I enrolled in photography school in Florence. They adjusted their expectations and soon became convinced that, before long, I would open a photo studio in my little town, where I would earn my living by documenting weddings, communions, and baptisms. However, once I had my degree, I began to look beyond my town's walls. After a few years, a well-known Italian magazine took me up on my idea of traveling around the world as a couch surfer for two years. I proposed that I would create weekly features for the magazine's readers, chronicling my experiences traveling through more than fifty countries with nothing but my camera, computer, and journals.

There were only two weeks from the day I signed the contract to my scheduled departure, so I had very little time to get used to the idea of being away for so long. Most important, I had to find time to visit everyone in my family and take my leave. I started with my more distant relatives—my aunts, uncles, and cousins. Finally, with my departure just a week away, the time came to say good-bye to my grandmother. My only remaining grandparent, she lives just thirty yards from my parents' house. Every day of my childhood, she watched me from her window as I played in the courtyard. In summer, when school was closed, my *nonna* would make me my lunch. In her eighty years, she has never gone beyond the borders of her Tuscany.

Of course, when I arrived at her house that day, lunch was waiting on the table. I sat down to eat with her and told her what I was about to do. "Well, Nonna," I said, "in just a

week I'll be leaving to travel around the world. I'm going to visit more than fifty countries and I'll be gone for nearly two years. I'll be going to Alaska, Zimbabwe, and China—everywhere, pretty much. I'll stay with people from all over the world, in their homes. I'll take their pictures and I'll interview them. They're people I met on the Internet, people I've never seen before, but they're offering me a place to sleep. A magazine is paying me to do it. Isn't that incredible? Every week you can pick up the magazine at the newsstand here on the corner and see where I am and who I'm staying with."

She just looked at me, her expression uncertain.

"Don't worry, Nonna. It's safe! I found these people on a secure Web site. They've all got excellent reviews, which means that other people who have stayed with them have highly recommended them. I chose my hosts carefully, so don't worry. Besides, the countries where I'm going aren't dangerous. I mean, in some of them I'll have to keep my eyes open, sure, but they're quiet places, for the most part. Nothing's going to happen to me, you'll see!"

I spent more than a quarter of an hour trying to reassure her because I could tell that the whole idea frightened her. I could understand why she felt the way she did, after all. She had rarely left home and she had no idea what the places where I would be traveling were like. In her mind, anywhere farther than thirty miles from home was a strange and foreign land. Then, finally, she asked me her first question. It was then that I realized what her true concern had been all along.

"But, Bagonghi," she said (she has always called me that, and I still don't know why), "what are you going to eat? Are you sure you want to go so far from home? Who's going to make food for you? I've heard they eat dogs in China, and in Africa they barely have any food at all! Stay here. It's better if you do. For lunch and dinner you can go to your mama's house, or come here to mine."

Her concerns had nothing to do with danger or with the job I had chosen to do! Her worries were simply about what I was going to eat.

I burst out laughing and said, "Don't worry, Nonna. The world is full of grand-mothers who know how to cook well. Just like you, they've always cooked for their grandchildren with love. I promise you I'll go and eat in their homes and, to prove to you how well they've treated me, I'll bring you pictures of the dishes they make for me, and copies of their recipes, too."

That is how this project was born.

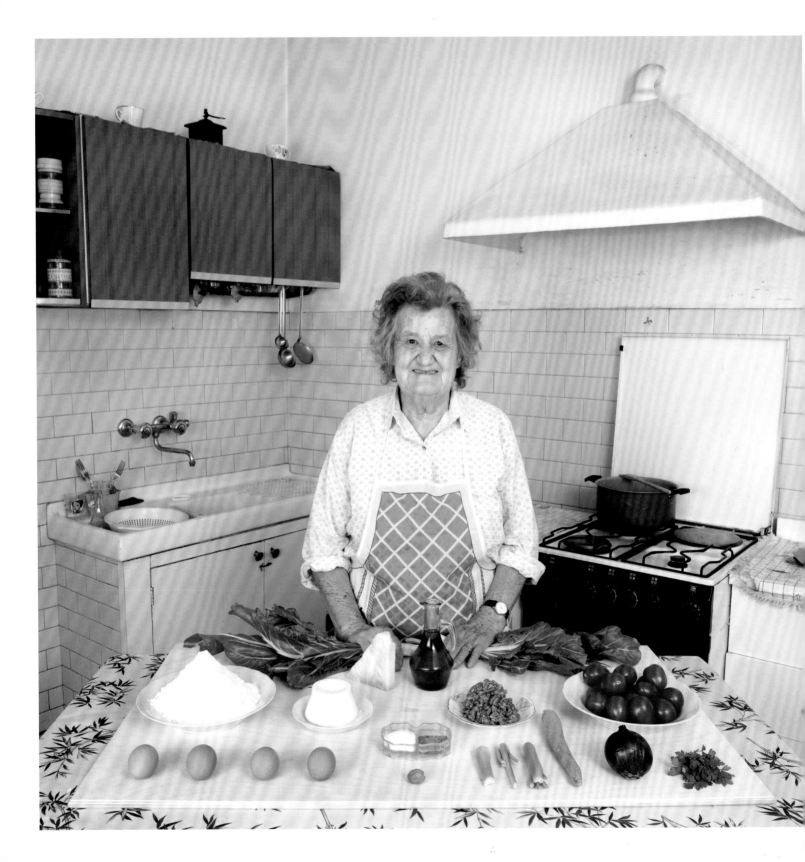

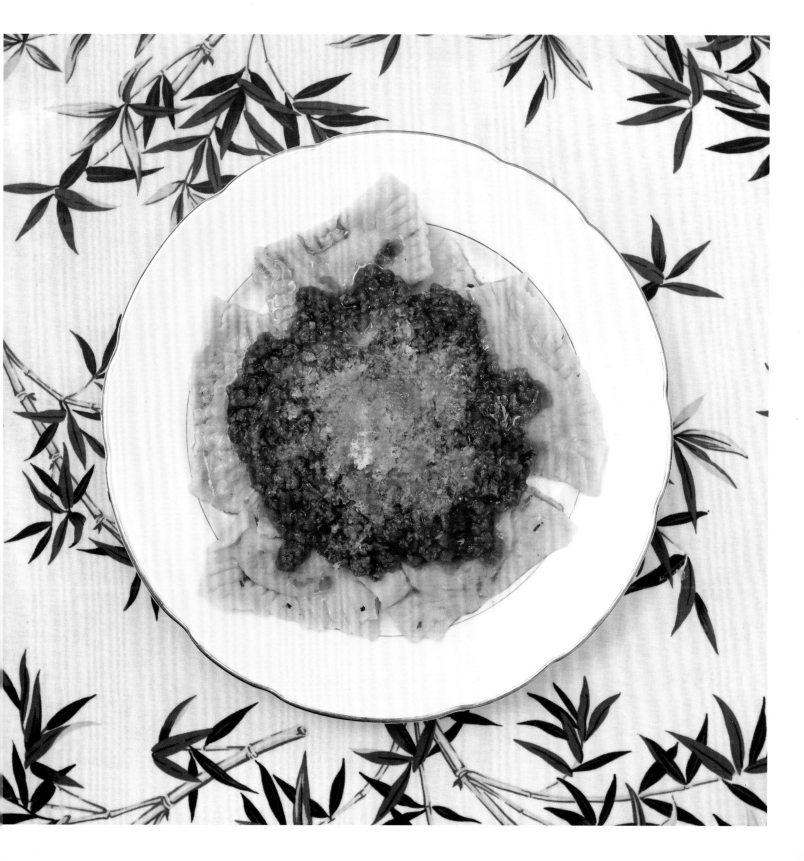

Marisa Batini

80 YEARS OLD

Marisa was born in Lucignano, a really small town in the middle of the Tuscan countryside. She was married at twenty-four and then she moved to Castiglion Fiorentino, the same town where I grew up. Yes, she is in fact *my* grandma Marisa. When I was young I spent a lot of time with her and would play with my sister and cousins in her yard all day long. While she has always been a housewife, she has never been a champion cook. Years ago she would often try to learn to make more dishes, but recently she has limited her cooking to very rare occasions. However, one of her dishes cannot be beat: Swiss chard and ricotta ravioli with meat sauce. When she makes ravioli, she gives our whole family a tour of the tradition of rolling out pasta by hand. Unfortunately, these rare tours last only for the duration of the meal; then we all go back to our busy lives.

Swiss Chard and Ricotta Ravioli with Meat Sauce

SERVES 4 TO 6

FOR THE SAUCE

2 pounds ripe tomatoes

2 tablespoons olive oil

1 medium yellow onion, finely diced

1 carrot, peeled and finely diced

1 celery rib, finely diced

¼ cup chopped fresh flat-leaf parsley

1 pound ground beef

¾ cup red wine (optional)

Salt and freshly ground black pepper

Pinch of ground nutmeg

FOR THE RAVIOLI

2 cups all-purpose flour

4 large eggs

2 teaspoons olive oil

1 pound Swiss chard, center ribs removed

⅔ cup fresh ricotta, drained

2 tablespoons grated Parmesan cheese, plus more to taste

Salt

Pinch of ground nutmeg

1 egg mixed with 1 teaspoon water (egg wash), if needed

1 Make the sauce: Fill a large bowl with ice water. Bring some water to a boil in a medium saucepan. Cut an X in the bottom of each tomato and gently place the tomatoes in the boiling water for 30 seconds to 1 minute. Remove and immediately plunge them into the bowl of ice water. When the skin begins to separate from the tomatoes, peel them and place them in a food processor or blender and puree them into a sauce. Set aside.

2 Heat the olive oil in a medium saucepan over medium-high heat. Add the onion, carrot, celery, and parsley and sauté until the vegetables soften and the onion is translucent. Add the ground beef. Cook until browned, about 10 minutes (if you like, add the red wine and allow the alcohol to cook off, about 5 minutes). Add the tomato sauce, 2 teaspoons of salt, and pepper to taste. Reduce the heat to medium and simmer gently, uncovered, for 3 hours. Add the nutmeg.

3 Make the ravioli: Mound the flour in the center of a board, as if it were a small mountain with a well in it. Beat 3 of the eggs and the olive oil in a separate bowl. Pour them gently into the flour volcano and use a fork to incorporate the flour, starting from the inside out, so that the flour absorbs the eggs. When the dough begins to come together, you can

work it with your hands, adding more flour as needed. Continue to knead the dough until it is smooth and elastic enough to be divided into 4 parts. Stretch each part into a ⅛-inch sheet, using a rolling pin.

4 While the dough is resting, make the pasta filling. Bring a large pot of water to a boil, add the Swiss chard, and cook for 15 to 20 minutes, until the chard is tender. Drain thoroughly by squeezing out all of the water.

5 Chop the squeezed Swiss chard with a kitchen knife or a mezzaluna. In a large bowl, combine the chard, ricotta, the remaining egg, the 2 tablespoons Parmesan, a pinch of salt, and the nutmeg. Bring a large pot of water to a boil. Season with salt.

6 Cut the 4 pasta sheets into small rectangles of about 3 inches by 1½ inches. Add 1 teaspoon of the filling to the center of half the rectangles. Top each with another rectangle of pasta and close the ravioli, pressing the borders with a fork. If needed, seal the ravioli with egg wash.

7 Add the ravioli to the boiling water and cook for about 10 minutes, or until the pasta is al dente. Drain and serve the ravioli with the meat sauce. Add some grated Parmesan and enjoy!

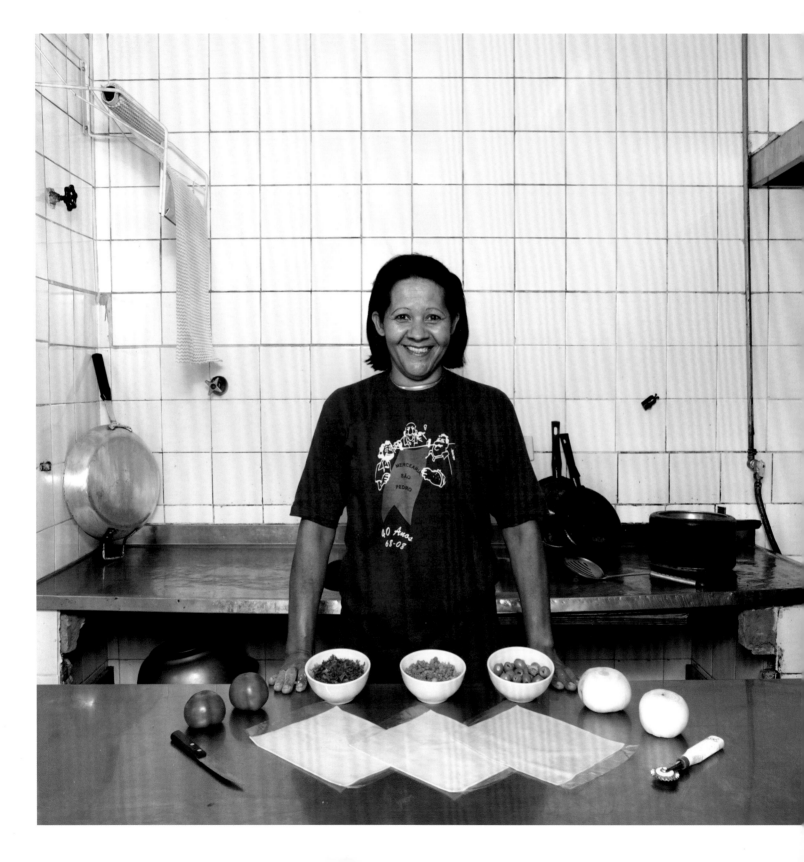

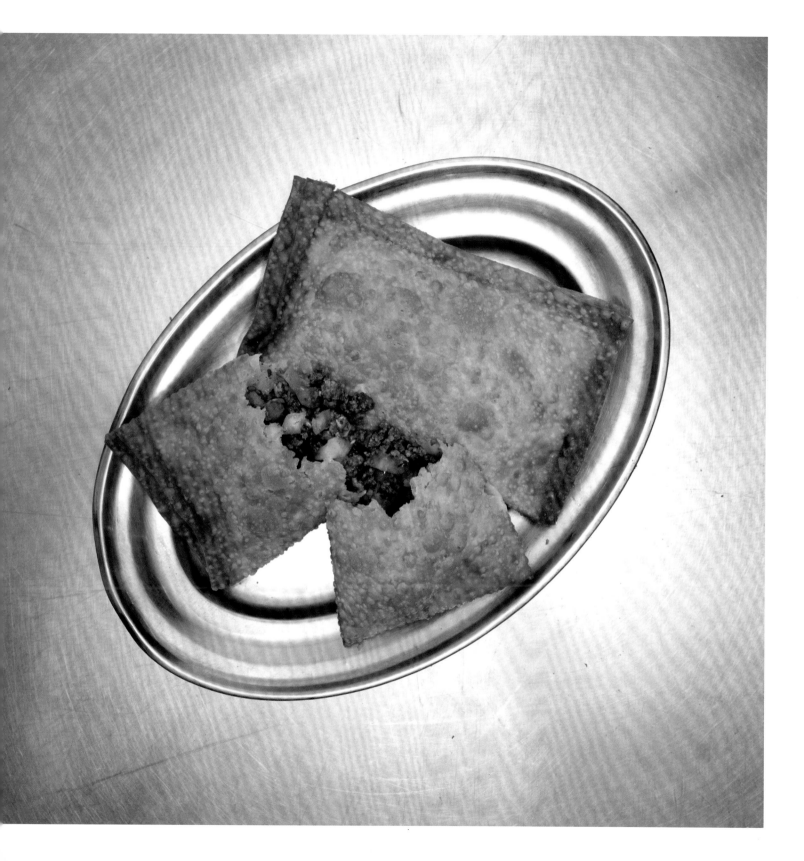

Maria da Penha Vito Barbosa da Silva

43 YEARS OLD

Although she is very young, Maria is already a grandmother. She was born in the Brazilian countryside but moved with her family when she was two to São Paulo, one of the biggest cities in the world. Her parents used to have a restaurant in the center of the city, and she learned how to cook by helping them in the kitchen. She still works in a kitchen, in one of the most popular restaurants in Vila Madalena, the youngest district of the city, where almost all the artists and creative people live. I met her there, but instead of sitting at a table, I was lucky enough to go into the kitchen and watch her cook just for me. She taught me how to make one of the most popular dishes in Brazil, the famous *pastel*!

You can buy pastel in restaurants, cafés, nightclubs, and many small street stalls or markets. Brazilians eat it for breakfast, as an afternoon snack, and often also for lunch or dinner—accompanied by an ice-cold beer.

Pasteles de Carne

MAKES 4 PASTELES

1 tablespoon grapeseed oil,
 plus more for frying
1 onion, chopped
1 pound ground beef
4 large tomatoes, diced
½ cup pitted green olives, diced
½ cup chopped fresh flat-leaf parsley
Salt
1 (12-by-12-inch) sheet frozen
 puff pastry, defrosted
1 egg, lightly beaten

1 Heat the 1 tablespoon oil in a pan over medium heat. Add the onion and sauté for 2 minutes. Add the ground beef, tomatoes, olives, and parsley and season with salt. Cook until the meat is no longer pink and the liquid has evaporated, 12 to 15 minutes. Season to taste. Remove from the heat and let cool for 5 to 10 minutes.

2 Cut the puff pastry into four 6-inch squares. Place a rounded ⅓ cup of cooked meat and vegetables in the lower half of each square, leaving a ½-inch border. Lightly brush the border with the beaten egg. Fold and press the sides together so it won't open (you can also use a fork to seal the edges).

3 Place 2 inches of oil in a deep pot. When the oil is hot (375°F), add the pasteles, a few at a time, being careful not to crowd the pan. Fry until they are golden and crispy, 2 to 3 minutes on one side, 1 to 2 minutes on the other side. Drain the pasteles on a rack set over paper towels, letting them cool a bit before you enjoy.

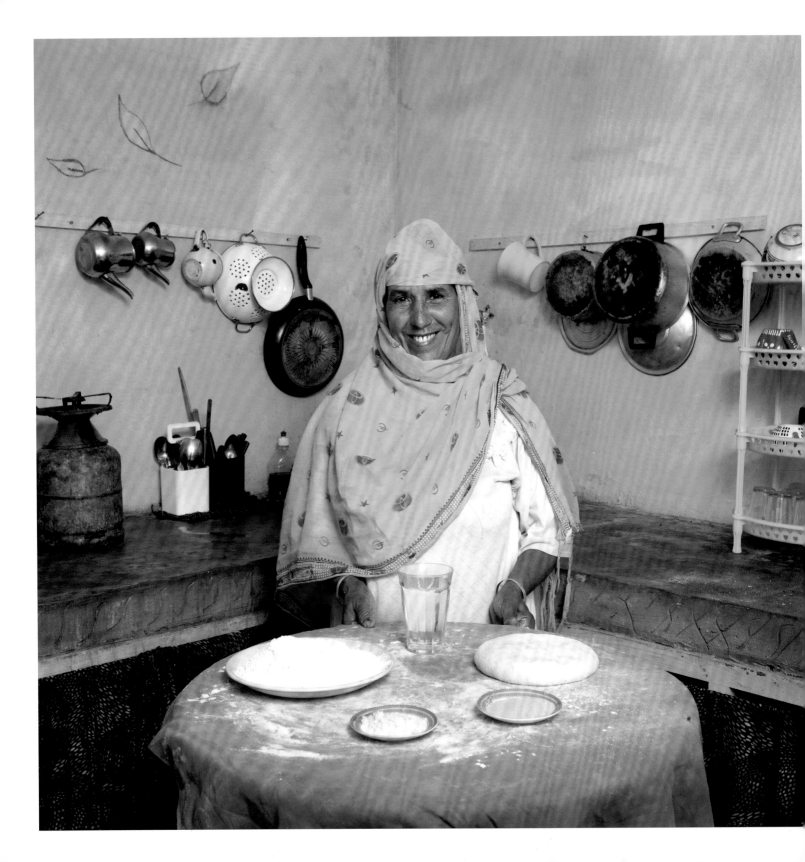

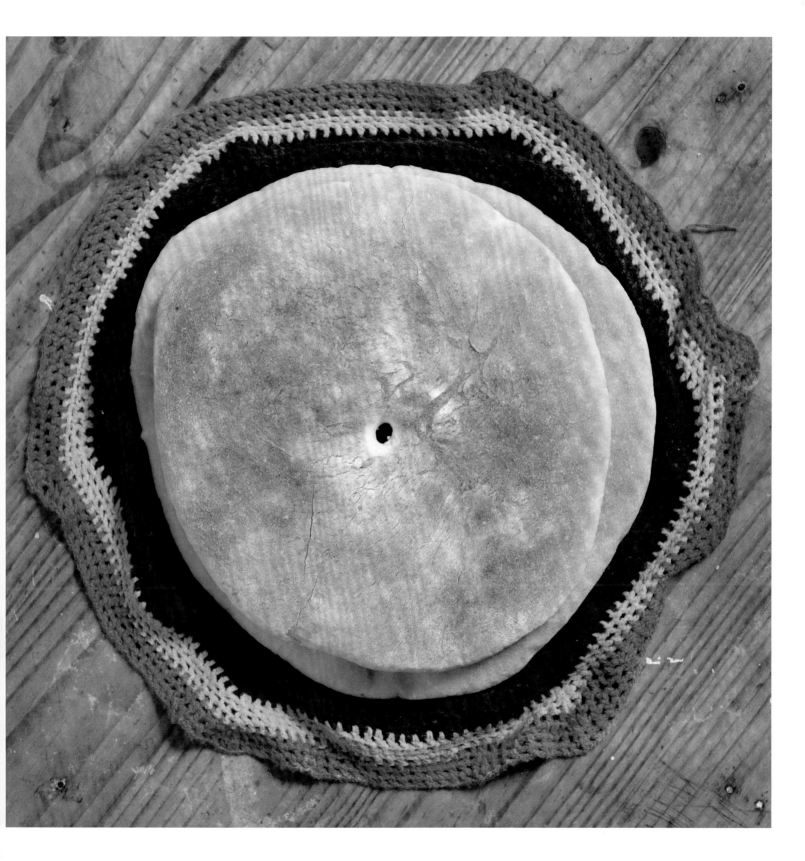

Fatma Bahkach /

59 YEARS OLD

Fatma and her husband have two sons, who are thirty-six and thirty-four years old, and a six-year-old grandson. They all live together in the same house, along with her elder son's wife. Though the house is not big, there is enough space for everybody, and it lies just ten minutes outside of the village and fifteen minutes from the sea. Fatma is the only cook in the house. "Cooking for the family is my job," she says, explaining that the rest of the family works in the fields from dawn to dusk. "Dinner is the only time of the day when we are all together under the same roof, because for lunch I usually prepare something that I take to the field. Every morning I wake up early to bake our special fresh bread, which is the easiest dish to take to work."

This Berber bread is not so different from the Italian *schiacciata* (a flat loaf of bread), and the ingredients and the process of making it are very similar. The difference is in the shape and baking. The Berber bread is cooked in a cast-iron pan and is softer than and not as crusty as the Italian bread.

Bat Bot

Berber Bread Baked in a Pan

MAKES 4 LARGE (8-INCH) LOAVES OR 8 MEDIUM (6-INCH) LOAVES

4 cups all-purpose flour

1½ tablespoons active dry yeast

2 teaspoons salt

1½ cups warm water (120° to 130°F), plus more as needed

1 Combine the flour, yeast, and salt in a large bowl. Slowly pour the water into the bowl, whisking with a fork or using your hand to combine all of the ingredients. If necessary, add more water, 1 teaspoon at a time. When the dough comes together, turn it out onto a lightly floured surface and knead it with your hands until it is smooth and soft, about 10 minutes.

2 Divide the dough evenly into 4 (or 8) pieces and roll each piece into a ball, then flatten slightly with your hand. Place the disks on a clean, well-floured dish towel. Dust each with a little more flour and cover with another towel. Allow the dough to rest for 10 minutes.

3 Working on a lightly floured work surface with 1 disk at a time (while keeping the other disks covered), use a rolling pin or your hand to flatten each disk until it is ¼ inch thick and measures about 8 inches (or 6 inches for medium loaves) in diameter. Place a dish towel dusted with flour on a baking sheet or large board and transfer the flattened disks to the towel, cover, and let rise in a warm area for 1 hour.

4 At this point, preheat a 9- to 10-inch cast-iron pan over medium-low heat until it is hot, about 5 minutes. Place 1 disk in the pan, letting it sit undisturbed for 5 minutes. Turn the bread over and heat for 4 to 5 minutes more. Continue turning the bread over every few minutes until it is evenly brown on both sides and the disk is puffed up (12 to 14 minutes total cooking time). The bread should be soft inside, with a thin crispy crust outside.

5 You can eat the bread plain or you can stuff it with chicken and vegetables.

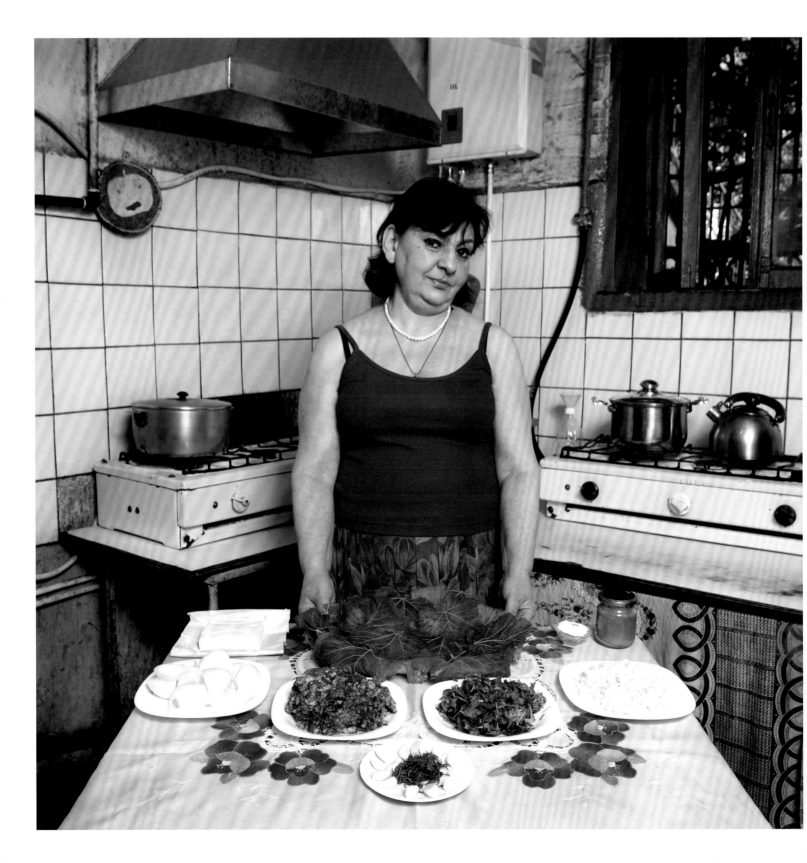

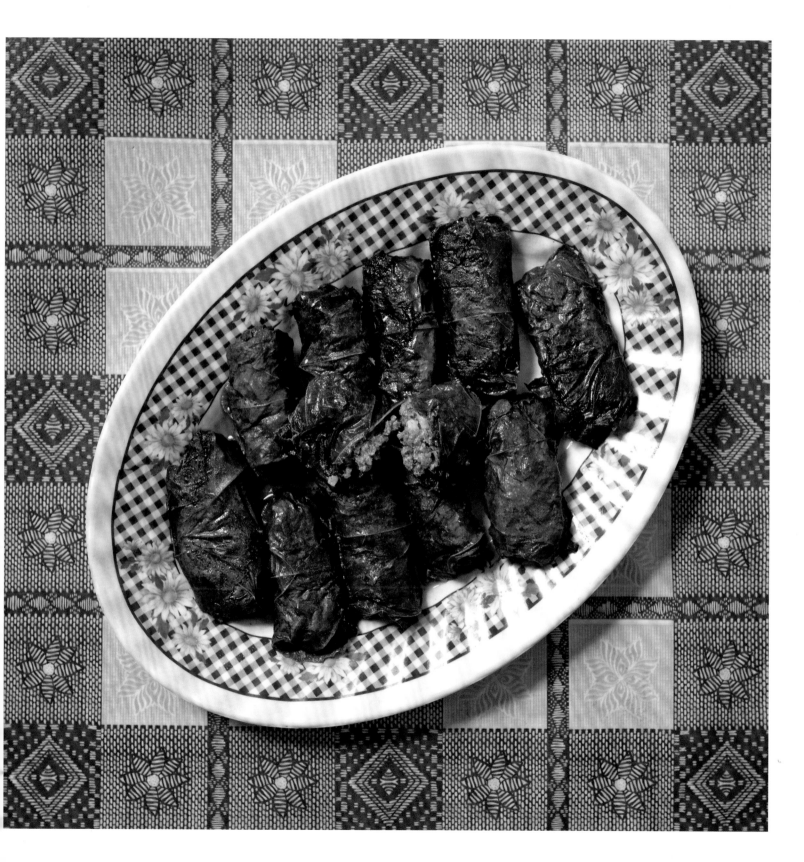

Jenya Shalikashvili

58 YEARS OLD

Dolma, a dish made of minced beef, rice, and vegetables wrapped in grape leaves, is typical of all those areas that once belonged to the Ottoman Empire—Greece, Syria, Egypt, Turkey, and Armenia—and in each of these places, the taste and preparation are slightly different. In Armenia the name, too, is a bit different: Here it is called *tolma*. Jenya, who has four grandchildren, has lived all her life in Armenia. She learned to cook tolma when she was fifteen and has been cooking this dish at least four times a week ever since. "It is my family's favorite meal. My grandchildren didn't like it when they were young, but now they love it and they always ask for it. When they come for dinner I prepare it in two different ways, because I don't use black pepper in the one I know they'll eat. (This is the trick to get kids to eat it.)"

Tolma

Grape Leaves Stuffed with Beef and Rice

MAKES 28 PIECES

1 medium white onion, roughly chopped

2 tablespoons coriander seeds

Leaves from 1 sprig of fresh thyme

2 garlic cloves

½ cup white rice

1 (8-ounce) jar grape leaves in brine, or fresh grape leaves

1 pound ground (or minced) beef

1 to 2 teaspoons (or less) freshly ground black pepper

2 tablespoons unsalted butter, cut into small pieces, at room temperature

¼ teaspoon salt

1 Combine the onion, coriander, thyme, and garlic in a blender. Puree until the mixture is smooth. Cook the rice until it is about 80 percent done, then set aside.

2 While the rice is cooking, bring some water to a boil in a medium saucepan. Drain the grape leaves and gently remove them from the jar. Unfold them, but do not separate them. When the water is boiling, turn off the heat and place the grape leaves in the pan. Let them sit for 3 to 4 minutes.

3 Remove the grape leaves to a bowl of cold water. By this time they should be easy to separate. Drain in a colander and pat dry. Set aside. (If using fresh leaves, follow the same procedure.)

4 In a medium bowl, mix the ground beef with the onion puree. Add the pepper (use a lot less if kids are going to eat the tolma), butter, warm rice, and salt. Work this mixture together with your hands until the butter is blended and the mixture becomes smooth.

5 Place the dry leaves, veined side up, on a clean work surface. Put 2 tablespoons of filling in the center of each leaf. Turn the sides in and roll up firmly into a burrito shape.

6 Set a large pot of water to boil. Cover the bottom of a second pot with several of the larger stuffed leaves. Place the tolma side by side over the bottom layer of leaves so as to fill the whole surface. Continue layering in this manner until all the tolma have been set in place. Place a heatproof dish with the same diameter as the pot on top of the tolma to cover them, as if to squash them. Put a weight on the heatproof dish (Jenya uses a stone from the garden, or use a bowl filled with water) and pour the boiling water into the pot over the top until it just covers the tolma. Turn on the heat underneath the tolma to medium and when the water comes back to a boil, reduce the heat to low, cover the pot, and gently simmer the tolma for 1 hour.

7 When the tolma are cooked, remove the dish and allow the tolma to cool in the pot. Carefully remove the rolls from the pot, being careful not to break them. Arrange them on a plate and serve.

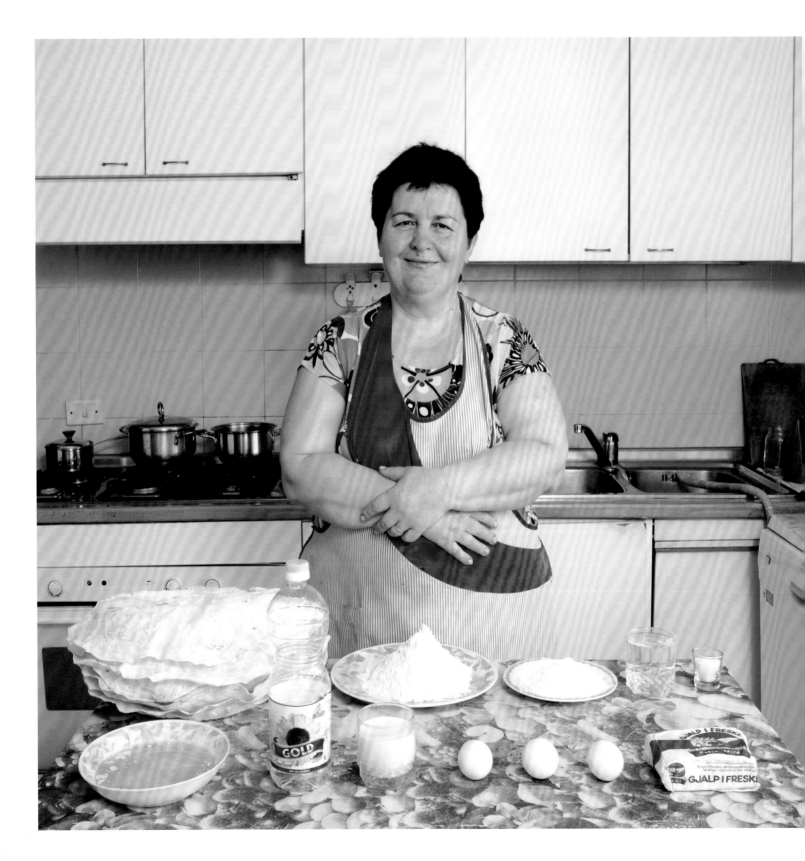

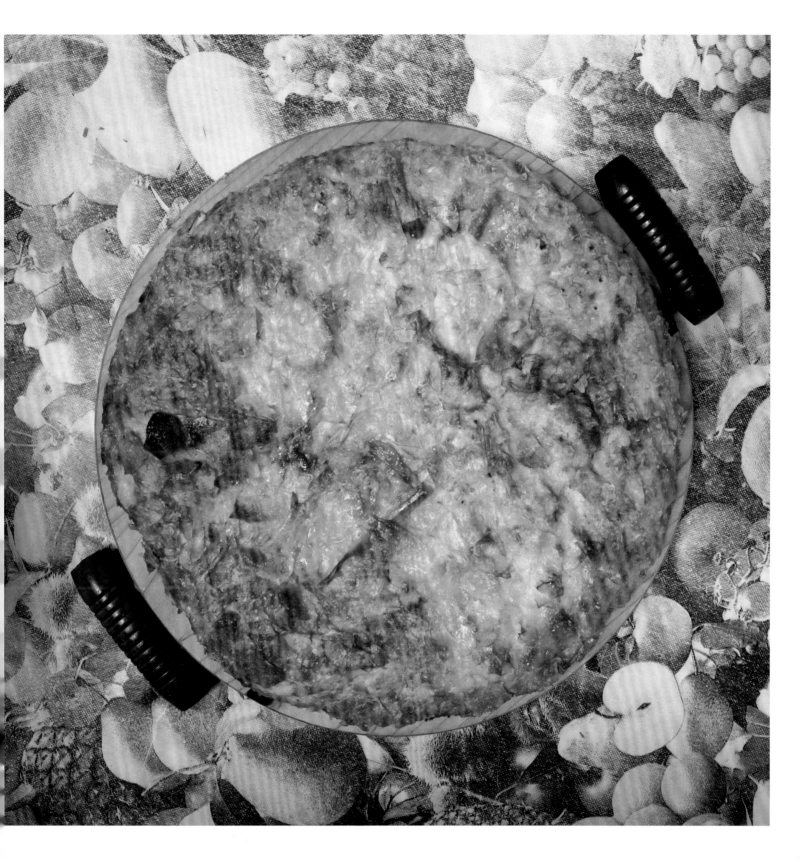

Neriman Mitrolari

52 YEARS OLD

Neriman has been familiar with kitchens since she was very young, because her mom was a cook. "I enjoyed accompanying Mom to the restaurant where she used to work. I learned so many things and I even dreamed of doing the same job," Neriman says. After getting married at twenty-one, she worked as an assistant chef in the university canteen, and then became a cook for the priests of an Italian parish in Tirana. Every day she cooks them breakfast, lunch, and dinner. "I like my job, even if it keeps me away from home and I never get the chance to cook for my family. We spend some time together only on Sundays and that's the day that I make the best effort to cook something special." Neriman's two grown children and three grandchildren live near her house and the parish, and sometimes join the priests for a meal. On those days, Neriman is especially happy to have cooked for them.

Burekoep Domate

Layered Egg Custard Pie

SERVES 6 TO 8

2 teaspoons salt, plus more for sprinkling

3 to 5 tablespoons vegetable oil

2½ cups all-purpose flour

Cornstarch, for dusting the dough

3 tablespoons unsalted butter

4 large eggs

2½ cups whole milk

Nonstick canola oil spray (optional)

1 In a bowl, combine 1 teaspoon of the salt, 1 tablespoon of the oil, the flour, and ⅔ cup of warm water. Turn the dough out onto a lightly floured work surface and knead with your hands for 10 to 15 minutes, adding some water if necessary, to obtain a smooth, soft dough that springs back when pressed with your finger. When the dough is ready, divide into eight 1¼-inch balls and dust lightly with cornstarch. Let the dough rest for 10 minutes.

2 Preheat the oven to 400°F.

3 Sprinkle a pastry board or clean work surface with 2 pinches of cornstarch and roll out the balls, one at a time, so as to create very thin round layers of pastry, about 12 inches in diameter. Use a very thin rolling pin (a ¾-inch dowel is perfect) to make the layers as thin as possible. The traditional method of rolling filo is to wrap the dough around a rolling pin floured with cornstarch, pressing and stretching it by moving your hands from the middle outward along the dowel, then to roll the dough back onto your surface or countertop. Rotate the dough one quarter turn and repeat the process until the dough is the size you need. Transfer the dough to a baking sheet lined with parchment paper.

4 Bake the layers, one at a time, for 5 minutes (it takes about 5 minutes to roll each ball, so 1 layer can be in the oven while you roll the next). Allow the layers to cool for a bit. (Leave the oven on.)

5 Melt the butter with 2 tablespoons of the oil. Whisk the eggs with the remaining 1 teaspoon salt and 2 cups of the milk. Add the melted butter and oil to the beaten eggs.

6 Generously grease the bottom and sides of a round baking pan or ovenproof skillet (12-inch diameter) with the remaining 2 tablespoons oil or with nonstick cooking spray.

7 Now, as if you were preparing lasagna, place 1 layer of pastry in the pan, pour some of the egg mixture into the pan, then top with another layer of pastry and repeat until you have used all the eggs and pastry. Gently press the layers with your hands so the dough layers are well submerged in the eggs. Pour the remaining ½ cup milk over the top layer and sprinkle with a pinch of salt.

8 Bake the pie for 40 minutes. Remove the pan from the oven and allow the pie to rest for at least 15 minutes before slicing and serving.

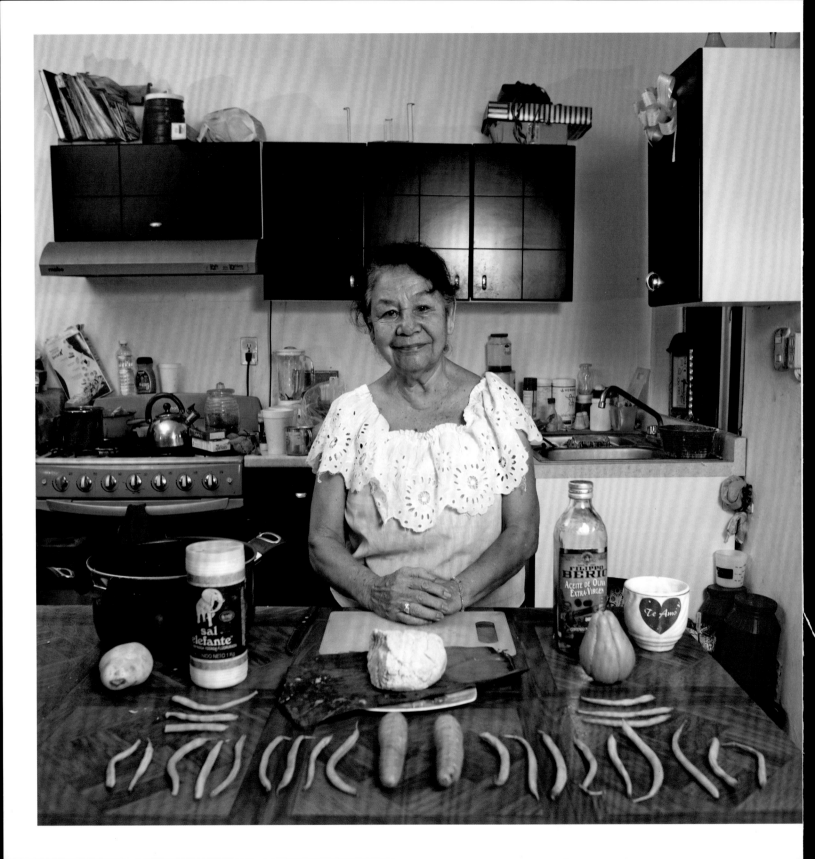

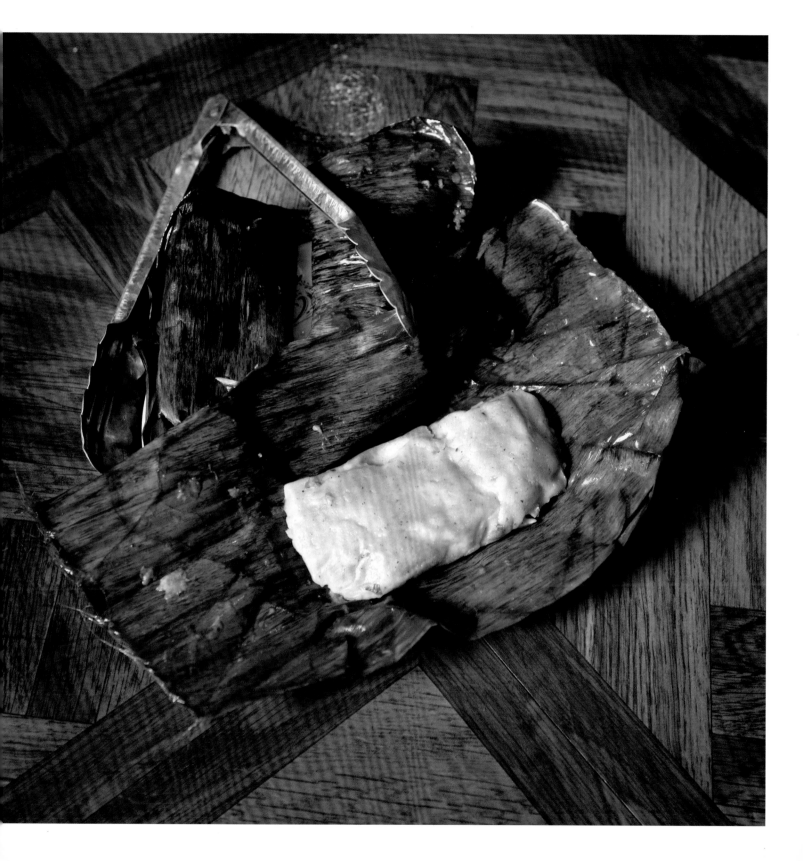

Laura Ronzón Herrera

81 YEARS OLD

Laura was born in Veracruz and still lives there in a big house with her husband and one of their two children. Her kitchen is a real mess: jars of spices are stacked in every corner; clean dishes (and dirty ones) are piled in the sink; there are vegetables everywhere and loads of empty beer bottles in the corner next to the full trash can. However, as soon as she starts to cook, I just close my eyes and let the smell take control of my senses: the aroma of frying vegetables mixed with spices and the sweet scent of banana tree leaves boiling in water. While Laura may not be so concerned about appearances, the substance of her kitchen is important. And, indeed, her meals are delicious, even if they are not so beautiful!

Vegetarian Tamales

MAKES 8 SMALL TAMALES

10 small banana leaves (available frozen or fresh at Asian and Mexican markets)

1 pound white corn flour (masa or masa harina)

Salt

4 tablespoons olive oil

2 carrots, peeled and cut into ½-inch dice

1 medium potato, peeled and cut into ½-inch dice

1 small chayote, cut into ½-inch dice

20 string beans, cut into ½-inch dice

Hot sauce or chili powder, for serving

1 Make the banana leaves: Wash and trim the tough edges. If the leaves are brittle, soak them in warm salted water for 1 hour. Pat the leaves dry and cut into 8-by-10-inch rectangles.

2 Make the masa: If you choose, you can obtain the masa harina like Laura does, from 4 dried white corncobs. Cut off the grains of the white corncobs and collect them on a dish. Then, crush the grains with a mortar and pestle or any other suitable tool in order to yield some flour.

3 To make masa with masa flour, in a large mixing bowl or in the bowl of a stand mixer fitted with the paddle attachment, combine the flour, 2 teaspoons of salt, 2 tablespoons of the olive oil, and 1¼ cups of water. (In the past, people would add a spoon of quicklime to the mixture because they thought it made their bones stronger.) Working the masa with your hands, add another 1¼ cups of water gradually to the masa, mixing well to combine. Continue until the dough resembles whipped potatoes.

4 Heat the remaining 2 tablespoons olive oil in a sauté pan or skillet over medium heat. Add the carrots, potato, chayote, and string beans and sauté the vegetables for about 15 minutes,

or until they are tender. Season with salt and set aside.

5 Lay the banana leaves out on a work surface with the light green, smooth side up and place ⅓ cup of masa in the center of each leaf, shaping the dough to resemble a small boat. Place ⅓ cup of the vegetables inside each masa boat, and close them up by bringing the masa around them. Fold 1 long edge of the banana leaf down over the filling. Bring the other long edge up over the top. Then fold both sides over each other to make a rectangular package. Be careful not to wrap the tamale too tightly, or the filling will squeeze out. Flip the package over so it is seam side down. Secure the tamale with kitchen twine or a long strip of the banana leaf.

6 Place a steamer basket in a large Dutch oven or soup pot with enough water to reach the bottom of the basket. Place some banana leaves on the steamer basket, layer your tamales on top of the leaves, and finish with more banana leaves to cover the tamales. Steam the tamales for 1 hour and serve them. You can eat them with hot sauce or simply top them with some chili powder.

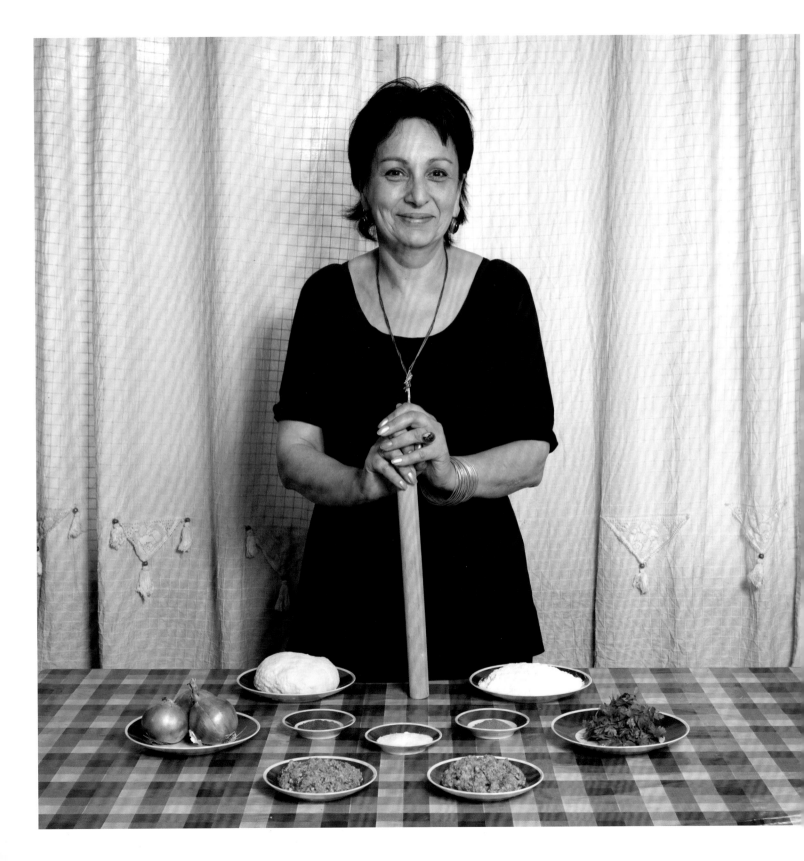

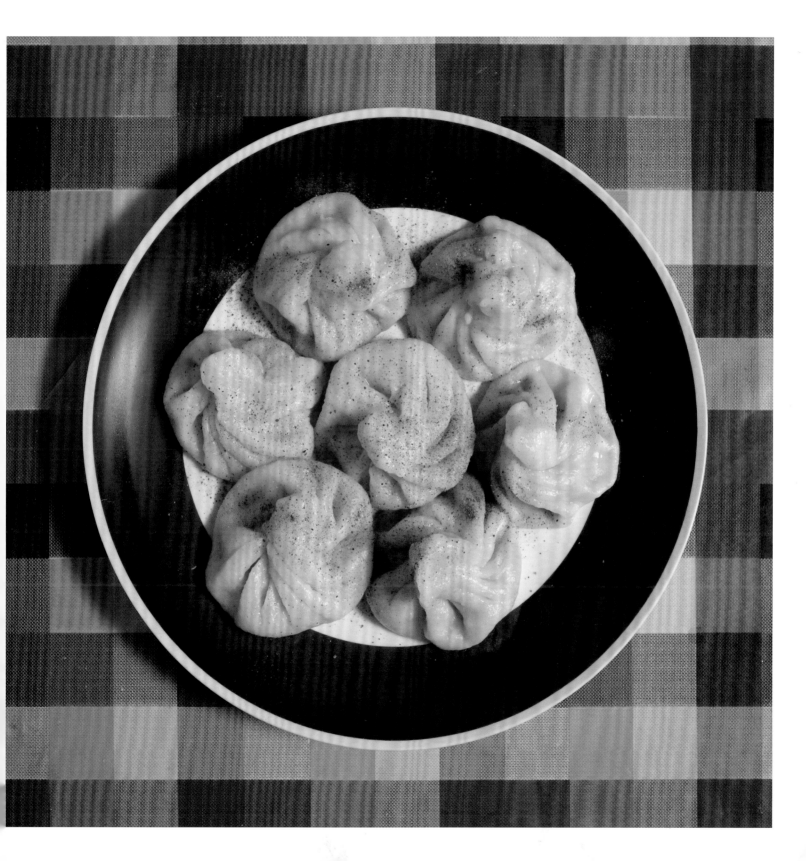

Natalie Bakradze

60 YEARS OLD

After thirty-five years of marriage, two children, and twin grandchildren, Natalie's greatest passions are knitting and cooking. Everybody in the family wears sweaters and scarves that she knitted for them, and everybody—including her daughter-in-law—brags that she is the best cook in town. I met Natalie and her family on a Saturday night for dinner in their big apartment in a huge building in the central part of the city. While we cooked together, we talked about our travels, politics, and art. I've felt like a member of Natalie's family ever since. In fact, Georgia was one of the places where I felt more at home than anywhere else. (In my opinion, Georgians and Italians are quite similar!)

This recipe is so popular in Tbilisi that it can almost be considered an official dish. You don't have to be a master chef to make these, but some precision and good manual skills come in handy!

Khinkali

Pork and Beef Dumplings

SERVES 4 (7 TO 8 DUMPLINGS PER PERSON)

4 cups all-purpose flour

12 ounces ground beef

12 ounces ground pork

1 small onion, minced

⅓ cup minced fresh flat-leaf parsley

Rounded ¼ teaspoon chili powder

Salt and freshly ground black pepper

1 Place the flour in a large mixing bowl. Gradually add up to 1¼ cups of warm water, working with your hands until you have a rather stiff dough. Place on a floured surface and knead the dough for 5 to 6 minutes, until it is smooth. Place the dough in a bowl and cover with plastic wrap. Set aside to rest for 30 to 40 minutes.

2 In a large bowl, combine the ground beef and pork. Add the onion, parsley, chili powder, 1 teaspoon of salt, and a dash of pepper. Set aside.

3 Working on a lightly floured surface, roll the dough into a thin layer (about ⅛ inch thick) and cut it into rounds with a diameter of 3 inches. Roll each round into a paper-thin disk, about 5⅛ inches in diameter. Dust the rounds with flour and lay them on a board, slightly overlapping.

4 Working on a flat surface, place 2 tablespoons of the meat filling in the center of each round. Bring the dough up around the filling, pleating the dough with your fingers and then twisting it into a knob to seal it.

5 Bring a large pot of salted water to a boil and cook the dumplings in batches for 18 to 20 minutes.

6 Serve hot and enjoy.

In Georgia people eat these dumplings with their hands, grabbing the top knob, which is called "the cap." There are three different tales explaining why you shouldn't eat the knob of the dumpling: 1. It is tough, not cooked properly. 2. The dumplings are so good that you lose track of how many you eat. So you leave the caps on your plate to count them. 3. It was a typical dish of the working class of the mountains. When laborers would order them in the restaurants, their hands were still dirty from work, so they wouldn't eat the caps that they had touched.

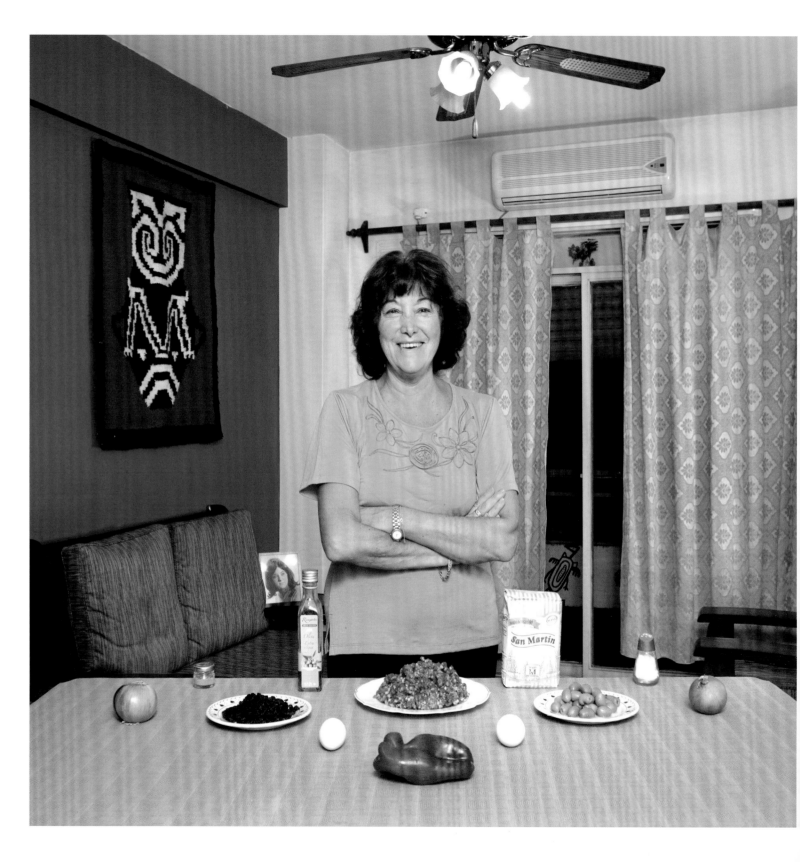

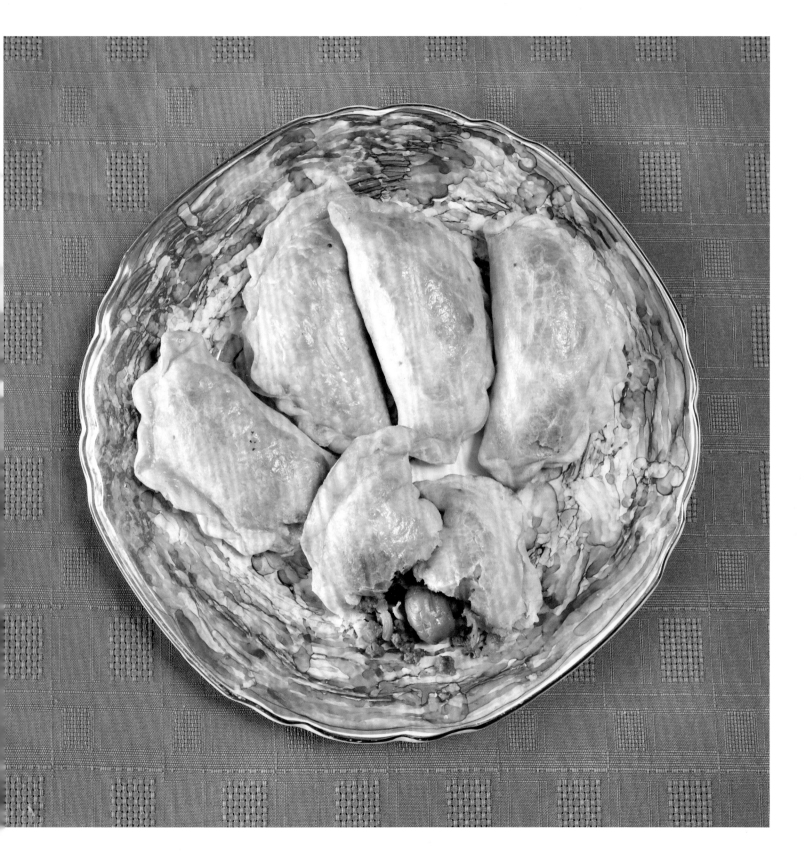

Susana Vezzetti

62 YEARS OLD

Susana has Italian ancestry, but she grew up in Buenos Aires. She went to work in a furniture factory when she was quite young, and for about twenty years she was in charge of the sales department. When she married and had kids, she decided to devote herself to the family, becoming a housewife for nearly twenty years. However, she has recently had much more free time, now that her children are grown and have families of their own. So Susana started a small business, importing religious books from Italy and selling them in the Argentinian market. Her new job keeps her busy for most of the week, but luckily on the weekend she can spare some time to visit her grandchildren. "Every time that I go visit my children and my grandchildren, I bring my special empanadas. They all love them and always say it is the food that they like the most. I'm so happy to see them eating my empanadas with great satisfaction."

Empanadas Criolla

Meat-Stuffed Pastries

MAKES 12 EMPANADAS

3½ cups all-purpose flour

2 teaspoons salt

1 large egg, lightly beaten

2 tablespoons olive oil

2 onions, chopped

1 red bell pepper, chopped

1 pound ground beef

1 teaspoon ground cumin

1 hard-boiled egg

1 to 2 tablespoons raisins

12 green olives, pitted

1 egg yolk, beaten

1 Place the flour in a bowl with 1 teaspoon of the salt. Add the beaten egg and ¾ cup of water. Work the mixture gently with your hands, adding water, if necessary, 1 tablespoon at a time, until it just comes together to form a smooth dough. Do not overwork the dough. Cover and let rest while making the filling.

2 Heat the olive oil in a pan over medium heat. Sauté the onions and bell pepper until the onions are translucent and the pepper is softened. Add the ground beef, the remaining 1 teaspoon salt, and the cumin. Cook until the liquid is completely evaporated, about 10 minutes. Remove from the heat and set aside to cool completely, about 30 minutes. If the mixture is still hot, it will ruin the dough when you stuff it.

3 When the filling is cool, mince the hard-boiled egg and add it and the raisins to the meat mixture.

4 Roll out the dough on a lightly floured work surface using a wooden rolling pin. Stretch it until it is about ¼ inch thick and then cut it into rounds of about 3½ inches in diameter. Roll each round out to ⅛ inch thick and about 6 inches in diameter.

5 Preheat the oven to 400°F and line a baking sheet with parchment paper.

6 Place ⅓ cup of filling on half of each round of dough, leaving a ½-inch border, and top each with 1 whole olive. Fold the dough over the filling so as to form a half-moon shape. Press the edges with your fingers to close the empanada. Place the empanadas on the baking sheet and brush the tops with the beaten egg yolk. Put the empanadas in the oven and bake for 15 to 18 minutes, until golden brown.

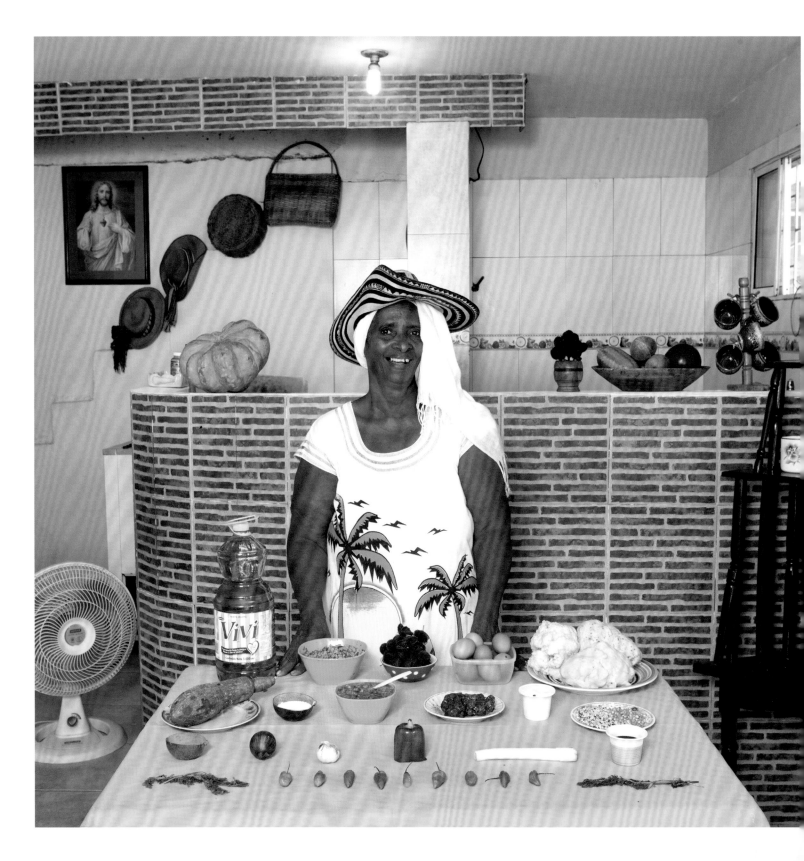

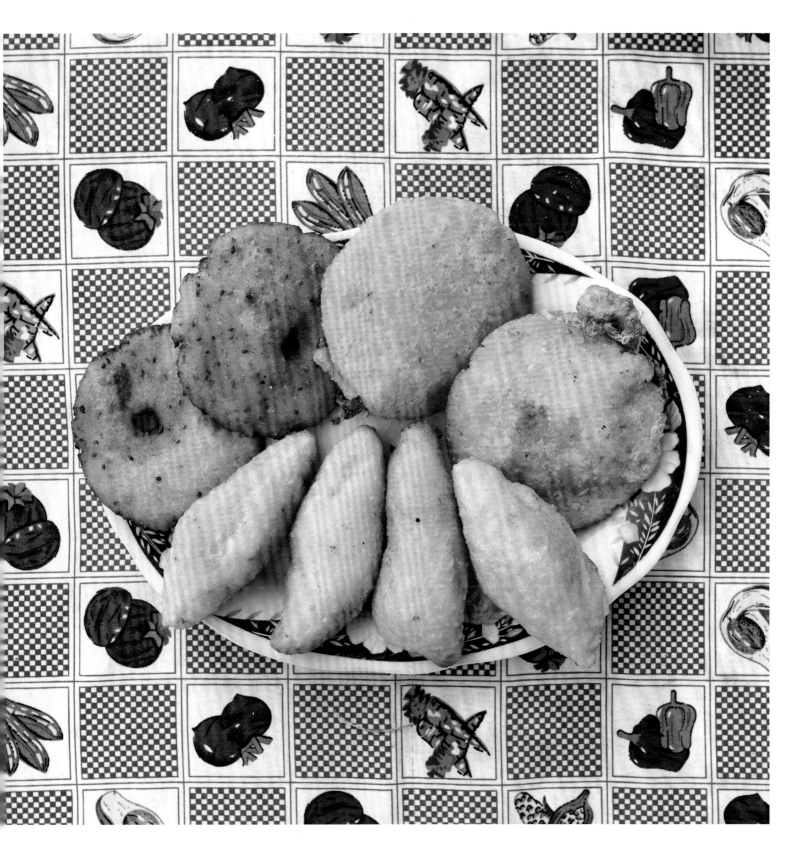

Ana Tulia Gómez

69 YEARS OLD

Ana Tulia is a star of Cartagena, a true local celebrity. Everybody knows her as *la reina del frito,* "the queen of fried food." She has actually taken the top prize at Cartagena's food festival nineteen times with her special arepas. "Three years ago I was invited to a cooking event in Paris. It was the only time I left Colombia and it happened thanks to my fried specialties! They treated me like a queen the whole time. I stayed in a luxury hotel; they took me around by taxi and took care of every meal. I would have never thought that what I do every day at home could take me so far away." I went to Ana Tulia's on a very hot afternoon at the end of May. As I arrived, I saw her waiting for me in the garden, next to a large pan full of oil. I immediately thought that eating arepas on such a hot day wasn't the best of ideas, but they were so good that after tasting the first one, I forgot about the terrible heat and ate four of them!

You can choose to stuff your arepas with just the egg or the meat, or you can give free play to your creativity and fill them with ingredients to your liking and also shape them in a different way.

Egg and Beef Arepas

SERVES 4 (2 AREPAS PER PERSON)

2 cups Masarepa or Harina P.A.N. white cornmeal

Salt

1 tablespoon high-heat canola or sunflower oil, plus more for deep-frying

1 small red onion, minced

2 small jalapeño peppers, minced

½ small red bell pepper, minced

10 ounces ground beef

Freshly ground black pepper

8 small or medium eggs

1 Make the dough: In a medium bowl, stir together the masarepa and 2 teaspoons of salt. Add 2¼ cups of hot water, stirring until combined. Let sit for 2 minutes. Using your hands, bring the dough together in the bowl and let sit for 3 minutes.

2 Turn the dough onto a flat work surface and knead with your hands until it is the texture of mashed potatoes. Divide the dough into 9 portions. Roll each of 8 portions into a ball and press gently with the palm of your hand to flatten into a disk ⅛ inch thick and 4 inches in diameter. Use your fingers and a little water, if necessary, to smooth out any cracks along the edges. Place the disks on wax paper and cover with another piece of wax paper while you prepare the filling. Set aside the remaining 1 portion of dough to seal the arepas after they are stuffed.

3 Make the meat filling for the arepas: In a medium sauté pan, heat the 1 tablespoon oil over medium heat. Add the onion, jalapeños, and bell pepper and cook until the vegetables are tender. Add the ground beef and let it cook for about 5 minutes.

Season with salt and pepper. Remove from the heat and let it cool.

4 Fill a heavy pot with 1½ to 2 inches of oil and heat until it registers 325°F on a deep-fry thermometer. Slowly add the arepas, one at a time, to the oil. Cook until they rise to the top, then turn them over and continue cooking until they are evenly golden, about 5 minutes total. Transfer to a plate lined with paper towels. Continue in this manner until all of the arepas are cooked. (If the frying oil has become dark, discard it and replace with fresh oil and bring back up to temperature.)

5 Once the arepas are cool enough to handle, use a sharp knife to make a cut of about 2½ inches along the rim of each arepa, cutting to the middle without slicing all the way through, to make a pocket.

6 Crack one of the eggs into a small ramekin and carefully pour it into the pocket of each arepa. Then add 2 tablespoons of the meat mixture. Using a bit of the reserved dough, seal the arepa closed. Repeat with the remaining arepas.

Fry the arepas in batches, turning once, for about 4 minutes, or until the egg inside is cooked. Remove the arepas from the pan with a slotted spoon and transfer to a paper-towel-lined plate. Allow the arepas to cool for a few minutes and serve.

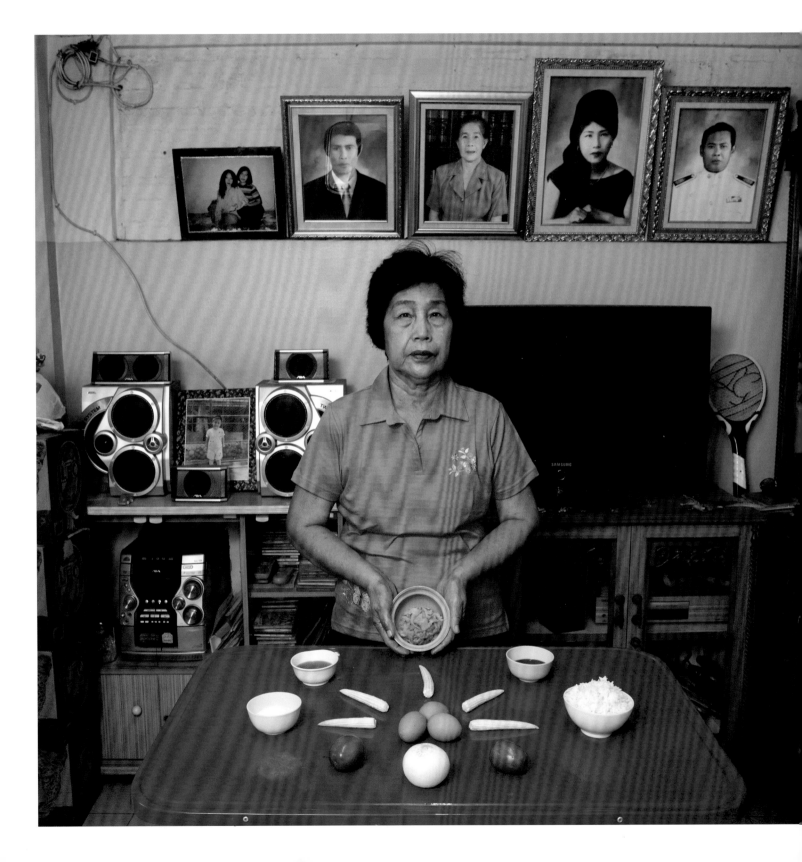

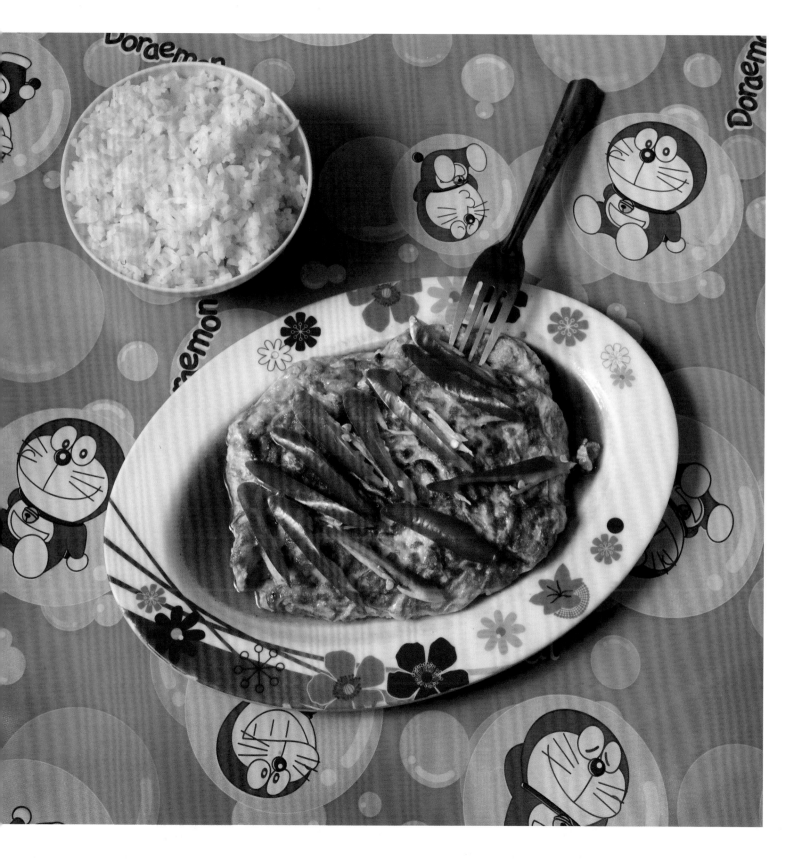

Boonlom Thongpor
69 YEARS OLD

Six large photos of all the members of her family keep Boonlom company every time she prepares a new delicacy in her kitchen. The mother of two daughters, and grandmother of a young child (whom you can see in the photo between the hi-fi speakers), Boonlom has spent her whole life in Bangkok and considers herself the best cook in her neighborhood. Until a few years ago, she ran a small street restaurant, the kind you find everywhere around Southeast Asia, where people eat quick (but often very tasty) dishes while standing or sitting in stalls on the sidewalk. (The average cost of a full meal at her restaurant rarely goes beyond four dollars!) Now her restaurant is run by one of her daughters, who has changed it slightly: In what used to be their garage, her daughter has arranged four tables so people can finally eat while properly seated!

Kai Yat Sai

Stuffed Omelet

SERVES 3 TO 4

Small bowl of steamed rice, for serving (optional)

1 or 2 tablespoons canola or safflower oil

8 ounces ground pork

3 to 4 teaspoons soy sauce

1 medium white onion, cut into small (⅜-inch) dice

4 medium plum tomatoes, cut into small (⅜-inch) dice

1 (14-ounce) can whole baby corn (10 cobs), cut into ¾-inch pieces

2 teaspoons sugar

1 tablespoon fish sauce

6 large eggs

Salt

Nonstick canola oil spray (optional)

Slices of red bell pepper (optional)

1 If you want to accompany your omelet with some steamed rice, first cook it according to the package directions. Set aside.

2 Heat a wok or large sauté pan over high heat. Add 1 tablespoon of the oil and heat until the oil is very hot. Add the pork and cook, stirring, for 1 minute. Add the soy sauce and cook for 1 more minute. Add the onion, tomatoes, baby corn, sugar, and fish sauce, stirring well to combine. Cook everything together for 4 to 5 minutes, until the pork is no longer pink. Remove the pork mixture from the wok and set it aside. Wipe out the wok and return it to the stove.

3 Whisk the eggs in a medium bowl with a pinch of salt.

4 Heat the remaining 1 tablespoon oil in the wok over high heat, then drain it so as to leave only a thin greasy layer on the wok. (Alternatively, you can spray a sauté pan with nonstick spray.) Pour the eggs into the wok and cook for slightly more than 1 minute, moving the wok in a circular motion to obtain a thin and large omelet.

5 When the eggs begin to set, lower the heat. Place the pork mixture in the center of the omelet and wrap the omelet around it. Cook the omelet for 1 more minute, turning it a couple of times. (If using a sauté pan, simply fold over the omelet.) The dish is ready to be eaten with the cooked rice. Boonlom suggests topping it with pieces of red bell pepper, but, personally, I prefer it plain!

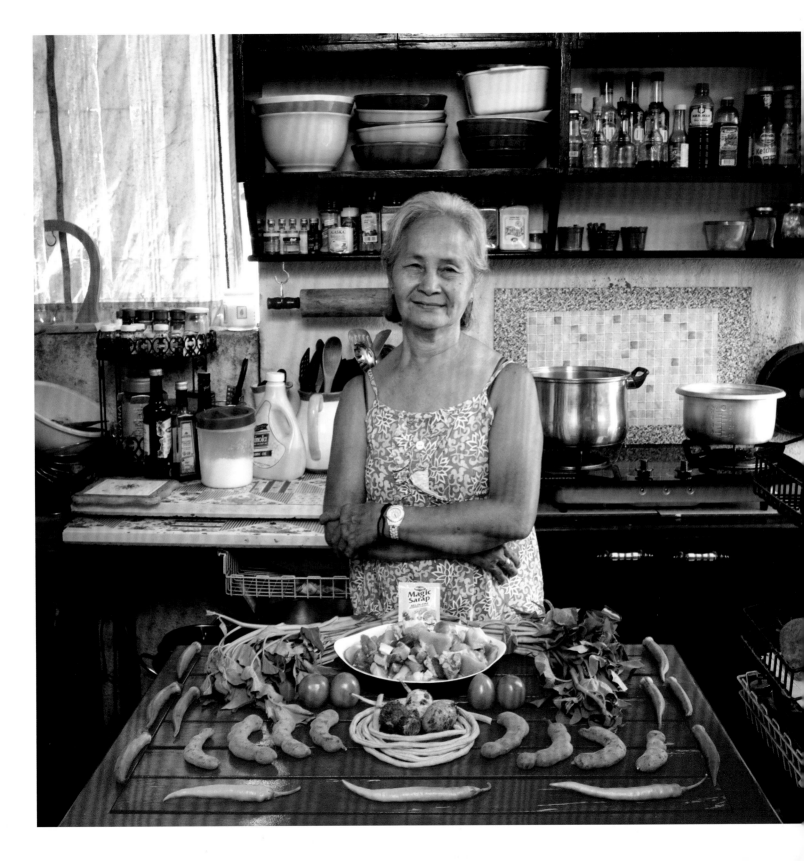

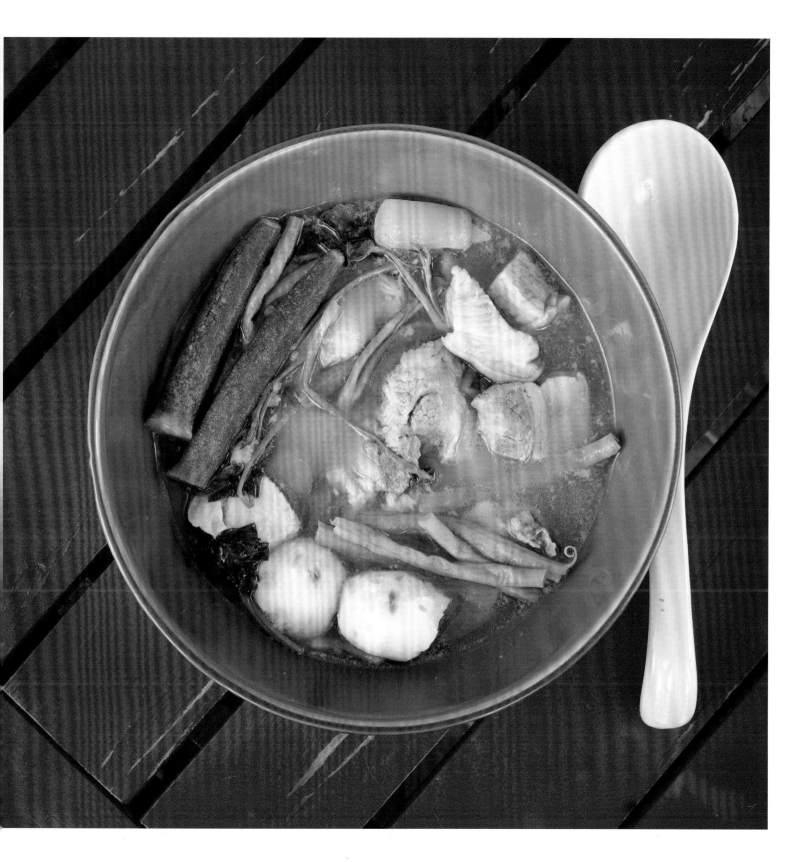

Fernanda de Guia

71 YEARS OLD

Fernanda was born in Manila and has lived there all her life. She has three sons and five grandchildren, and she lives with her husband in a big house in the northern part of the city. All of her sons not only live in the neighborhood, they live on the same street. The house of the son who lives the farthest is no more than half a mile away. "I really love the fact that my sons and my grandchildren are nearby; I never have a moment of rest," she says with a giggle. "They are always here: lunch, dinner, teatime. You could say I'm a full-time cook, but without a salary. Sometimes I'm tired of cooking so much, but in the end I think that having a family so close to me is the best thing I could ask for. They keep me happy all the time. I welcome all of them on a nice Sunday morning and we have a fantastic lunch together."

Sinigang

Tamarind Soup with Pork and Vegetables

SERVES 4

1½ pounds pork belly, cut into 1½-inch pieces

Salt

4 fresh tamarind pods (avoid anything labeled as sweet tamarind)

3 ripe tomatoes

2 small (about 6 ounces each) taro corms, peeled and chopped into 1-inch pieces

Boiling water

4 cups kangkong (also called "water spinach" or "ong choy") or baby spinach

8 okra pods

8 string beans, cut in half

2 large green finger peppers (frying peppers), cut into 1-inch pieces

1 In a medium pot, combine the pork with enough water to cover (about 6 cups). Add 1 teaspoon of salt. Bring to a boil over medium-high heat, then reduce the heat to medium-low and simmer for 20 minutes. Add the tamarind pods and whole tomatoes. Cook for 10 minutes, then remove the tomatoes with a slotted spoon. Peel and mash them and then put them back into the soup. Add the taro corms. Simmer for 5 more minutes, or until the tamarind is tender and the shells begin to show cracks. Remove the pods from the soup. Open them and remove the tendrils (they should be discarded along with the pod shells). Place the pulp and seeds in a heatproof bowl and pour in ¼ cup of boiling water to cover. Press a fork gently against the pulp and seeds to extract the juices and allow to sit for 1 to 2 minutes. Pour the juice through a fine-mesh strainer back into the soup. Discard the remaining pulp and seeds. Continue to gently simmer the soup for another 15 minutes.

2 When everything has simmered for about 55 minutes in total, add the kangkong, okra pods, string beans, and green finger peppers. Season with salt and simmer for another 10 minutes.

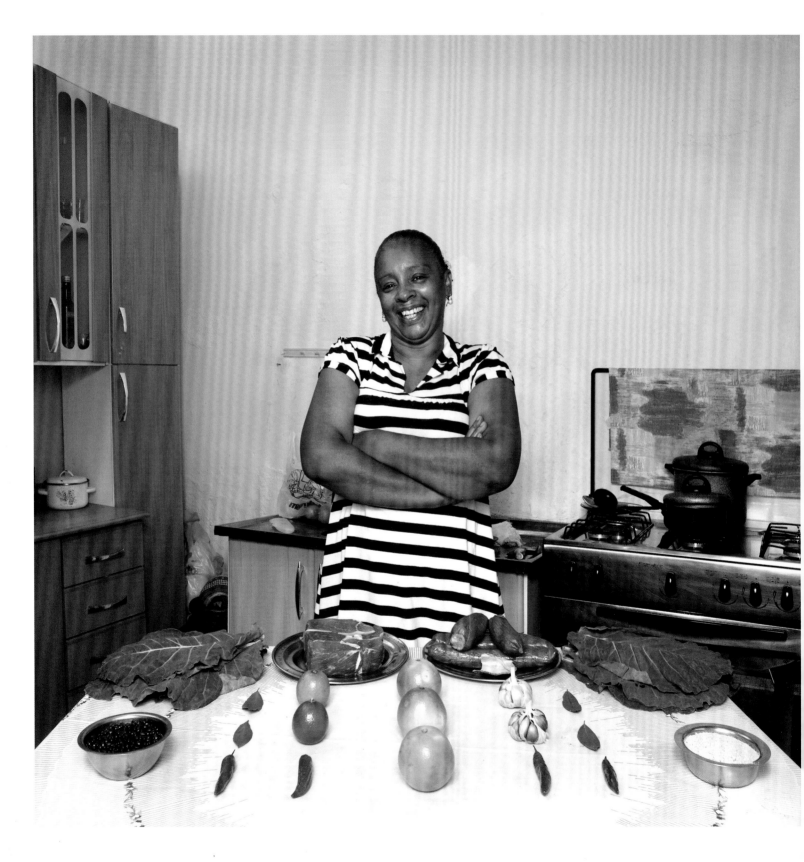

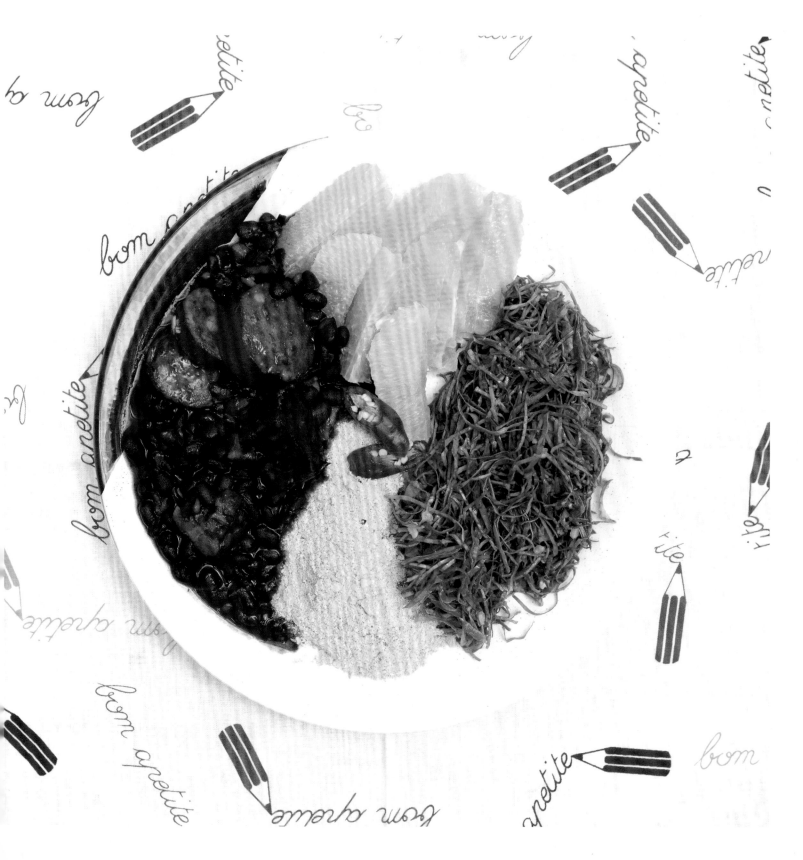

Ana Lucia Souza Pascoal

53 YEARS OLD

Ana Lucia was born on the outskirts of São Paulo, into a family that hailed from the state of Bahia. She attended the samba school in her neighborhood when she was still very young, and at fifteen she was crowned queen of her dance group for the carnival parade. She stopped dancing a few years later and started to play percussion instruments. Now she is the *madrina de la batería* ("the queen of the drums") and plays the leading role in her percussion band. Ana Lucia is a sort of celebrity in her neighborhood; almost everybody knows her! She has two children and four grandchildren and every Wednesday evening she cooks her special *feijoada* for them. Most days, her grandchildren spend time at home with her because their parents work late. Ana Lucia takes them to the samba school and she hopes that one day they will become great dancers.

The most representative and typical dish of Brazil is undoubtedly feijoada. Ana Lucia showed us how to make its lighter version. Traditional feijoada is made with fattier cuts of pork, but Ana Lucia uses precooked sausage and serves the stew with a side of fresh fruit.

Feijoada Light

SERVES 6 TO 8

8 ounces dried beef or beef jerky

2½ cups dried black beans

4 bay leaves

5 tablespoons olive oil

2 garlic cloves, chopped

8 ounces thick-sliced bacon, diced

2 precooked hot sausages, sliced

4 precooked *paio* or chorizo sausages, sliced

8 ounces collard greens, thinly sliced

2½ cups manioc flour

2 to 3 oranges

1 The morning of the day before you plan to make the feijoada, soak the dried meat in water to remove as much of the salt as possible, changing the water 2 or 3 times. That evening, place the beans in a large pot or bowl with water to cover by several inches. Soak the beans overnight.

2 The next day, drain the meat and cut it into pieces. Drain the beans, rinse them well, and add them to a deep stockpot. Cover the beans with fresh water and add the bay leaves. Bring the beans to a boil, then lower the heat and simmer for 60 to 90 minutes, until the beans are just beginning to feel tender (about 80 percent cooked).

3 Heat 1 tablespoon of the olive oil in a large pot. Add the garlic and bacon and sauté for about 2 minutes. Then add the drained beef. Pour in enough water to just cover (1¼ to 2 cups),

then cover the pot, reduce the heat to a simmer, and cook for 30 minutes.

4 Add the sliced sausages to the pot along with the beans and their water (6 cups); remove the bay leaves. Return to a simmer and continue cooking, uncovered, for another 30 minutes, or until the beans are very tender.

5 Heat 2 tablespoons of the olive oil in a pan and sauté the collard greens for 3 to 4 minutes.

6 In a separate pan, warm the remaining 2 tablespoons olive oil over medium-low heat and stir in the manioc flour. Cook, stirring frequently, for 4 minutes, or until the manioc is toasted.

7 Peel the oranges and divide into segments. Arrange all the ingredients you have prepared on a plate, as shown in the photo, and serve.

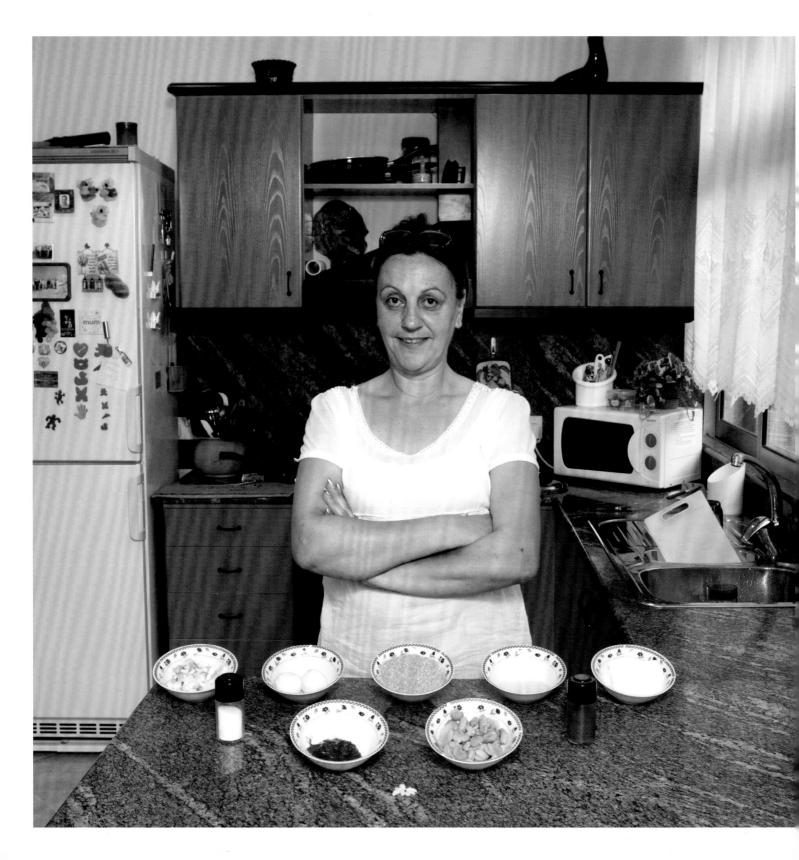

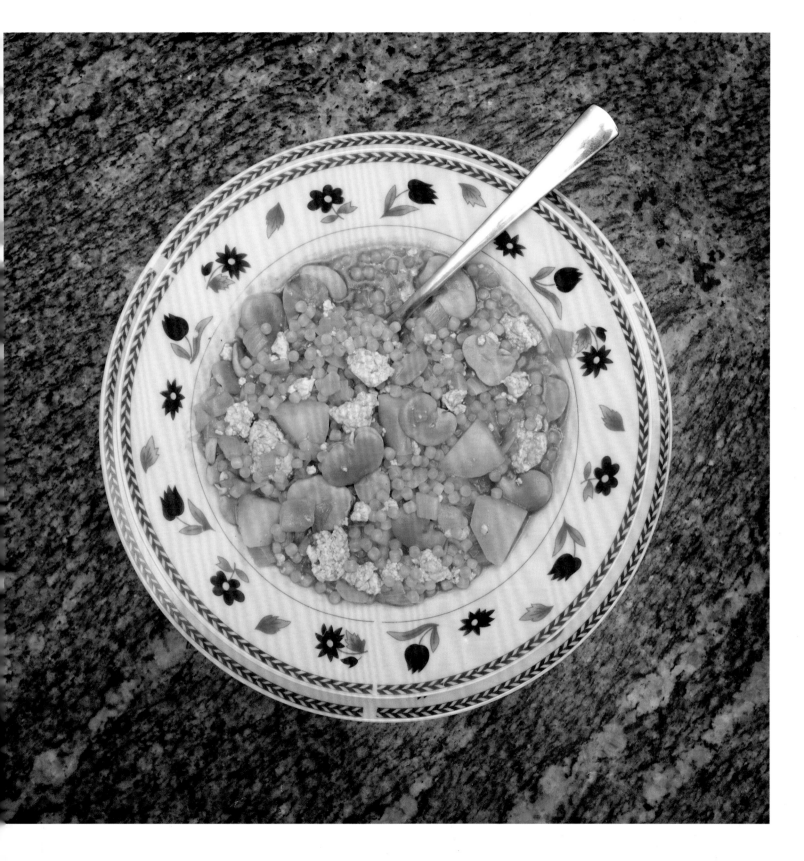

Cettina Bugeja

53 YEARS OLD

While Cettina has distant Italian origins, she has lived in Valletta, the capital of Malta, her entire life. Often she wishes she could go back to Italy in search of her roots and, maybe, move there. "I really love living here, but you can sometimes feel a bit isolated in Malta. The island is beautiful, but small. You can just about visit the whole island in a day. I know almost everybody in town and sometimes I would like to see new faces around. Fortunately, in the past few years we have been getting more and more tourists," she explains. Cettina has now been married for thirty years and has two children and three grandchildren, whom she cooks for almost every day. The recipe that she prepared for me was a delicious soup that has Italian and Arabic origins. Some people love the soup with the addition of a fried egg on top.

Cosksu

Kusksu Soup with Vegetables and Ricotta Cheese

SERVES 4

1 tablespoon olive oil

1 small onion, cut into small dice

1 large garlic clove, minced

Salt and freshly ground black pepper

1 tablespoon tomato paste

1 cup fava beans, shelled and peeled (available frozen from Goya)

1 large red-skinned potato, cut into medium dice

¾ cup kusksu pasta (Maltese pasta or pasta beads) or pastina

½ cup ricotta salata or creamy ricotta

1 Heat the olive oil in a medium saucepan fitted with a lid over medium-low heat. Add the onion, the garlic, and salt and pepper to taste and sauté until the onion is slightly golden, about 8 minutes. Add the tomato paste, stir to combine, and cook for 3 minutes. Add the fava beans and potato and let everything cook for about 5 minutes. Stir in 4½ cups of hot water, cover the pan, and cook for 10 more minutes. Add the pasta and cook, uncovered, for 5 minutes more, or until the potatoes and pasta are tender.

2 Remove the pan from the heat and season the soup with salt and pepper. Let sit for 3 minutes. If using a firm ricotta (ricotta salata), crumble the cheese and add it to the soup while it sits.

3 To serve, divide the soup among 4 individual bowls. If you are using soft ricotta, add it to the soup in dollops. Serve with white wine.

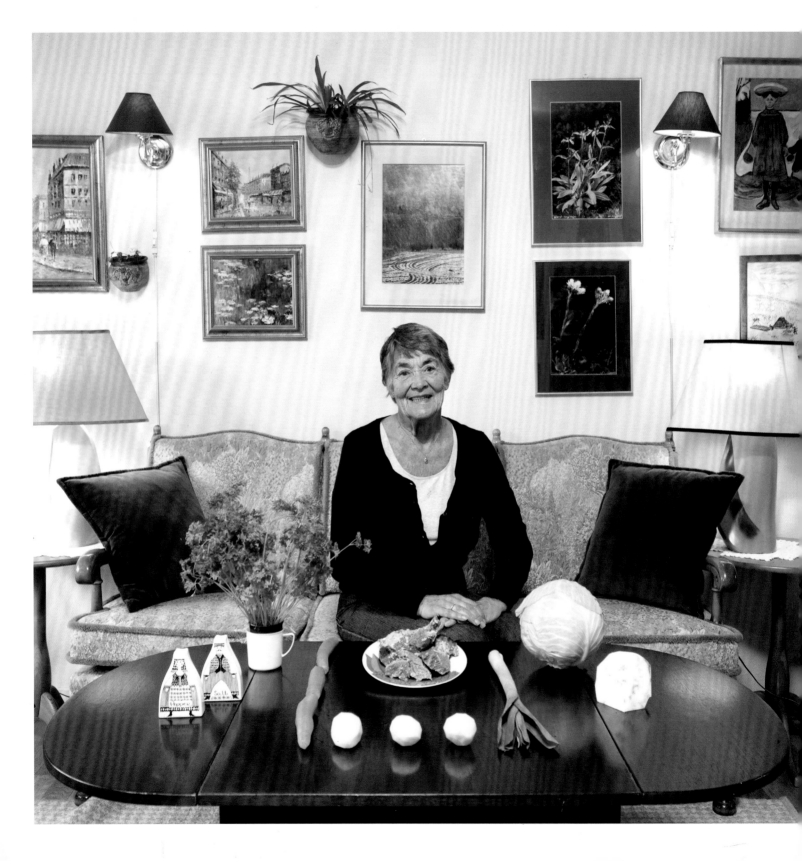

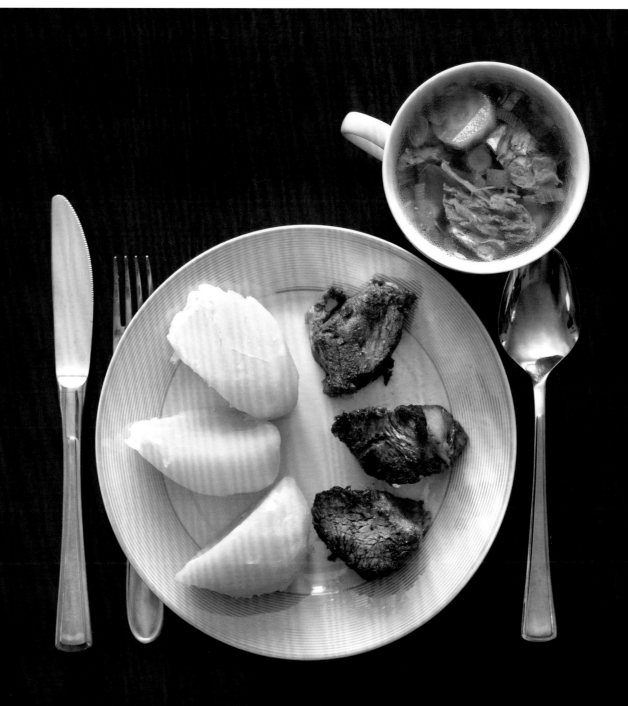

Synnøve Rasmussen

77 YEARS OLD

Synnøve is nearly eighty, but she has the energy of a twenty-year-old. She lives on her own in a big flat in the center of Bergen, and from the windows she can see the mountains and the sea. Every morning, cold weather or not, she takes a nice one-hour walk to keep fit, and she travels with some friends, or even by herself, twice a year. When she is at home, she paints, plays the piano, or cooks. "I have always enjoyed life; I used to have a job I loved and I was married to a wonderful man. We did many fantastic things together. Unfortunately, he is not here anymore, but when my son visits me in the summer and leaves my grandchild here with me for a few days, I am the happiest grandma in the world. I bring the little boy to walk with me every morning and I keep fit in not only my body, but also in my heart!"

Kjötsúpa

Icelandic Bull Meat and Vegetable Soup

SERVES 4

2½ pounds bull meat round roast (or beef chuck roast), cut into 2 large pieces

Salt

3 medium potatoes, peeled and quartered

3 carrots, peeled and thinly sliced

½ small Savoy cabbage, thinly sliced (3½ to 4 cups)

1 small rutabaga (a Swedish turnip), peeled and thinly sliced

1 small leek, thinly sliced (about 1 cup)

1½ cups chopped fresh flat-leaf parsley

2 tablespoons unsalted butter

Freshly ground black pepper

1 Bring 6 cups of water to a boil in a large pot. Add the meat and season with salt. Boil for 5 minutes, skimming any foam rising to the top. Lower the heat, cover the pot, and gently simmer for just under 2 hours.

2 Meanwhile, in another pot, boil the potatoes, carrots, cabbage, and rutabaga together for 15 minutes. Remove the potatoes with a slotted spoon, set aside in a bowl, and keep warm. Drain the carrots, cabbage, and rutabaga and set aside in a separate bowl from the potatoes.

3 When the meat is done, remove half of the meat from the broth and set aside. Cut the removed meat into 2-inch pieces and dry with a cloth or paper towel. Add the carrots, cabbage, and rutabaga to the broth along with the leek. After 5 minutes, add the parsley to the broth and cook for 5 minutes more. Remove from the heat.

4 Heat a nonstick sauté pan over medium-high heat and melt the butter. When the butter begins to bubble, add the meat cubes and cook until browned on all sides, about 2 minutes on each side. Cut the remaining meat in the broth into bite-size pieces and add back to the broth. Season with salt and pepper.

5 Arrange the fried pieces of meat on a serving dish with the potatoes and pour the soup into a bowl. (The traditional soup recipe does not include the additional fried meat, but according to Synnøve, this version adds a lot more flavor to the recipe.)

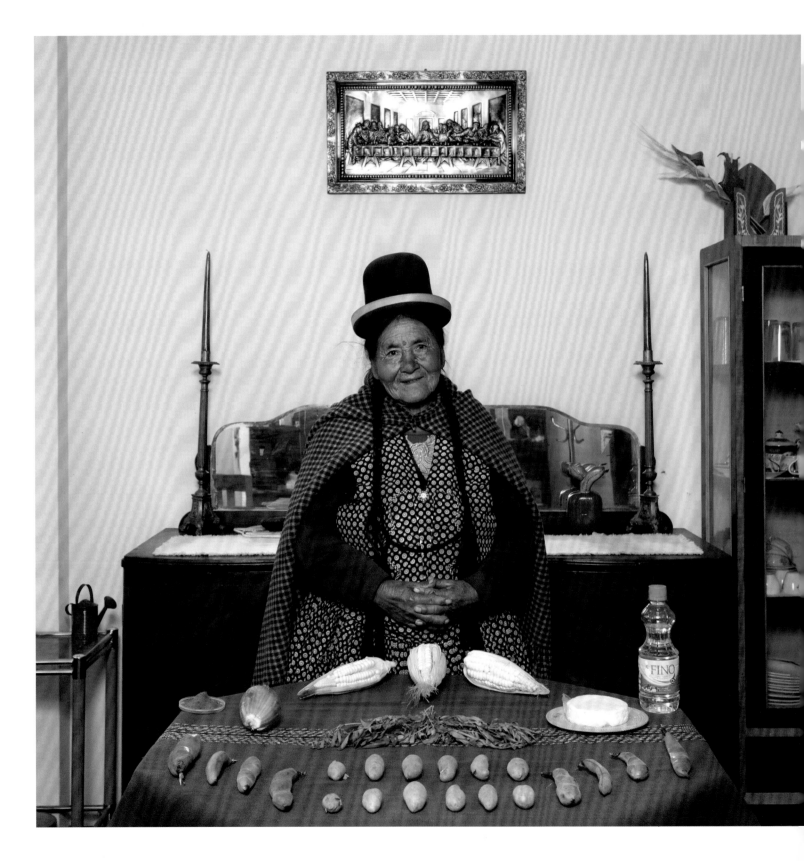

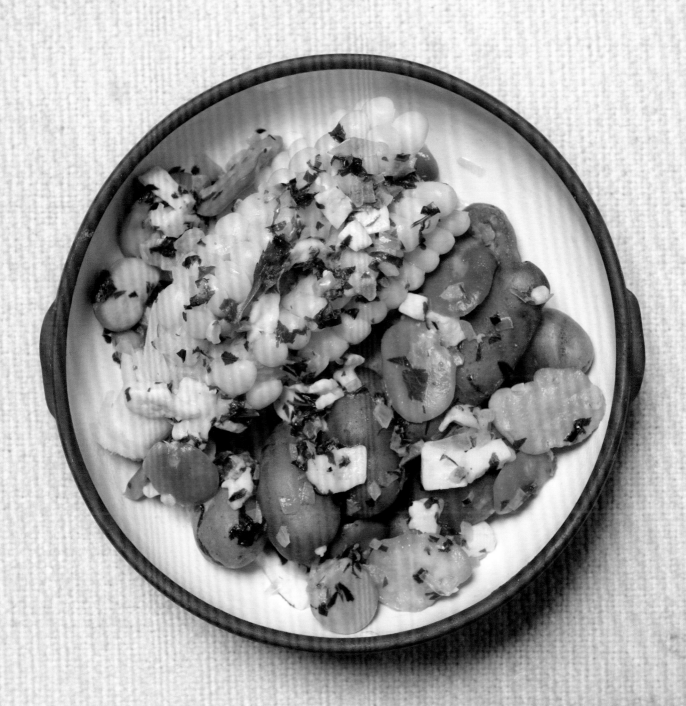

Julia Enaigua

71 YEARS OLD

In Julia's family everybody is a fisherman or a farmer. Indeed, she grew up first playing in and then working the fields in a little village on the shores of Lake Titicaca. When she was twenty-five, she got married and moved to La Paz, the city where her husband was from. From that moment her job changed: from being a farmer to a vendor at one of the many markets in the city. Every day she takes the early bus to the countryside and buys huge bags of vegetables from the local farmers to take back to the city's market. After arranging her stall for the day, she stays at the market until she sells almost all the vegetables. Unfortunately, nobody is waiting for her at home now, as her husband died a few years ago and her children live in another house. However, it's a pleasure of hers to host her children and their kids every weekend so she can cook for them.

Queso Humacha is one of the most popular and traditional dishes in Bolivia. You can easily find it in any restaurant in La Paz and, even better, at the street-food vendors near markets.

Queso Humacha

Vegetable and Fresh Cheese Stew

SERVES 4

2 ears of white corn

12 small red-skinned potatoes

Salt

8 large fava bean pods

1 tablespoon vegetable oil

1 medium red onion, chopped

½ cup huacatay or fresh mint

½ teaspoon chili powder

8 ounces fresh cow cheese (queso
 fresco), diced

1 In 2 separate pots of boiling water, cook the corn and the potatoes until tender, about 25 minutes. Drain and set aside.

2 Meanwhile, to prepare the fava beans, bring a small pot of salted water to a boil. Fill a small bowl with ice and water and set aside. Remove the fava beans from their pods and blanch the beans in the boiling water for 1 minute. Drain and immediately plunge them in the bowl of ice water. Now the beans are ready to be peeled by removing a tiny piece of the shell from the dimpled end of each bean and gently squeezing the bean out. Set aside.

3 Heat the oil in a medium skillet over low heat. Add the onion and the blanched fava beans. Sauté for 10 minutes. Add the huacatay and chili powder. Pour in 1 cup of hot water and cook until the beans are tender, 6 to 8 minutes. When the beans are tender, add the cheese and let everything cook for 6 to 7 minutes more to soften the cheese.

4 Cut each ear of corn in half lengthwise and cut the potatoes in half if you like. Place them on a plate and pour the bean and cheese sauce on top. If necessary, sprinkle a pinch of salt on top.

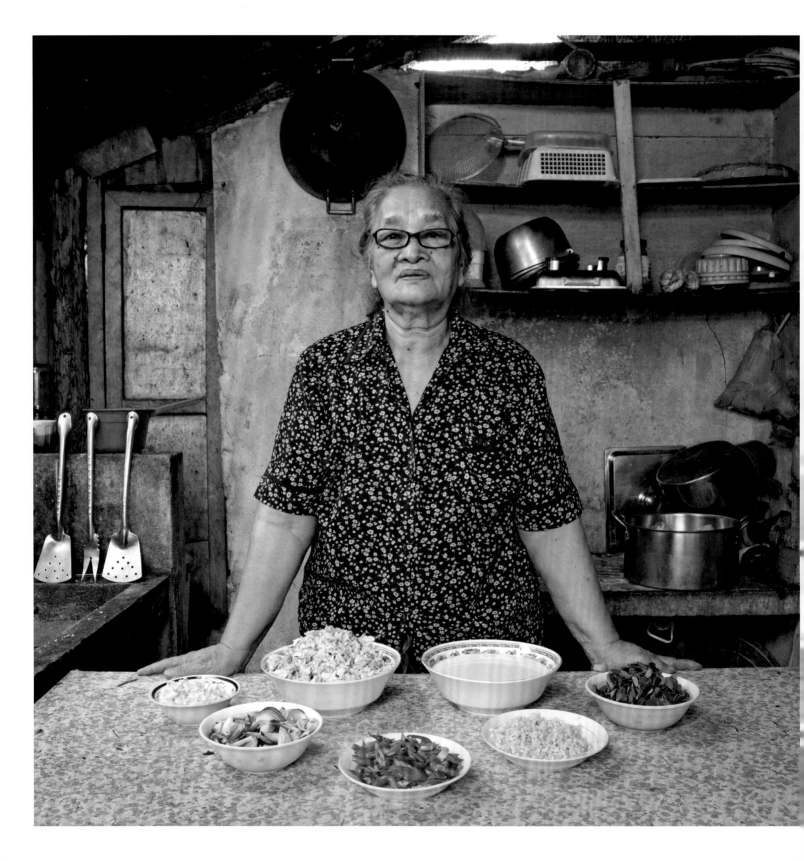

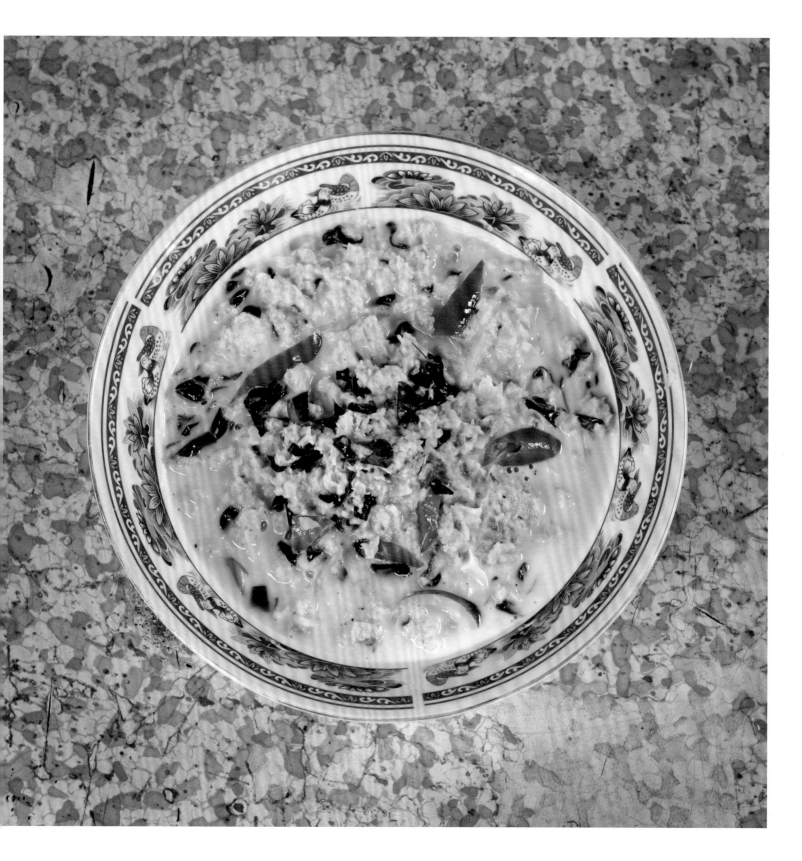

Carmen Alora

70 YEARS OLD

Carmen has always lived in El Nido, in the north of Palawan Island, in the Philippines. The island is a sort of paradise with beaches, fantastic green mountains, and an incredibly beautiful sea. El Nido is a small fishermen's village that sits between the jungle and the barrier reef, and Carmen was the first person to open a restaurant there, nearly forty years ago. The restaurant kitchen has presently become her home kitchen and, there, she cooks her delicacies for the only one of her three sons who still lives in El Nido and her two grandchildren. I met Carmen thanks to the couch surfer who hosted me. He introduced her to me, bragging, "She's the best cook in town and her *kinunot* has to be in your book. It is for sure the most representative dish of this area." Indeed, the sea around the island is rich in the species of shark necessary for this dish. While sudsud shark (a small shovel-nosed shark) is considered to be one of the finest fishes by the local fishermen, it is illegal to fish in some parts of the world, where it is considered an endangered species.

Kinunot

Shark in Coconut Soup

SERVES 6 (1¼ CUPS PER SERVING)

3 pounds sudsud shark fillets (or skate or stingray fillets)

2 tablespoons (or more) palm oil

1 large red onion, chopped

6 garlic cloves, finely chopped

One (1-inch) piece of fresh ginger, peeled and finely chopped

5 red and 3 green bird's-eye chilies, chopped

¼ cup white vinegar

4½ cups coconut milk

Salt and freshly ground black pepper

4 cups malunggay (also known as "moringa") leaves (a common plant in the Philippines) or baby spinach

Steamed white rice (optional)

1 Bring a large saucepan of water to a boil, add the fish, and cook until opaque, 10 to 15 minutes. Remove the cooked fish to a bowl, let it cool, and crumble the meat into pieces.

2 Heat the oil in a large skillet over medium-low heat. Add the red onion, garlic, and ginger. Sauté for 5 minutes, or until the mixture is golden brown. Add the chopped chilies and the vinegar. Simmer for 5 minutes, then add the pieces of fish. Let everything cook for 15 minutes, then pour in the coconut milk and bring to a rolling simmer. Taste the soup every now and then and add salt and pepper to taste.

3 Simmer the soup for 15 minutes before adding the malunggay leaves. Cook for another 10 minutes before serving over steamed white rice.

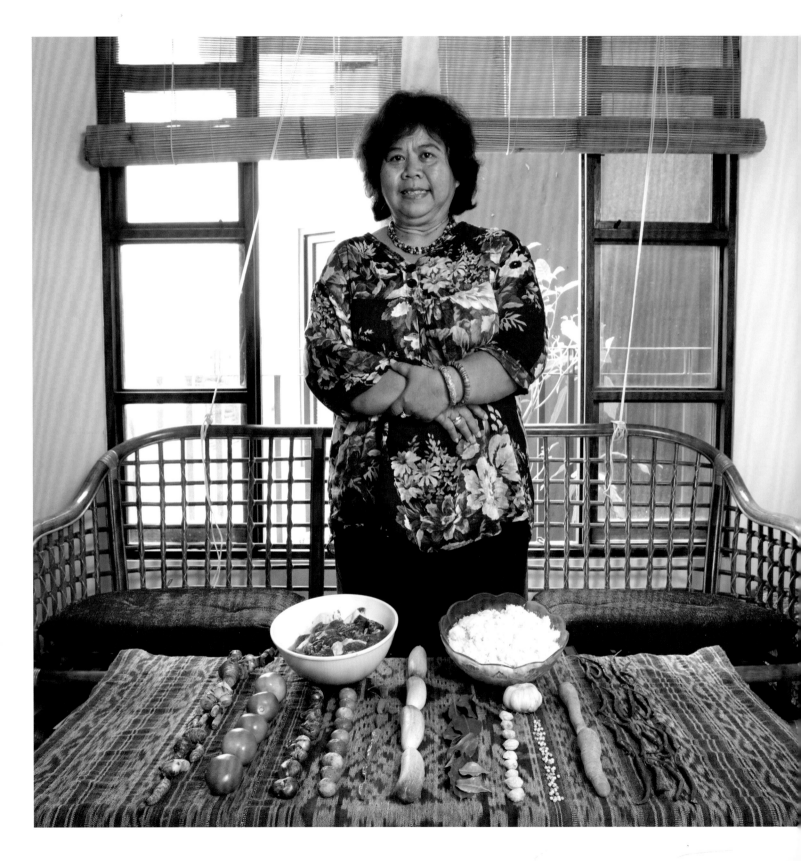

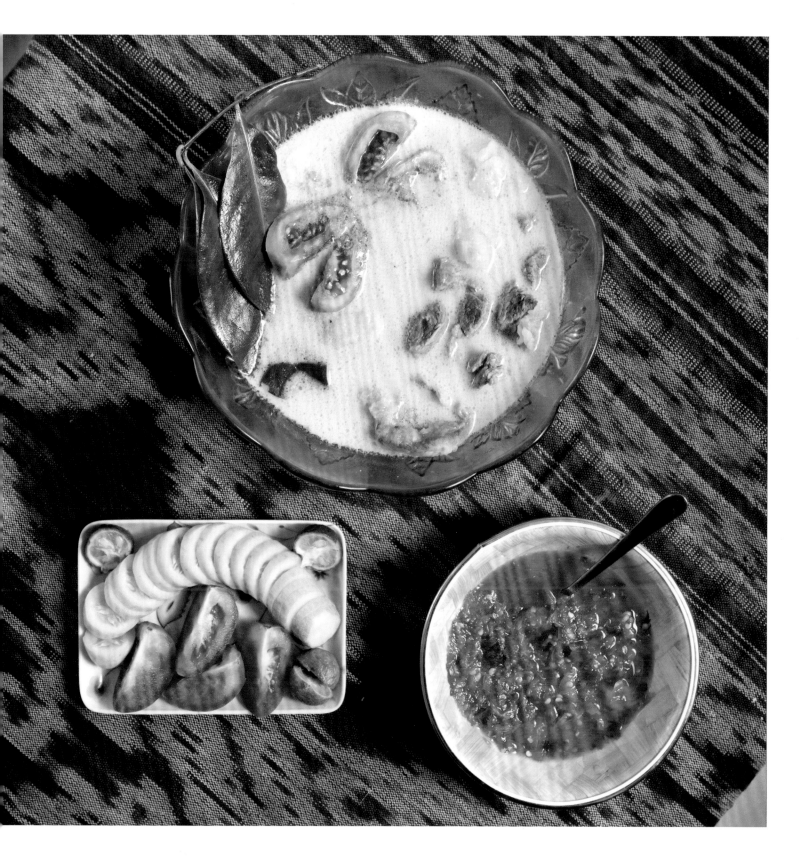

Eti Rumiati

63 YEARS OLD

Eti has been spending at least four hours a day in her kitchen for nearly forty years, ever since she got married. Every day she cooks lunch and dinner for her husband, her thirty-nine-year-old daughter, her son-in-law, and her two teenage grandchildren. "I've gotten used to cooking for six or more people at a time. . . . If one day I had to make lunch for just myself, I wouldn't know what to cook. I guess I would have to go to the city center and buy one of those American burgers that my grandchildren like so much," she says, laughing madly, and then adds, "Of course, I'm joking; I wouldn't be able to eat that stuff!" The day I went to her house for lunch, she prepared many different things, but for sure the dish that I liked the most was the *soto betawi*, a soup made with coconut milk, vegetables, and beef. (I really love anything made with coconut milk!)

Soto Betawi

Beef Soup with Coconut and Vegetables

SERVES 6

FOR THE SOUP

2 pounds beef, cut into cubes

10 kaffir lime leaves

1 (2-inch) piece of fresh ginger, peeled and minced

10 cups (2½ quarts) coconut milk

3 tablespoons vegetable oil

10 garlic cloves, roughly chopped

1½ cups roughly chopped red onions

5 candlenuts (see Note) or 6 or 7 macadamia nuts, roughly chopped

5 small hot red chilies, stems removed

10 small sweet chilies, roughly chopped

1 teaspoon freshly ground white pepper

Salt

FOR THE SPICE PASTE

8 garlic cloves, minced

2 cups finely chopped red onions

2 ounces sweet chilies, finely chopped

2 hot red chilies, finely chopped

1 (½-inch) piece of fresh ginger, peeled and finely chopped

5 candlenuts (see Note) or 6 or 7 macadamia nuts, roughly chopped

1 large cucumber, peeled and sliced

2 large limes, halved

2 large tomatoes, sliced

1 Make the soup: In a large saucepan, combine the beef, kaffir lime leaves, and half of the minced ginger. Add the coconut milk to cover. Bring to a boil, then reduce the heat and allow the meat to simmer for 50 minutes, or until it is just tender.

2 While the meat is cooking, prepare the puree for the soup. Heat 2 tablespoon of the oil in a skillet. Add the garlic cloves, onions, candlenuts, and the remaining ginger to the pan. Sauté until the onions are translucent, about 5 minutes. Remove from the heat and transfer the mixture to a blender and puree. Set aside.

3 In a small saucepan, combine the hot red chilies and the sweet chilies, and enough water to cover. Bring to a boil and cook for 15 minutes. Drain, transfer to a blender, add the white pepper and salt to taste, and puree. Set aside.

4 Now combine the nut and chili purees in a small saucepan, add the remaining 1 tablespoon oil, and cook for about 5 minutes, or until heated through and the flavors are well combined.

5 When the meat is just tender, add the candlenut-chili puree to the beef, stirring to blend it well with the coconut milk mixture. Continue cooking until the meat is very tender, 15 to 20 minutes more.

6 Make the spice paste: Crush the minced garlic and the chopped onions, sweet chiles, hot chilies, ginger, and candlenuts using a mortar and pestle or a mixer. Serve the paste as a condiment for the soup so that guests can add it, to their taste, for additional spice.

7 Arrange the cucumber, limes, and tomatoes on a plate and serve them as a fresh salad to accompany the soup.

If you are buying candlenuts, be sure they have been cooked. They cannot be eaten raw, as they contain two toxic substances.

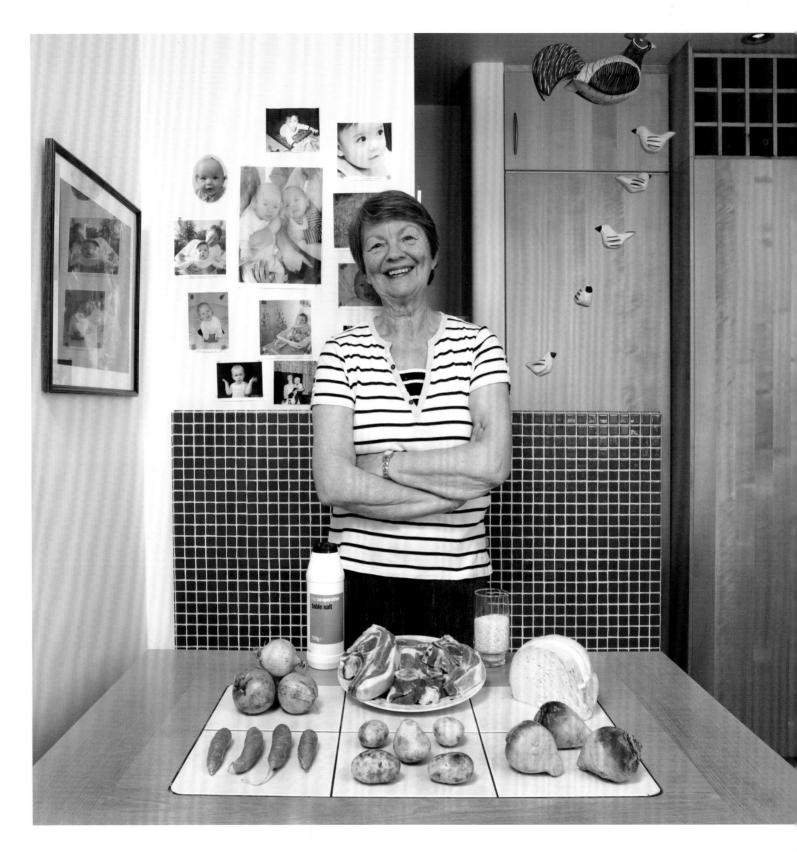

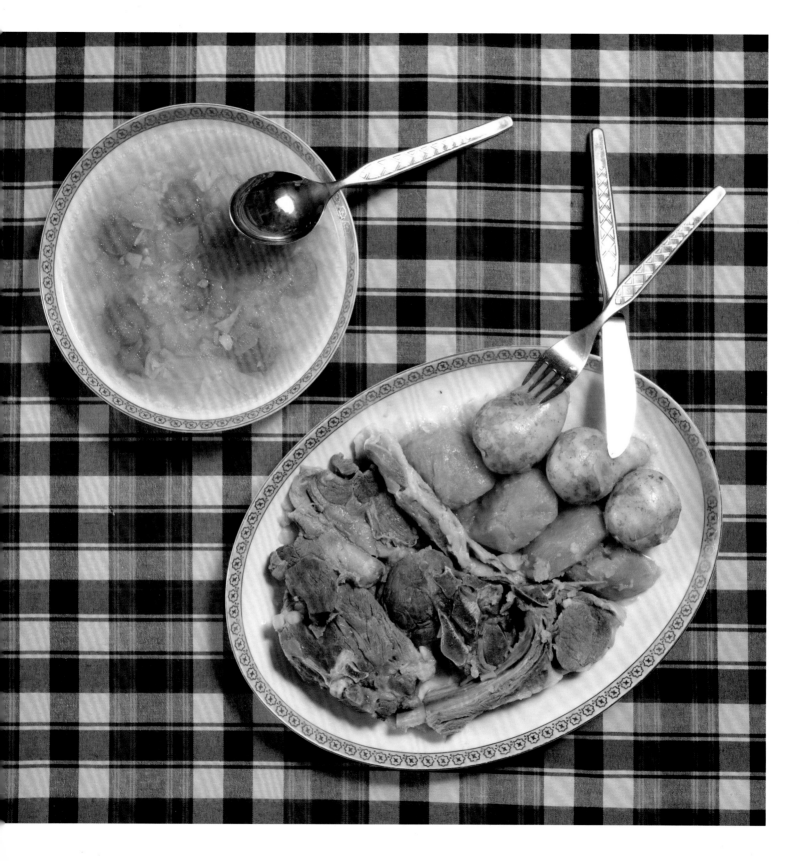

Valagerdur Ólafsdóttir

63 YEARS OLD

"I was born in Reykjavík, but I spent much of my childhood in the countryside with my grandparents, who were farmers. I am still very much attached to nature and my best moments are when I am relaxing in one of our family's summerhouses: One is surrounded by green bushes, moss, and blueberries and the other one is on a remote island where everything revolves around fishing and bird-watching—the perfect relief from my work as a medical secretary." These are the words that Valagerdur used to describe herself. The night I met her and her family for dinner was special, as the aurora borealis filled the sky—one of the best memories of my long trip around the world. As Valagerdur told me, "My husband has been my closest companion for almost five decades and we share an interest in many things, including regularly trying out new dishes."

The majority of typical Icelandic dishes are based on soups, but without any doubt the most popular one is lamb soup. And it isn't very difficult to prepare. Valagerdur doesn't prepare her *kjötsúpa* with any spices, but you may add seasoning such as chili powder to suit your taste when you add the vegetables.

Kjötsúpa

Lamb and Vegetable Soup

SERVES 6 TO 8

4 large shoulder blade lamb chops
 (2½ to 3 pounds)

Salt

2 yellow turnips or rutabagas, cut into
 large pieces (about 6 cups)

4 large boiling potatoes, cut in half

3 carrots, peeled and thinly sliced
 (about 1½ cups)

3 onions, finely chopped
 (about 3¾ cups)

½ Savoy cabbage, thinly sliced
 (3 to 4 cups)

⅓ cup long-grain rice

1 In a large pot, combine the lamb chops with 3 quarts of slightly salted water and bring to a boil, skimming the fat periodically as it rises to the surface; let simmer for 30 minutes. Add the vegetables to the broth, stirring to combine. Let everything cook for about 1 hour and then add the rice. Cook for 25 minutes more. Season with salt.

2 Kjotsúpa can be served two ways: You can separate the lamb, turnips, and potatoes from the soup and serve them in two different bowls (as shown in the photo). You can also remove the meat from the bones and cut it into small cubes. Cube the potatoes and turnips, then return the lamb and vegetables to the soup and serve.

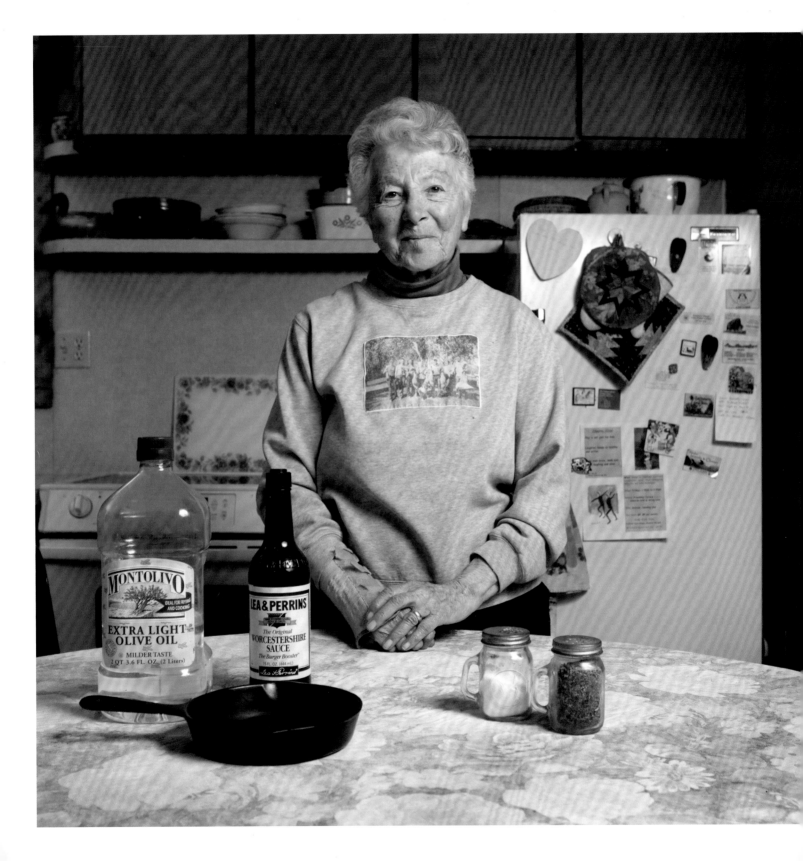

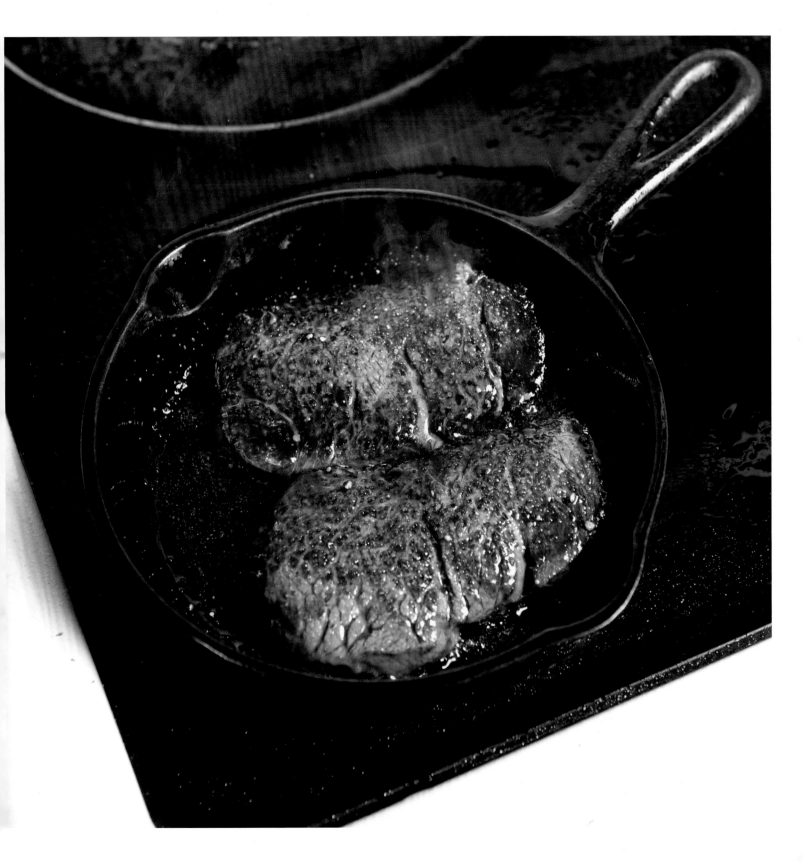

Susann Soresen

81 YEARS OLD

Susann's sweatshirt shows a picture of her with her two daughters and her son. "I became a grandmother more than twenty years ago, thanks to my son, Mark. Since then our family has grown, and now I have six grandchildren," she tells me.

When I asked her to cook something typical from her state, she gave me the choice: moose or salmon. Since I had never tried it before, I chose the moose. "My son and my grandson chased this animal," she explains while cooking, "but here, ninety percent of the time you don't need to go hunting to get moose meat. Very often we run over one, since the streets are full of them, especially at night. Hard luck—they smash your car!"

Moose Steak

SERVES 1

2 to 3 tablespoons olive oil

1 moose fillet

Salt and freshly ground black pepper

Lea & Perrins steak sauce

1 In a cast-iron skillet, heat the olive oil over high heat. When the oil is shimmering, place the moose fillet in the skillet and sear for 1½ minutes per side (a bit less if you like it rare or a bit more if you want it well-done).

2 Season the fillet with salt and pepper. Transfer to a serving dish and sprinkle with the steak sauce. If you're in Alaska, enjoy with an ice-cold beer or even a Coke, or, if you're Italian, like me, I would suggest drinking a nice red wine.

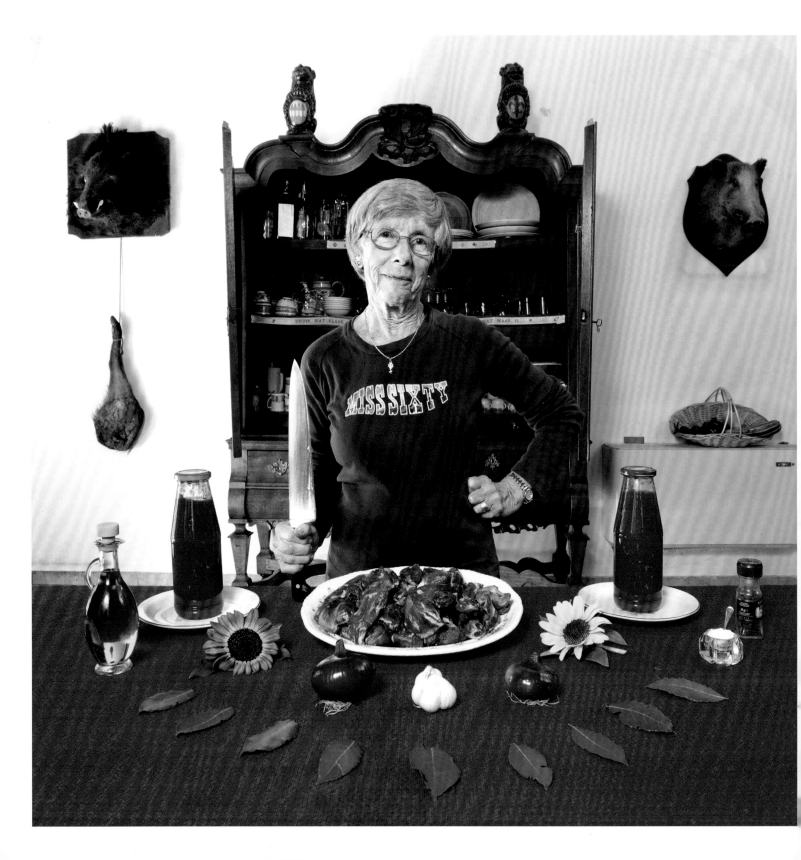

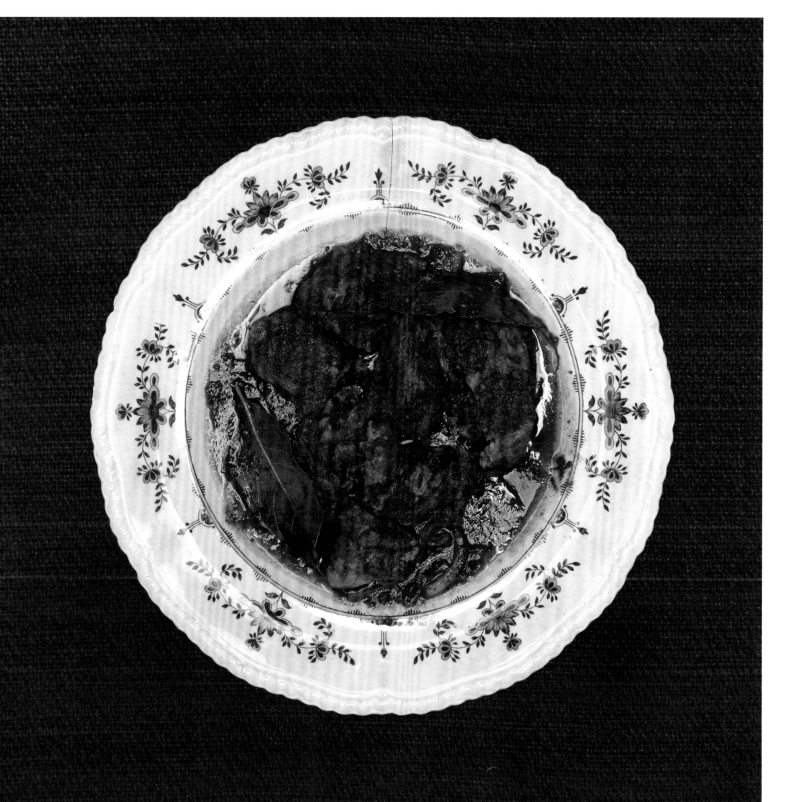

Eldina Albarda

75 YEARS OLD

Eldina has three children and six grandchildren. She is Dutch, studied in England, and moved to Italy in 1967. She grew up in a Dutch Protestant culture, with a strong Calvinistic upbringing, which gave her, among other things, an aversion toward consumerism. As a result, she feels strongly about the proper role of leftovers: to feed humans, then to feed dogs and chickens, and finally to become humus (compost).

Eldina runs a goat farm in the Tuscan hills and has a strong love for the sense of creation that she experiences every day through the plants and the animals on the farm. She lives in a big farmhouse that she shares with renters, foster children, and a few stragglers. Making a living from the farm is difficult and Eldina lives in a frugal manner. The land is not very productive, but it's rich in beauty. She has survived thirty-two years of married life and three very lively sons (with the occasional glass of Chianti!).

If the wild boar comes from your own field, it just adds to the joy of the recipe. Your hatred for the animal that has destroyed your field only amplifies the bliss in eating its meat! It is essential to decorate your table with flowers, and better if they come from your field or backyard, just like the wild boar.

Tuscan Wild Boar Stew

SERVES 4

2 pounds wild boar shoulder meat,
cut into 1¼-inch cubes

FOR THE MARINADE

¾ cup dry red wine

1 small onion, chopped

1 celery stalk with leaves

2 bay leaves

1 lemon, cut in half

FOR THE STEW

2 red onions, sliced

10 garlic cloves

10 bay leaves

6 cups Pomì tomato puree
(or homemade)

¼ cup olive oil

Salt and freshly ground black pepper

1 Make the marinade: Marinate the wild boar meat for an entire night before starting the cooking. Put the pieces of meat in a casserole with the red wine, onion, celery, bay leaves, lemon halves, and ¾ cup of water. Cover and refrigerate overnight.

2 Preheat the oven to 375°F.

3 Make the stew: Remove the meat from the marinade and place it in a 5- to 6-quart ovenproof pot fitted with a lid. (The pot should be big enough to hold the meat, vegetables, and tomato sauce.) Sprinkle the meat with the red onions, garlic, and bay leaves. Pour the tomato puree over the meat and vegetables to cover everything and season with the olive oil and salt and pepper.

4 Mix all the ingredients together and, if necessary, add enough water to allow the sauce to coat the meat well. At this point, cover the pot and put it in the oven. Let it cook for about 20 minutes, and then lower the heat to 350°F. Stir the meat and continue cooking, covered, for 1½ to 2 hours more. The meat is done when it is very tender.

5 Let the stew cool for about 10 minutes and serve your dish accompanied with a good red wine; Chianti would be the perfect match.

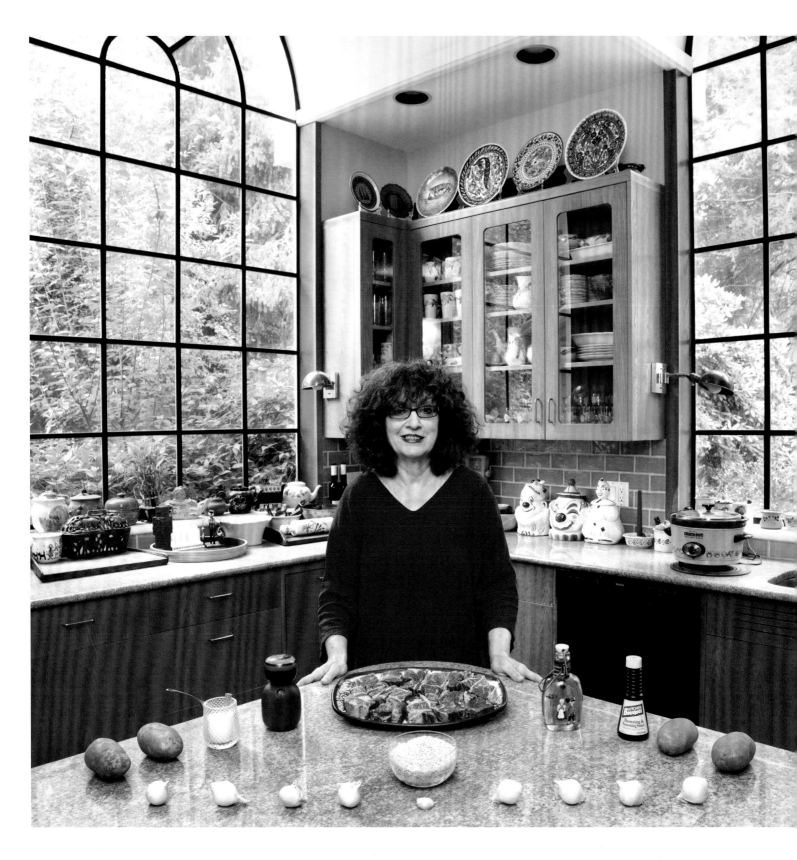

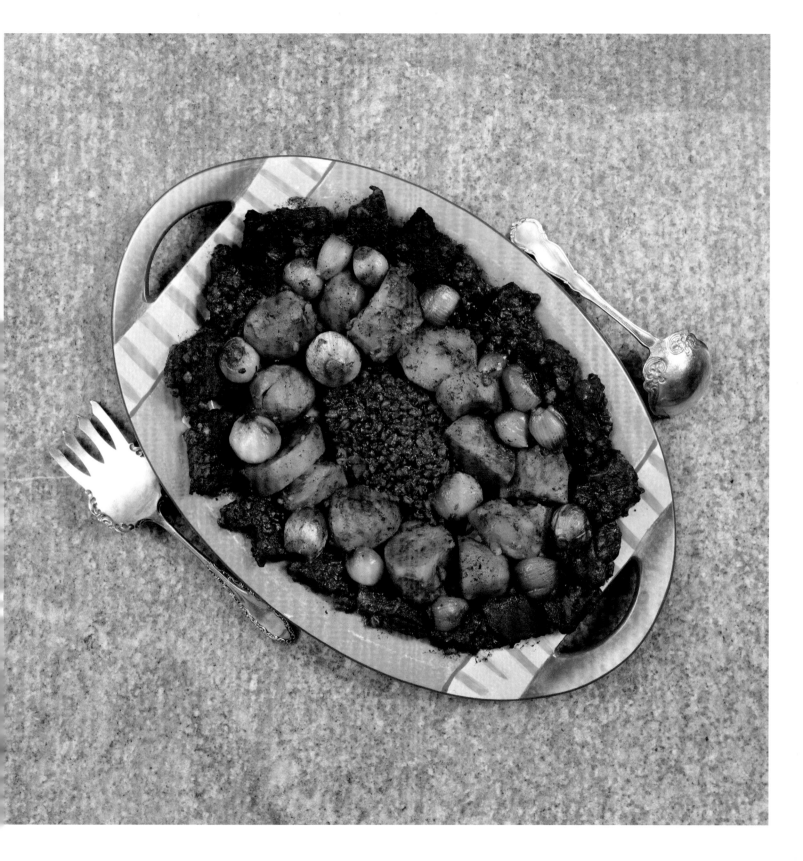

Shelley Harwayne

65 YEARS OLD

A native New Yorker, Shelley recently moved to the suburb of Croton-on-Hudson with her husband. Since retiring as a school superintendent, she has had more time to cook for her family of two children and five grandchildren. On holidays, she takes pride in hosting sit-down meals for extended family and friends, often totaling forty people. She is thrilled to have a kitchen that is big enough for all the family to hang out in. Of course, the grown-ups pitch in, helping with the preparations, while the little ones poke around looking for the sweet treats to come at the end of the meal.

Cholent is a traditional Jewish stew that cooks overnight and is usually the only hot dish served on the Sabbath, because you can leave the stove on overnight. This recipe was given to Shelley by her mother, who passed away at age ninety-five. Shelley easily recalls from her childhood the wonderful aroma and taste of slow-cooked meat, potatoes, and barley. Although Shelley's grandmother added beans to the big cooking pot, Shelley's mother never cared for that ingredient, and so Shelley's cholent today remains true to her mom's liking.

Cholent

SERVES 6

8 white pearl onions

2 tablespoons vegetable oil

2 pounds boneless short ribs, cut into 1¼-inch pieces

1¼ cups pearl barley

4 potatoes, peeled and cut into large pieces

1 tablespoon Kitchen Bouquet Browning & Seasoning Sauce

3 garlic cloves, chopped

Salt and freshly ground black pepper

1 Bring a kettle or large pot of water to a boil.

2 In a large oven-safe pot or a roasting pan, sauté the onions in the oil over medium heat for 5 minutes, or until they begin to color. Remove them to a plate.

3 Add the short ribs to the pot (do not crowd) and brown well on all sides. Stir in the barley. Return the onions to the pot, along with the potatoes and just enough boiling water to cover the meat and vegetables. Add the Kitchen Bouquet and garlic, stirring to combine. Season with salt and pepper. Bring to a boil, skimming the foam from the top, then lower the heat and simmer, partially covered, for 20 minutes on the stovetop.

4 Preheat the oven to 200°F or prepare a slow cooker. Cover the pot tightly and place in the preheated oven, or place everything in the slow cooker. Whatever your cooking apparatus, allow the cholent to cook overnight for 12 to 15 hours. Check periodically to make sure you have enough liquid to cover; add small amounts of water if needed. Do not stir, to avoid breaking up the chunks of potatoes.

5 When the cholent is cooked, let it rest for 30 minutes before serving it.

To prepare cholent, you will need more than twelve hours. Although the preparation is that long, it's really easy.

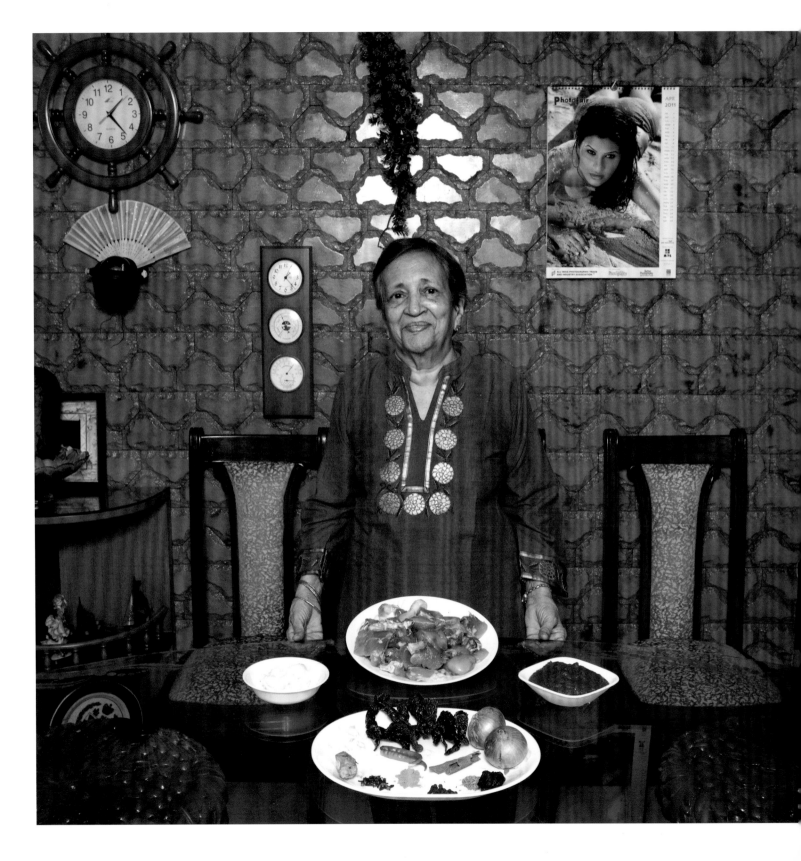

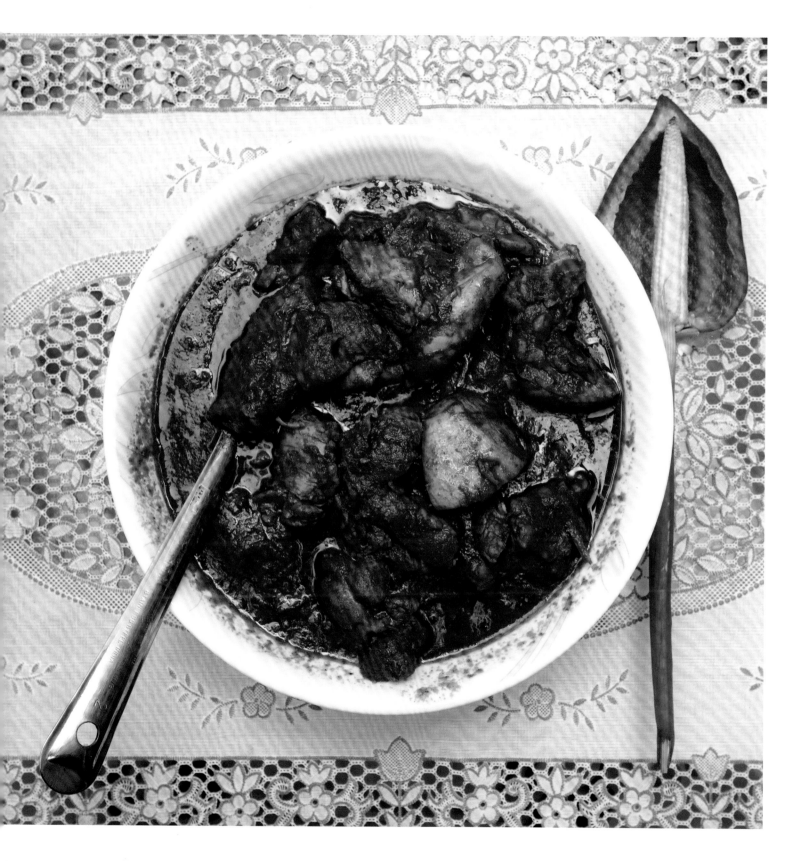

Grace Estibero

82 YEARS OLD

Grace grew up in Goa, in the south of India, in between the sea and the jungle in a nice colonial house. However, for the past ten years she has lived in a new building made of concrete and glass in the northern quarter of Mumbai, with one of her two sons and his family. She is of Portuguese origin, like the majority of Indians in Goa, and as a result her cooking has that same influence. Some years ago, for the first time in her life, she left India with her younger son to visit Lisbon, where her parents were from. "I could see with my eyes the place of my origins—the place my language and culture came from. I had always thought of it as similar to Goa, but, in fact, it wasn't. There is no jungle there and the houses are really different from what I thought they were. I liked it, but I'm happy that I grew up in Goa instead of Lisbon," she says.

Typical of Indian cooking, chicken vindaloo is a hot dish, which was originally introduced to Goa by the Portuguese. Often served on special occasions, this dish is traditionally prepared with pork, but I am sure you will be fully satisfied with this chicken version.

Chicken Vindaloo

SERVES 6

2 red onions, finely diced

10 dried red finger chilies

2 fresh hot green chilies, roughly
chopped

½ to 1 teaspoon ground cinnamon

10 garlic cloves, roughly chopped

One (½-inch) piece of fresh ginger,
peeled and roughly chopped

1 teaspoon ground cumin

10 whole cloves

10 whole black peppercorns

1 teaspoon ground turmeric

1 tablespoon tamarind paste

1 tablespoon sugar

8 skinless, boneless chicken thighs
(about 2 pounds), cut into bite-size
pieces

Salt and freshly ground black pepper

2 tablespoons vegetable oil

1 In a blender, combine half of the diced red onions with the red chilies, chopped green chilies, cinnamon, garlic, ginger, cumin, cloves, black peppercorns, turmeric, tamarind paste, sugar, and ½ cup of water. Blend until everything is finely chopped. Add another ½ cup of water and blend until the mixture becomes a puree.

2 Season the chicken with salt and pepper.

3 In a large sauté pan, heat the oil over medium heat. Add the remaining diced onions and sauté until they become golden. Add the masala sauce to the pan and stir to combine. Cook the sauce for 5 minutes, then add the chicken pieces. Continue to cook for 18 to 20 minutes, until the chicken is cooked through.

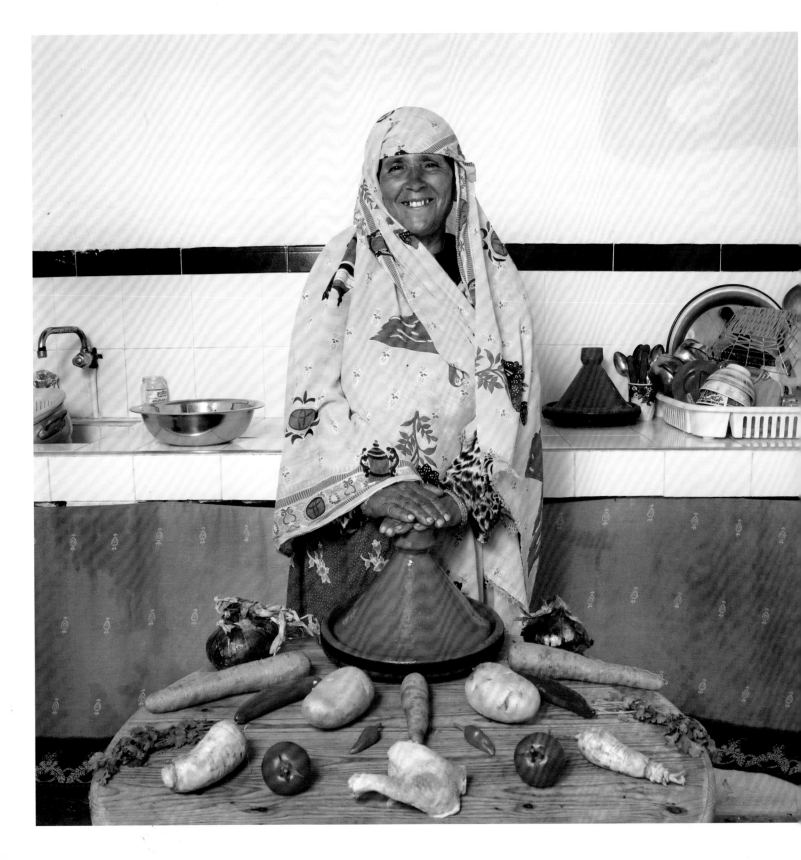

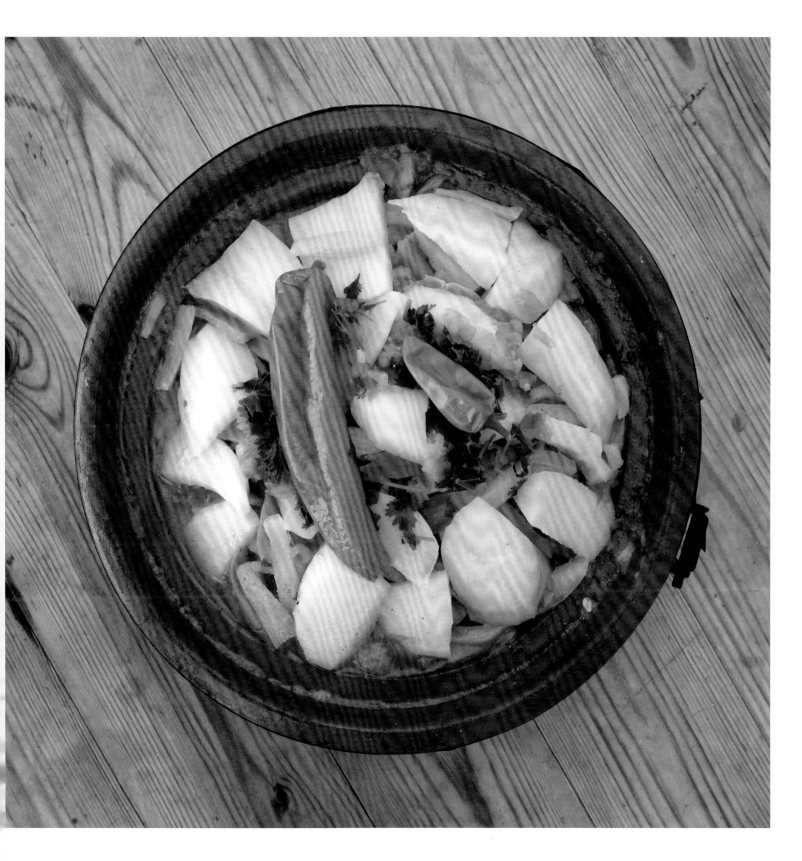

Eija Bankach

62 YEARS OLD

Eija's kitchen has neither a gas nor an electric stove, so when she cooks, she uses only embers (which are always kept burning) in the yard outside her house. The house is on top of a small hill overlooking the fields where her family works every day. "I can always see what they do," she says with a smile. From what Eija remembers, she has always lived in Massa, which is one hour south of Agadir. She lives with her husband and her younger daughter; her older daughter lives only a couple of miles from Eija's house. Thanks to her, Eija became a grandmother four years ago. Her grandson, Norden, enjoys helping her in the kitchen. "He's really good at chopping carrots. He loves to measure the pieces and try to make them all the same size. He's the best helper I could ask for."

Tagine draws its name from the characteristic vessel used to cook it, which is traditionally made of clay and is composed of two parts: a lower flat-bordered, round plate, which is used as the serving dish at the table, and an upper conical lid, which covers the dish during cooking. The shape of the lid forces the condensation downward, and it has a knob on top for easy handling.

Chicken Tagine

SERVES 4

1 tablespoon olive oil

½ cup chopped fresh flat-leaf parsley

2 hot green chilies, minced

2 large red onions, chopped (about 3 cups)

One 3½-pound chicken, cut into quarters, skin removed

Salt and freshly ground black pepper

2 large potatoes, peeled and roughly chopped

2 sweet chilies, minced

2 tomatoes, roughly chopped

2 white turnips, roughly chopped

3 carrots, peeled and roughly chopped

1 Place the lower part of the tagine, or a skillet without its lid, on the embers of a fire or over medium-low heat. Add the olive oil and sauté the parsley, green chilies, and half of the chopped onions for 7 to 8 minutes, until the onions are translucent and the chilies have softened.

2 Season the chicken with salt and pepper and place it on top of the onion mixture. Top the chicken with the potatoes, sweet chilies, tomatoes, turnips, carrots, and the remaining onions. Season with salt and pepper, cover the tagine or skillet with the lid, and let cook until the vegetables are tender and the chicken is cooked, 1 hour and 15 minutes to 1 hour and 30 minutes.

3 At the end of the cooking, set the tagine plate on a place mat or trivet in the middle of the table and, as part of the tradition, let your guests help themselves to the dish, using their hands. If you prefer using cutlery, the food will taste the same, but you won't have the pleasure of literally licking your fingers in the end.

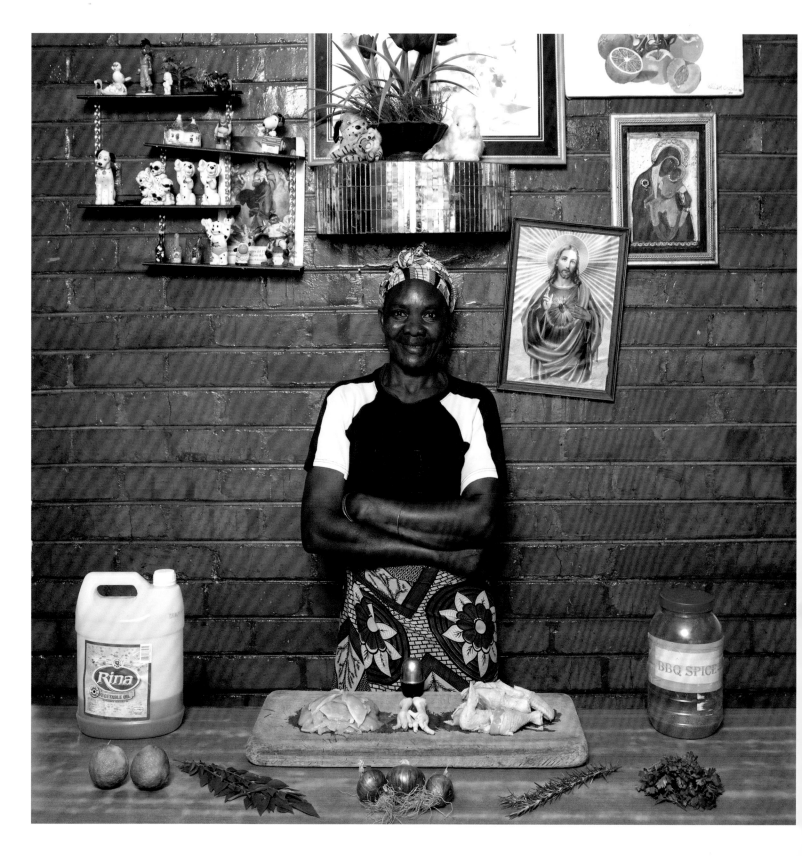

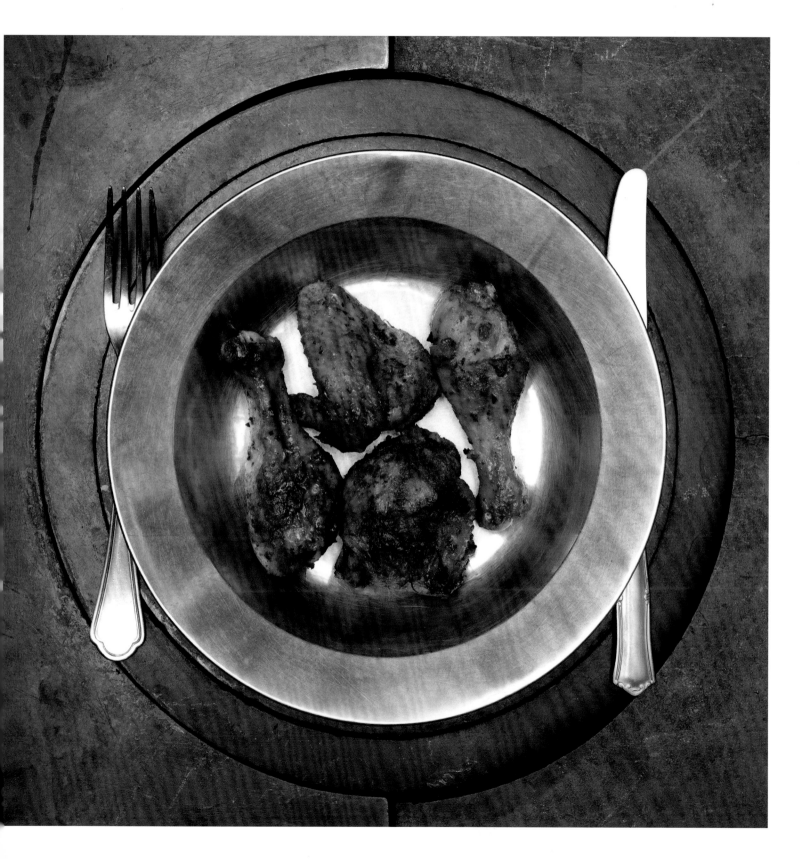

Joyce Muape /

49 YEARS OLD

Joyce was born and raised in Kitwe, one of the biggest cities in Zambia, but since she married twenty-five years ago, she has been living in Kalulushi, a small village in the northern countryside close to the Congo border. The village is in the middle of the forest and the closest city is a two-hour bus ride away. Joyce has two daughters and a son, but only her son lives near her. Her married daughters moved to Lusaka, the capital of Zambia, nearly seven hours south. Joyce hardly sees her five grandchildren, so she tries to make up for their absence by spending time with other children. Indeed, she works as a janitor in a primary school for deaf students and spends most of her time with more than two hundred children. While working there, she has learned sign language, and every time she sees her grandchildren, she tries to teach it to them, too.

Inkoko Nama Spices

Roasted Spiced Chicken

SERVES 4

1 large onion, finely chopped (about 1½ cups)

2 tablespoons chopped fresh rosemary

2 tablespoons chopped fresh flat-leaf parsley

2 tablespoons chopped fresh basil

¼ cup freshly squeezed lemon juice (from 1½ lemons)

⅓ cup plus 2 tablespoons vegetable oil

2 tablespoons mixed ground barbecue spices (or spices to your taste)

2 teaspoons salt

One 3- to 3½-pound chicken, cut into 8 pieces

1 In a large bowl, combine the onion, rosemary, parsley, and basil. Add the lemon juice, the ⅓ cup oil, the barbecue spices, and the salt. Stir well to combine and set aside for 10 to 15 minutes.

2 Preheat the oven to 400°F. Add the chicken pieces to the herb and lemon juice mixture and turn to coat well.

3 Brush a baking dish with the 2 tablespoons oil, add the chicken, skin side down, and roast it in the oven for 45 to 50 minutes, turning the pieces after 25 minutes. If you would like the skin crispy, place the chicken under the broiler for a minute or two.

4 If you are using a wood-fired oven, just like Joyce does, check the chicken quite often, because the temperature of the oven is more uncertain and can vary at moments during the cooking time.

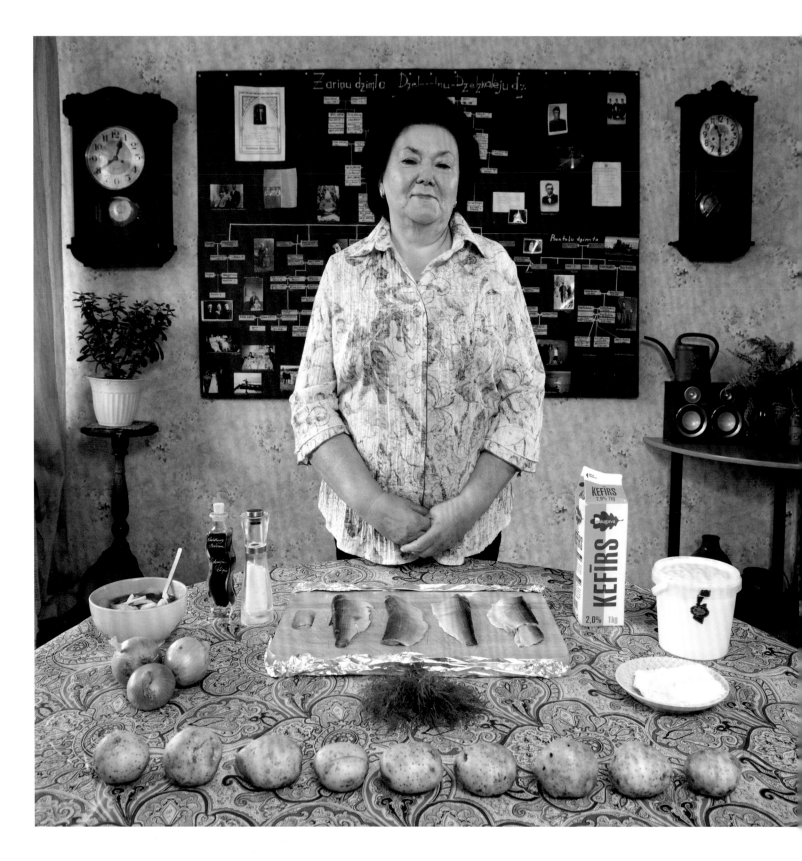

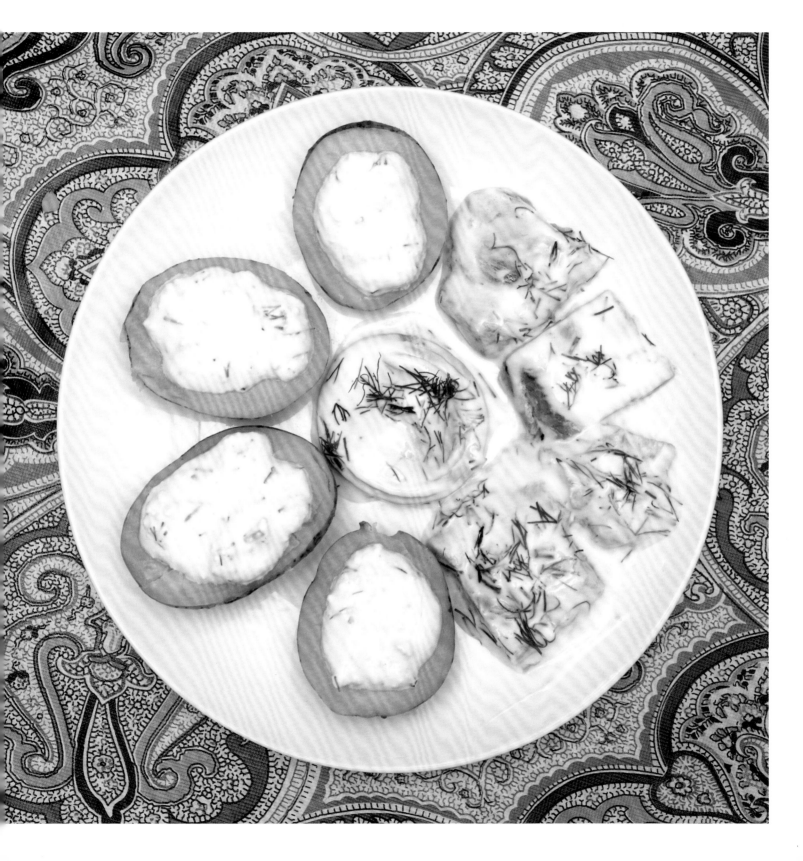

Inara Runtule

68 YEARS OLD

"This big poster on the wall shows my whole family, starting from my grandparents' grandparents," Inara says, leading me to the living room. "My granddaughter made it when she was fourteen, for a school project. It's one of the most beautiful things I have in my house. I love looking at it and thinking about all my relatives, especially the ones who live far away and I can't invite for dinner or lunch. There is only one thing I'm sorry about now that I have other grandchildren: that the family tree should have more branches, but my granddaughter is never in the mood for adding them."

Inara was born and raised in Kekava, a small town very close to Riga, the capital of Latvia. She has retired with her husband to a big house with a greenhouse in the backyard, where they grow fresh vegetables almost all year long. I met them with their granddaughter on a cold evening at the end of October and we all cooked together for a couple of hours. I usually don't like herring, but Inara's preparation is really delicious.

Silke Krèjumà

Herring with Potatoes and Sour Cream

SERVES 4

4 salted herring fillets

2 large boiling potatoes, peeled

2 tablespoons white vinegar

1 large yellow onion, thinly sliced

2 cups sour cream

1½ cups kefir (kefir works best here, as Greek yogurt is too thick)

2 sprigs fresh dill, chopped

⅔ cup cottage cheese (15 ounces)

Salt and freshly ground black pepper

1 Soak the herring fillets in water for at least 2 hours, changing the water several times. (This process is used to wash the salt from the herring. If you want to give the herring a sweeter taste, use milk instead of water. You can also add 1 to 2 tablespoons of sugar to the water to cut the sharpness of the herring.) Remove the fillets from the water and rinse.

2 Boil the potatoes until they are cooked to your desired tenderness. Cut each into 8 slices.

3 Meanwhile, fill a bowl with the vinegar and the sliced onion. Pour enough hot water over the top to cover the onion, and let it marinate for about 20 minutes. Drain and set aside.

4 Remove the skin and pin bones from the herring fillets. Cut the fillets into 1-inch pieces and lay them on a plate. Top the chunks of herring with the marinated onion to cover the fish completely.

5 Combine the sour cream and 1 cup of the kefir in a medium bowl, stirring until well blended. Pour the cream over the fish and onion. Sprinkle with half of the chopped dill and refrigerate for at least 1 hour.

6 In a separate bowl, mix the cottage cheese with the remaining ½ cup kefir and the remaining chopped dill. Season with salt and pepper. (This cream will be used to season the potatoes in the end.)

7 Now that everything is ready, plate the dish: Place the herring and the potatoes on the same dish, seasoning the fish with some cream from its own marinade and the potatoes with the cottage cheese mixture. Serve with white wine or ice-cold beer.

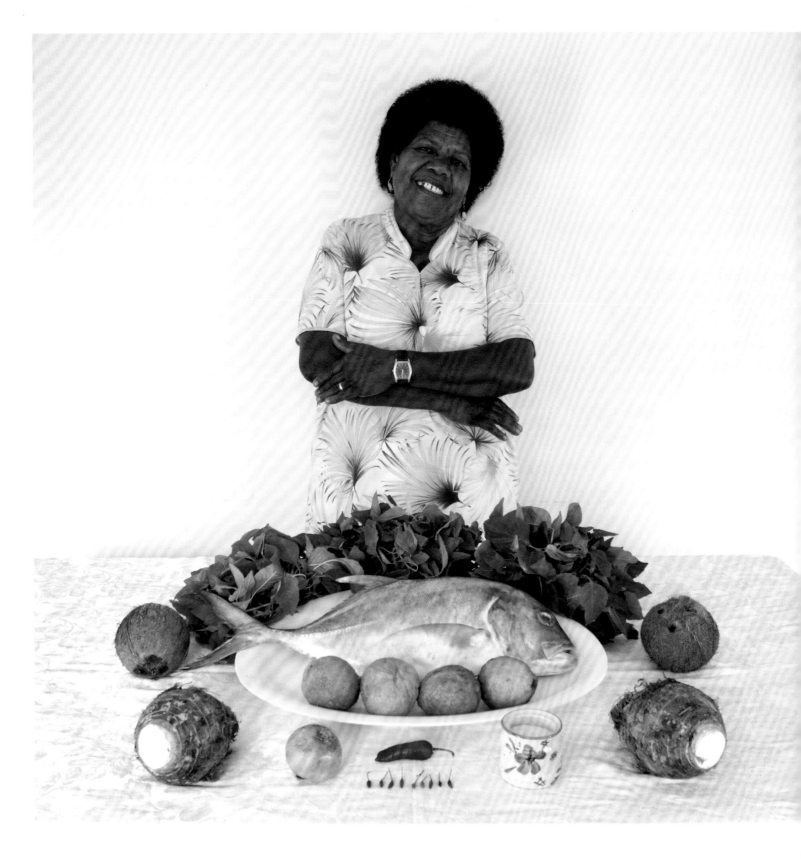

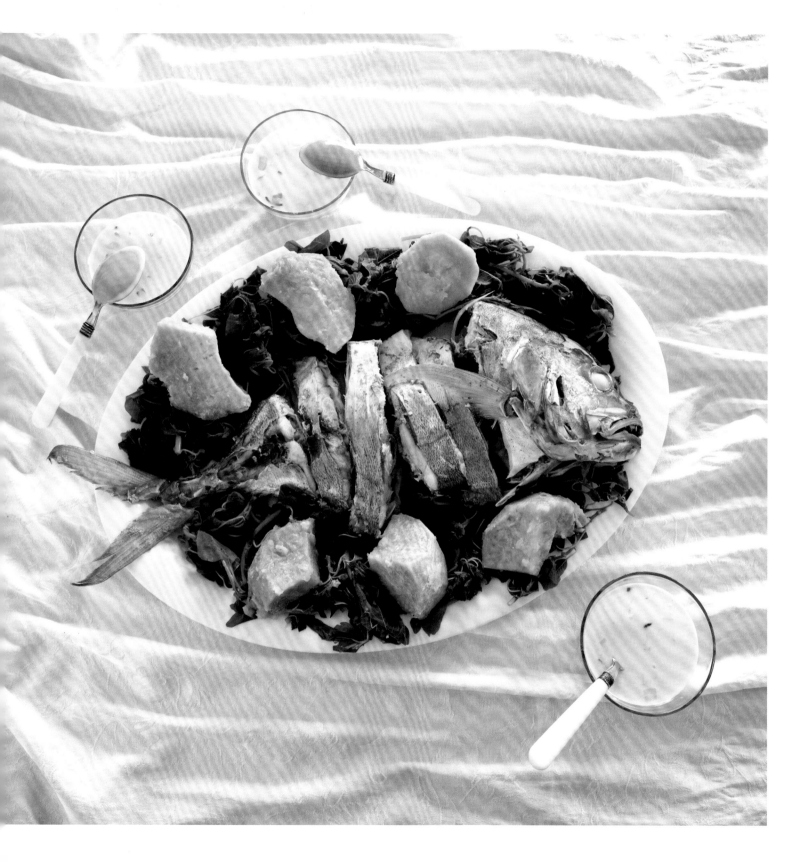

Balata Dorote

62 YEARS OLD

Balata is the grandmother of three grandsons, who she hopes will become fishermen as their grandfather, her husband, once was. She lives in a small house among palm trees and close to the sea. One bedroom, one bathroom, and a kitchen are enough for her and her husband, but the house was enough even before, when their two children lived with them.

Almost every day Balata cooks fish caught by someone in her family, and only a couple of times a week do they have meat, mainly chicken. She has never worked in her sixty-two years of life and she doesn't understand why women are so keen on working outside their home nowadays. Of modern Fijian women, she says, "Women have to take care of their house and children; there is no time to work. They have to cook at least twice a day—this is their job."

The most difficult step of this recipe is probably getting the dalo, a common Fijian tuber whose taste is similar to that of a potato. (Taro root is an excellent substitute here.)

Miti Ika

Fish in Coconut Sauce with Dalo

SERVES 4

3 small dalo or taro roots, peeled and cut into large chunks

Salt and freshly ground black pepper

1 coconut (not a young coconut)

Juice of 1 lemon or lime

1 small red chili pepper, such as jalapeño, chopped

A few small Fijian chilies, such as Junglee Mircha, or bird's-eye chilies, finely chopped

1 small yellow onion, chopped

One 2½- to 3-pound white-filleted fish of your choice, such as red snapper (Balata used trevally or ulua, which is a firm white-fleshed reef fish)

3 bunches of fresh spinach (about 8 cups)

1 Place the dalo in a large pot of boiling water, reduce the heat, and simmer gently until fork-tender, 40 to 50 minutes. When the dalo is ready, drain and season with salt and pepper. Set aside to keep warm to serve as a side dish for the fish.

2 Open the coconut and add its water to a bowl. Separate the white coconut flesh from the husk and grate it into the bowl with the coconut water. Stir the mixture, and allow it to sit for a few minutes. Then, using your hands, squeeze the mixture into another bowl, reserving the liquid. (Discard the solids.) Add the lemon juice, 1 teaspoon of salt, the chilies, and the onion to the coconut liquid. Stir to combine, then set aside.

3 Fill a large roasting pan or fish poacher three-quarters full with water. Bring to a rolling simmer, add the fish, and cook until the fish is opaque, 10 to 15 minutes, depending on the thickness of the fish.

4 While the fish is cooking, bring a medium saucepan with water to a boil. Add the spinach and cook for 3 to 5 minutes. Drain the spinach, season well with salt and pepper, and place on a serving platter.

5 When the fish is ready, carefully remove it from the water and slice it into serving-size pieces. Season it with more salt and pepper and set it on top of the spinach, arranging the fish in its original shape. Pour the coconut sauce over the fish. Add the dalo to the platter and serve.

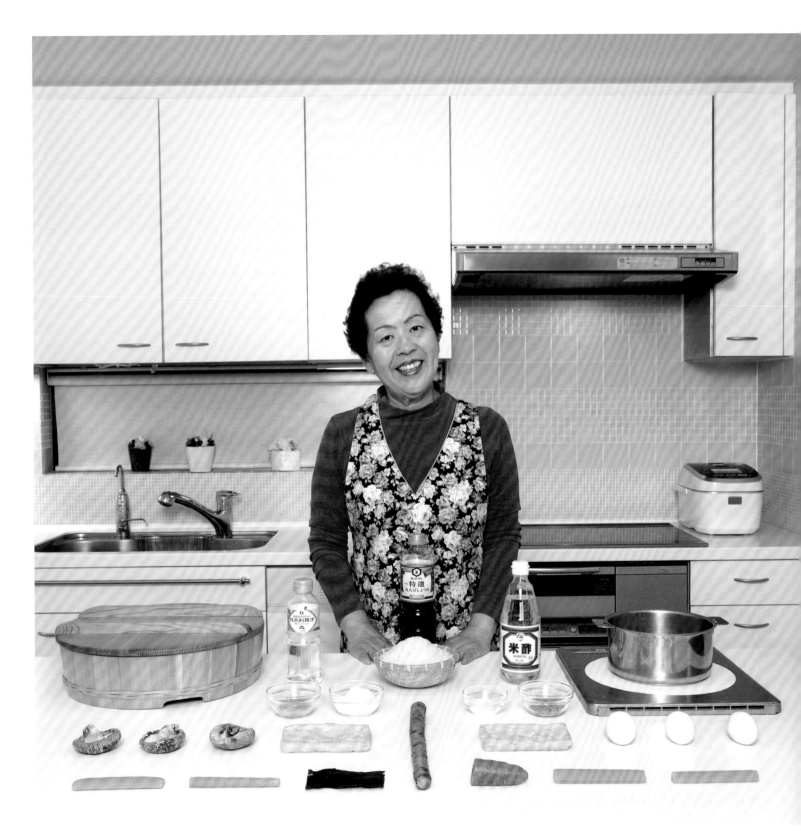

Hiroko Horie

66 YEARS OLD

Hiroko was born in the small town of Miyazaki on the island of Kyushu, in the south of Japan. She spent the first five years of her life there in a wonderful house reminiscent of ancient Japan. "My family donated it to the government after we moved to Tokyo, and it is now a national historic site. Many tourists visit the house, and we are really proud of it. My only regret is that we can't go back to live there," Hiroko tells me about her life.

I met her in Tokyo in her new house, which is not traditional at all. Rather it has a large and well-supplied kitchen. In fact, Hiroko cooks so well that she has been a star of Japanese television cooking shows since the age of thirty. "I have been working for Channel Four for many years. Almost every day I cook live and teach my audience how to make quick and tasty recipes. When at home, I don't just stick to quick and tasty things, but I cook the most delicious dishes I know for my children and grandchildren."

Chirashizushi

Scattered Sushi

SERVES 6

3 large dried shiitake mushrooms

2 cups sushi rice

Salt

1 leaf of Japanese seaweed

12 teaspoons sugar

5 tablespoons rice vinegar

1 burdock root (about 2 ounces), peeled and thinly sliced into 1½-inch-long pieces

2 fried or sautéed pieces of tofu, cut into thin 1½-inch-long strips

2 tablespoons sake

2 tablespoons soy sauce

½ carrot, shredded

4 fuki (a Japanese herb), or 1 large celery stalk, thinly sliced

3 eggs

2 tablespoons ground sesame seeds

Sweet-and-sour pickled ginger, for serving

1 Soak the dried mushrooms in water to cover for 5 hours.

2 Wash the rice well and put it in a rice cooker with 2¼ cups of water, 2 teaspoons of salt, and the leaf of Japanese seaweed on top of the rice. Let cook for about 30 minutes, or until the rice is just tender.

3 Meanwhile, prepare the sauce for the rice. In a small bowl, mix 5 teaspoons of the sugar, 1 teaspoon of salt, and the rice vinegar. Stir until the sugar is dissolved.

4 When the rice is ready, transfer it from the cooker to a large bowl (or use a *handai*, a typical Japanese wooden bowl to make sushi rice, if you have one) and mix it with the sauce. Thinly slice the seaweed leaf that cooked with the rice and set aside.

5 Using a slotted spoon, remove the mushrooms from the soaking liquid. Place the mushrooms, burdock, and tofu in a small pot, add 1 cup of the mushroom soaking liquid, cover the pot, and cook on medium heat. After 3 minutes, add 4 teaspoons of the

sugar, the sake, and the soy sauce to the vegetables. Cover and let cook for 20 more minutes, without stirring. Add the carrot, fuki, and seaweed to the vegetables and let cook for 2 more minutes. Remove from the heat and drain in a colander, squeezing the vegetables, if necessary, to eliminate as much liquid as you can. Set aside.

6 In a medium bowl, beat the eggs with a pinch of salt and the remaining 3 teaspoons sugar. Heat a nonstick pan over medium heat. Working in batches, add a thin layer of egg and cook, without stirring, until you have a very thin omelet. Once the egg is set, flip the omelet over and cook on the other side for 30 seconds. Remove from the pan and repeat with the remaining eggs. Slice the omelets into very thin strips.

7 Top the rice with the drained vegetables. Sprinkle with the ground sesame seeds. Mix well to combine, breaking up any clumped rice. Top the rice with the omelet strips and some sweet-and-sour ginger.

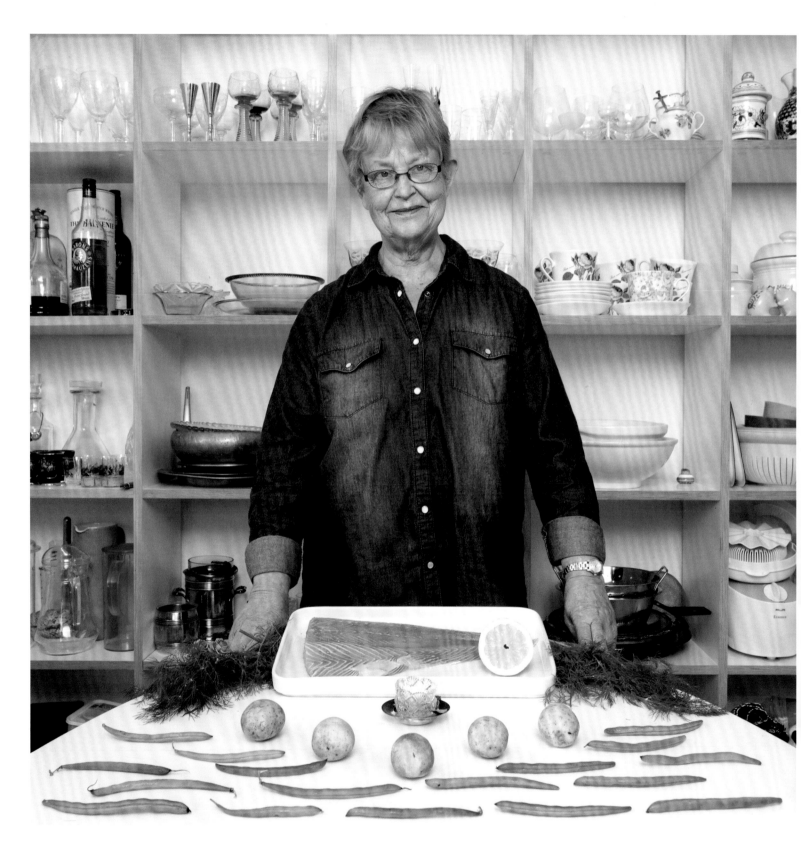

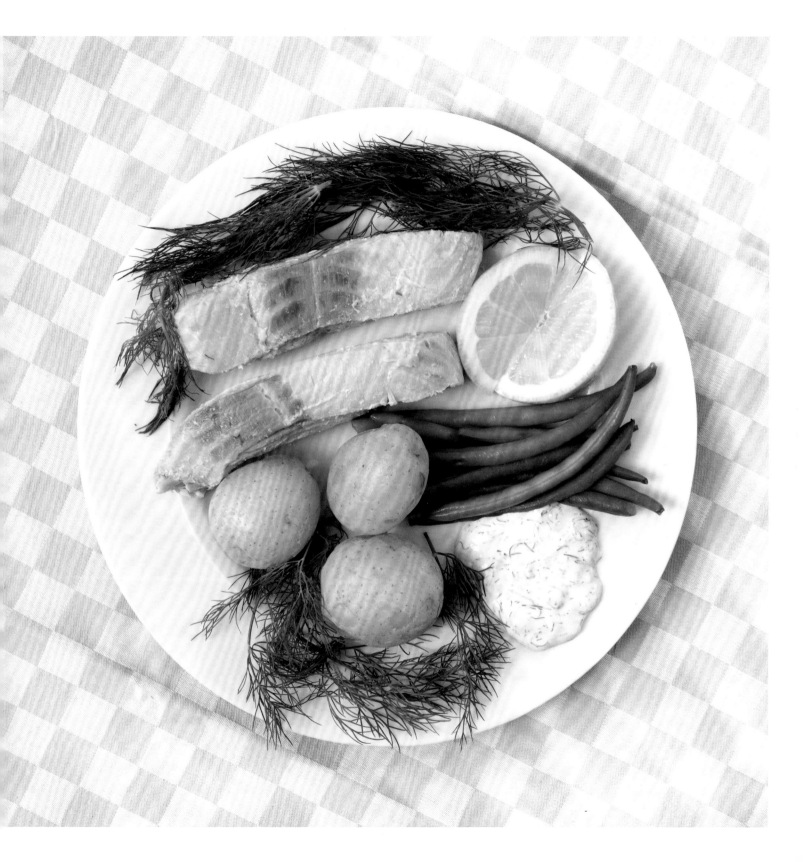

Brigitta Fransson

70 YEARS OLD

Brigitta is one hundred percent Swedish, having been born and raised in Stockholm, though she is well traveled. Her tidy, light-filled apartment sits on the second floor of a new condo, and everything is set with extreme precision. Entering her home, I initially had the impression that I was in an Ikea showroom, but then the smell of salmon wafting from the kitchen wiped that idea out of my mind. Brigitta lives with Nina, a German student who is renting her daughter's former room. "My grandchildren live far away and I don't see them often. Nina has lived with me for a year and now she is like part of the family. I'm glad to be able to cook for someone at the end of the day and not to be alone. We sit at the same table almost every night and we have dinner together. I feel like I have a new grandchild and I love it."

Undoubtedly, salmon is the most widely served food on Swedish tables. It can be cooked in a thousand different ways, simple or not. This recipe follows the most common procedure (and it's probably even the healthiest). It is a typical summertime recipe for two reasons: because it is served cold and because new potatoes can be found only in summer.

Inkokt Lax

Poached Cold Salmon and Vegetables

SERVES 4

4 new potatoes (8 if they are very small)

8 ounces string beans

2 sprigs fresh dill, plus more for garnish

2 teaspoons salt

1 lemon, thinly sliced, plus more for garnish

1 (1-pound) salmon fillet

1 cup Greek yogurt

1 Boil the potatoes and the string beans in 2 separate pots until they are cooked to your taste. (In Sweden string beans are usually boiled for a few minutes only, so that they are still hard and crisp.) Set aside.

2 Remove the dill fronds from the stalks and reserve. Place the stalks in a skillet or saucepan large enough to hold the fish in 1 layer with 4¼ cups of water and the salt and bring to a boil. When the water boils, add the sliced lemon, cover, and let cook for 5 to 6 minutes.

3 Cut the salmon fillet into 4 pieces and place them in the pot, making sure that the fish is completely cov-ered with water. Cover the pot and turn off the heat. Leave everything in the pot, covered, until the water cools completely, 40 to 45 minutes. (This cooking method enhances the taste of the salmon, because it doesn't waste its aroma in the boiling water.)

4 Place the reserved dill fronds in a small bowl, add the yogurt, and mix well to combine.

5 Remove the salmon from the poaching liquid and arrange the pieces on a dish with the potatoes and the string beans, garnish with some fresh dill and sliced lemon, and serve with the yogurt sauce. Enjoy this dish with chilled white wine.

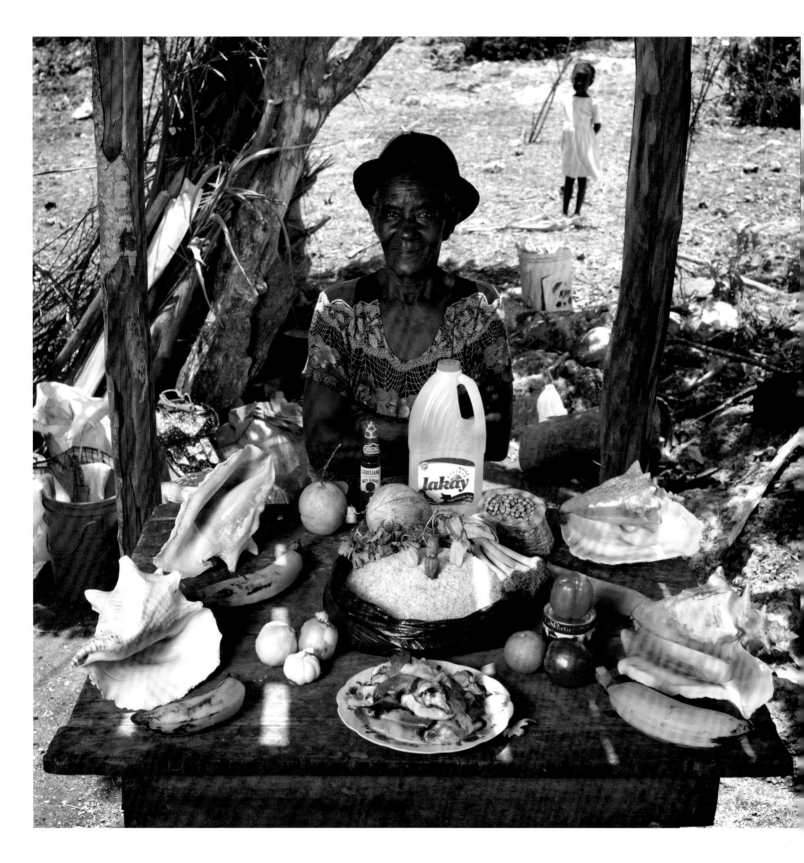

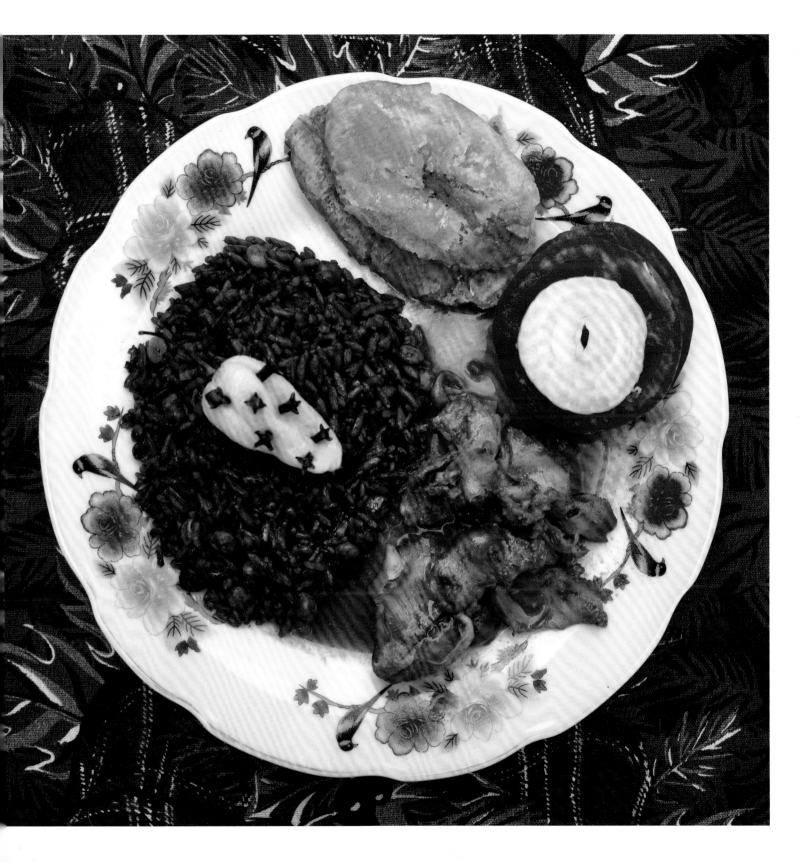

Serette Charles

63 YEARS OLD

Serette has ten sons and daughters (all of them alive, which in Haiti, unfortunately, is not so common) and fifteen grandchildren. She lives in the countryside near Saint-Jean-du-Sud, in the southern area of Haiti, not far from the sea. Getting to her house from Les Cayes (the second-biggest city in Haiti) involves a one-hour drive on an unsurfaced road in a four-wheel-drive vehicle, followed by a fifty-minute walk. Her house, which is actually a hut, is in the middle of the forest near other families; all together they form a little village. She has neither electricity nor running water at home, but, fortunately, there is a nice river that runs very close to the house, which she uses. She cooks with the coal that she makes from burned logs and loves to prepare *lambi*, a Haitian type of conch. Of course, someone has to fish it for her, usually one of her nephews.

Lambi in Creole Sauce with Haitian Rice and Fried Plantains

SERVES 6

4 large lambi (about 1½ pounds)

1 coconut, meat grated (about 1 cup)

1 large onion, sliced

1 garlic clove, minced

1 small leek, thinly sliced

¼ cup chopped fresh flat-leaf parsley

2 habanero chiles, minced

Juice of 1 bitter orange

Juice of 1 lime

1 tomato, chopped

Salt and freshly ground black pepper

FOR THE HAITIAN RICE

½ ounce dried Haitian djon djon mushrooms (or dried shiitake)

2 tablespoons canola or vegetable oil

1 small leek, cleaned and thinly sliced

¼ cup chopped fresh flat-leaf parsley

2 garlic cloves, minced

1 green Scotch bonnet or habanero chili, seeded and minced

¼ ounce dried river shrimp (*tritri*)

One (15-ounce) can black beans

1 teaspoon salt

2 cups long-grain rice

FOR THE PLANTAINS

Canola oil, for frying

6 yellow plantains

1 **Make the lambi:** The first thing to do is to fish the lambi in the Caribbean Sea. Lambi (*Strombus gigas*, also known as "conch") is protected by a big shell, about 1 foot in length. You can pull out the shellfish by making a hole in the upper edge. Skin the lambi and thinly slice.

2 Place the grated coconut in a small bowl. Add 1 cup of water and set aside.

3 Combine the onion, garlic, leek, parsley, chilies, bitter orange juice, and lime juice. Add the tomato and lambi, season with salt and pepper, and mix well. Transfer the mixture to a medium saucepan.

4 Drain the liquid obtained from soaking the coconut into a bowl and add water so you have 3 cups liquid total; discard the coconut meat. Add the coconut liquid to the saucepan and bring to a boil. Then reduce the heat and simmer, uncovered, for 45 minutes, or until the lambi is tender.

5 **Make the rice:** Soak the dried mushrooms in a bowl with 1 cup of warm water for at least 15 minutes. Strain and reserve the soaking water; discard the mushrooms.

6 In a medium saucepan, heat the oil over medium-high heat. Add the leek, parsley, garlic, and chili. Cook, stirring, for 1 minute. Add the dried shrimp and black beans. Cook, stirring frequently, for 2 to 3 minutes. Add the salt, the reserved mushroom water, 3 cups of water, and the rice. Bring to a boil, then reduce the heat to low, cover, and simmer for 20 minutes, or until the rice is tender and the water has been absorbed. Fluff with a fork. Cover and let stand for 5 minutes before serving.

7 **Fry the plantains:** Peel the plantains and cut them diagonally into ¼-inch slices. Heat ¼ inch of canola oil in a large sauté pan over medium heat. When the oil begins to shimmer, add the plantains, in batches, and fry for 1½ minutes on one side, then flip and cook for 1 minute on the other side. Remove the plantains from the pan and drain on a plate lined with paper towels.

8 Arrange the lambi, rice, and plantains on the six plates and serve.

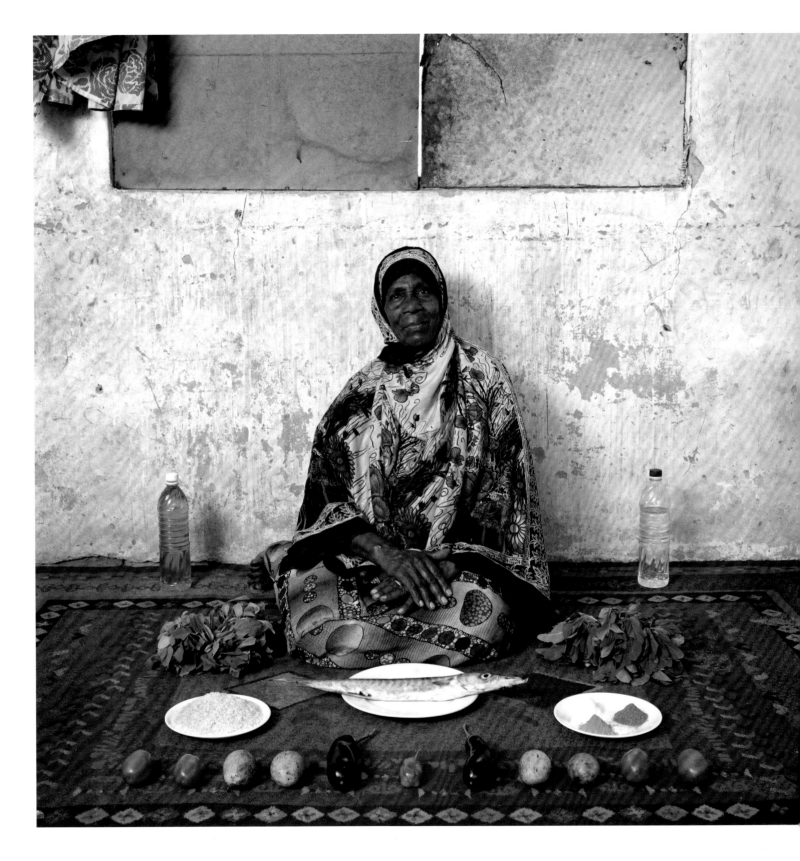

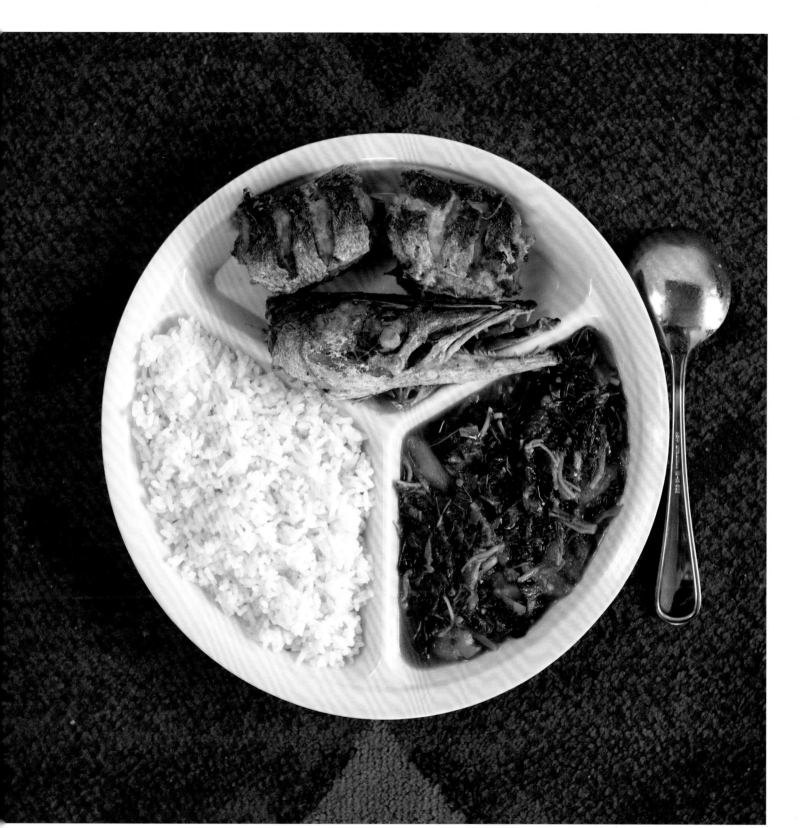

Miraji Mussa Kheir

56 YEARS OLD

Miraji was born in Zanzibar and has never left the island. She lives in a northern suburb of the capital, Zanzibar City, in a small house that she shares with her husband and two of her three daughters. The house is small, with just two rooms and a kitchen in a hut outside. Every day after school her only grandchild helps her prepare dinner for the family. "My grandson is really good at helping me with cooking. I always ask him to go to buy some fish or vegetables at the small market at the end of the road. All the sellers there know him now; he might be the youngest client they have. Then, when he gets home, he helps me with cutting the vegetables, cleaning the fish, and many other things. Cooking together with him makes me one of the happier grandmothers on the island," says Miraji, smiling.

Barracuda is one of the most popular catches in Zanzibar, but it is not necessary for this recipe. You can use any other kind of fish; black sea bass, blue fish, and mackerel also work well.

Wali na Mchuzi Wa Mbogamboga

Fish, Rice, and Vegetables in Green Mango Sauce

SERVES 4

2 pounds spinach, washed and cut into strips

¼ cup grapeseed or sunflower oil

2 tomatoes, diced (about 1¾ cups)

1 medium eggplant, diced (about 4 cups)

1 teaspoon curry powder

1 teaspoon garam masala

Salt

2 green mangoes, diced (about 1¼ cups)

1 cup long-grain rice

3 pounds whole barracuda, scaled and gutted, or fish of your choice (black sea bass works well here)

1 (½-inch) piece of fresh ginger, peeled and chopped

1 Fill a medium saucepan with water and bring to a boil. Add the spinach and cook for 5 minutes. Drain well and set aside.

2 Heat 2 tablespoons of the oil in a large pan over medium heat. When the oil is hot, add the tomatoes and cook for 5 minutes. Add the eggplant, curry, garam masala, and 1 teaspoon of salt. Cook for 5 more minutes, then add the mangoes and cook for 5 minutes more. Add the cooked spinach and 1 cup of water to the pan and stir the mixture to combine. Increase the heat to medium-high and bring the mixture to a boil. Cook for 10 to 15 minutes more.

3 While the mango sauce is cooking, prepare the rice. In a medium saucepan, bring 2 cups of water and the rice to a boil over medium-high heat. Reduce the heat to medium, cover the saucepan, and cook until the water is absorbed and the rice is tender, 15 to 18 minutes. (If you have a rice cooker, you can use it instead.)

4 Pat the skin of the fish with a paper towel or cloth until it is completely dry. Cut the fish into 4-inch pieces (or leave whole for more delicate fish). With a knife, make several cuts into the sides of the fish. Season inside the slits with salt and some of the chopped ginger. Scatter the remaining ginger on top.

5 Heat the remaining 2 tablespoons oil in a large nonstick pan and fry the fish for about 10 minutes on each side, or until done. Remove the fish and drain on paper towels.

6 Serve the fish alongside the rice and sauce.

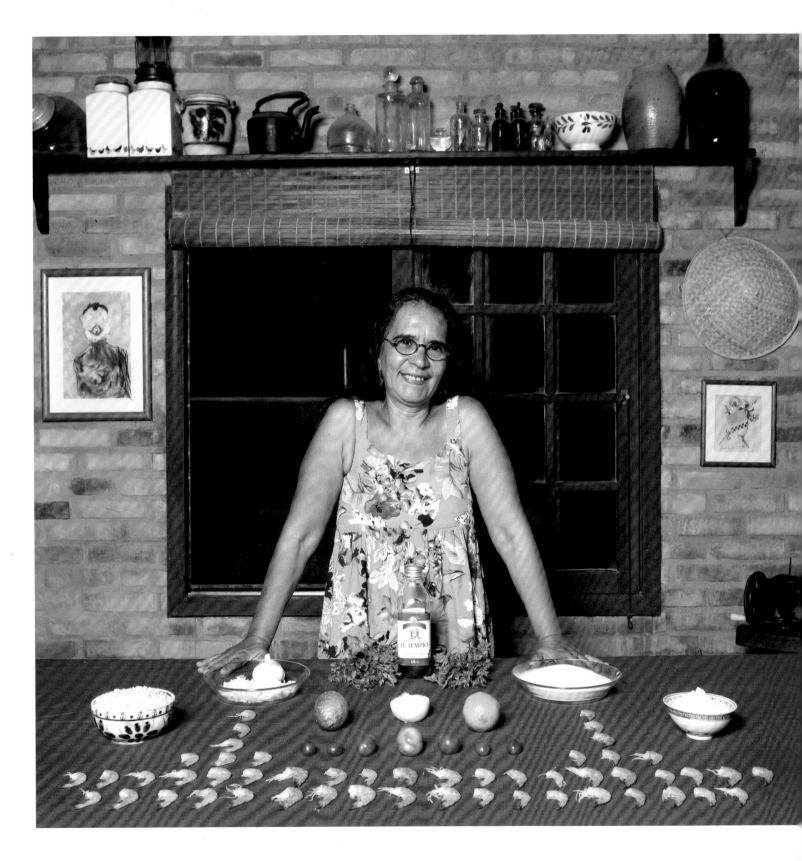

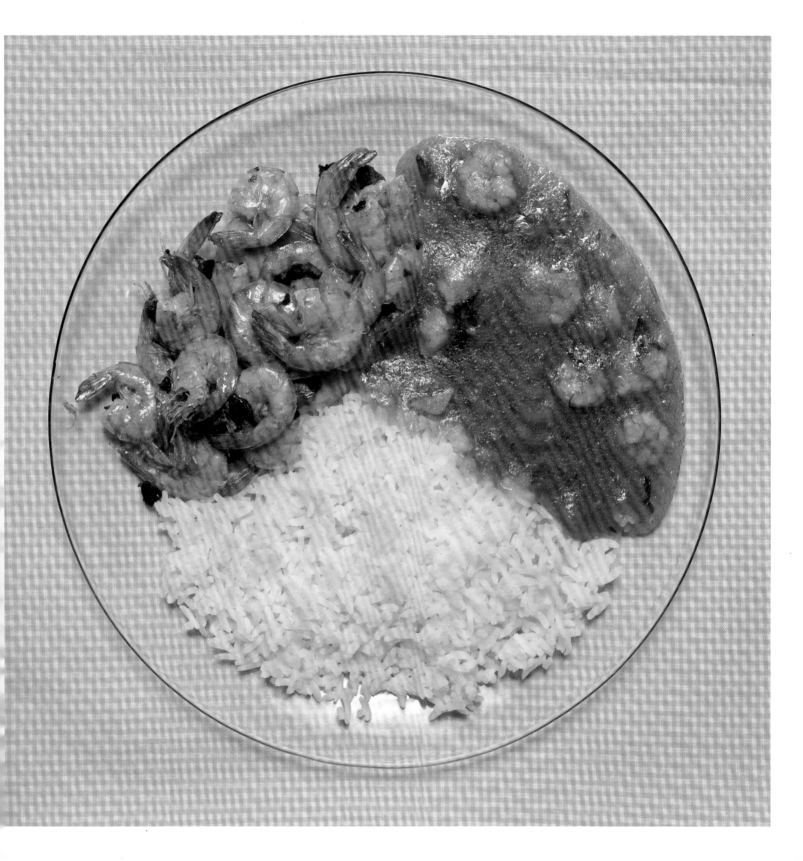

Rosane Liborio

54 YEARS OLD

Rosane was born in Rio de Janeiro and grew up in Copacabana, dividing her time between school and the beach. One day, at the age of twenty-two, she met a man on the seafront. "He was playing the guitar. I stopped to listen to him and we started to chat. We spent the whole afternoon talking and walking on the beach. We got married a few months later and we are still together." Her husband was living on a boat in Porto Alegre when Rosane moved in with him; they lived in their floating home for several years and sailed to the Caribbean for three months every summer. Ten years later, after Rosane became pregnant, they moved to the mainland to start their family. They have lived in Florianópolis ever since and now they own a small clothing factory. Their son, who is now twenty-three, lives in the United States and is married to an American woman who is expecting their first child together. So, Rosane will soon become a grandma. "I can't wait to see my first grandchild and, of course, I can't wait to cook something for him, or her . . . who knows?"

Prawn Pirão

Garlic Prawns with Rice

SERVES 4

6 tablespoons olive oil

1 small onion, finely chopped

1½ cups long-grain rice

Salt and freshly ground black pepper

6 ripe tomatoes

½ cup chopped fresh flat-leaf parsley

60 large shrimp (about 1¾ pounds), shells on

⅔ cup manioc flour

10 garlic cloves, peeled and thinly sliced

1 In a medium sauté pan, heat 1 tablespoon of the olive oil over medium heat. Add half of the chopped onion and cook for 3 to 4 minutes. Add the rice and mix to coat. Cook for 2 to 3 minutes, then add 3 cups of hot water or enough to cover the rice by 2 inches. Season with salt and pepper, reduce the heat, and cover. Simmer for 12 to 15 minutes, until all of the water is absorbed.

2 Bring a saucepan of water to a boil and prepare a bowl of ice water. Cut an X in the bottom of each tomato. Add the tomatoes to the boiling water and blanch for 30 seconds. Transfer the tomatoes to the ice bath to stop them from cooking. When cool enough to handle, peel and finely chop the tomatoes.

3 In a large sauté pan, heat 2 tablespoons of the olive oil over medium heat. Add the remaining chopped onion, the parsley, and the chopped tomatoes and cook, crushing the tomatoes with a wooden spoon as they soften. Cook for 10 minutes.

4 Peel and chop 20 of the shrimp and add them along with 2½ cups of water and 1 teaspoon of salt to the pan with the tomato sauce. Cook for 5 minutes. Then add the manioc flour slowly, stirring constantly. Reduce the heat to low and continue stirring while the sauce cooks, 8 to 10 minutes, until the *pirão* has thickened (as you would do when preparing polenta). The pirão will thicken as it sits. If it becomes too thick, add a few tablespoons of hot water until it reaches your desired consistency.

5 Heat the remaining 3 tablespoons olive oil in a large skillet over medium-low heat. Add the garlic and sauté until golden. Add the remaining (unpeeled) shrimp, and cook them until opaque, 10 to 12 minutes, turning them over quite often. The garlic can be moved to the edges of the pan to prevent it from burning.

6 Place the rice, pirão, and garlic shrimp on a plate and serve.

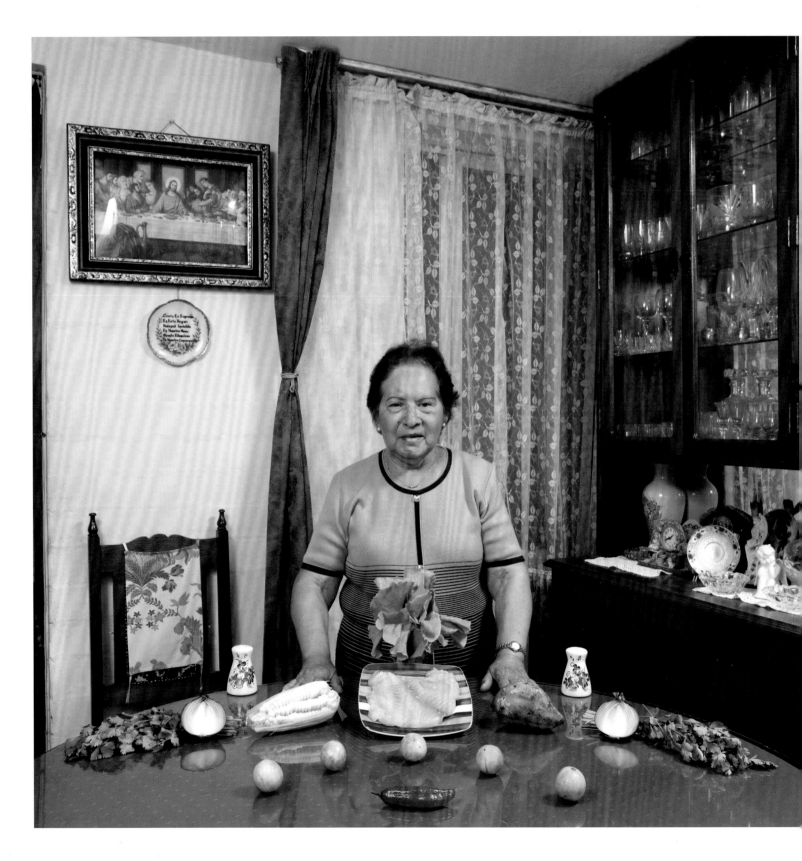

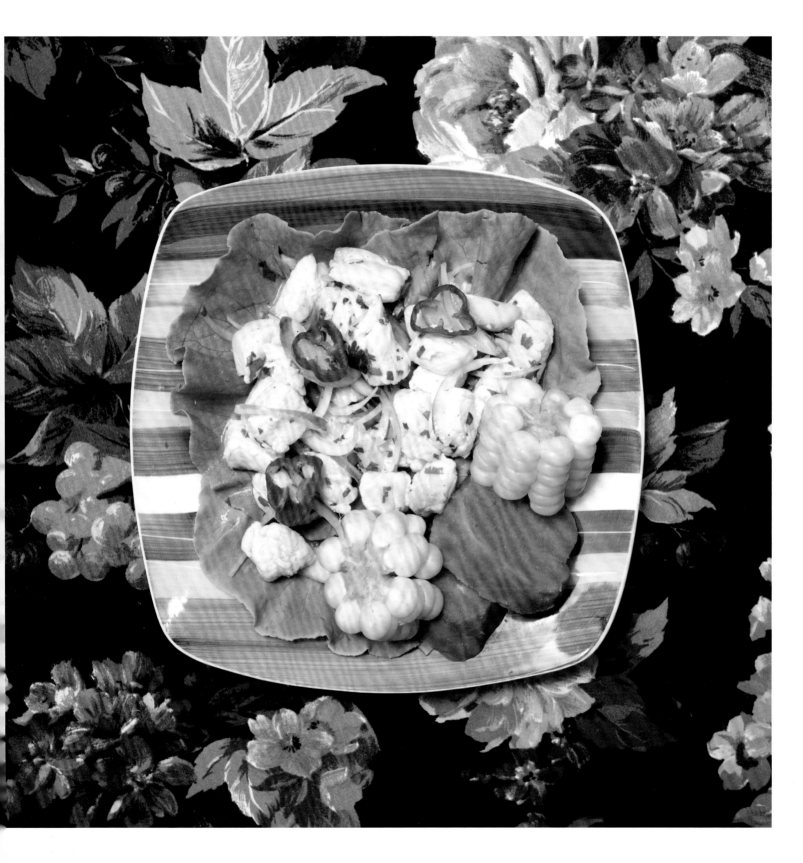

Itala Revello Rosas

77 YEARS OLD

Itala's house is cozy, spacious, and well arranged. The walls of the living room are covered with glass cabinets full of various dishes, glasses, and crockery. Looking at them, you get the impression that Itala often entertains large numbers of people. However, most of the time she cooks only for her husband and herself, because, unfortunately, their children and grandchildren live far away. "They rarely come to visit us. If I want to see my grandchildren, I have to take a bus for many hours up to the mountains where they live," she says. Itala and her husband hope that in the future their children and grandchildren will move to the city, so they can see them more often.

Ceviche, which is marinated fresh raw fish, is a popular dish in Latin America, but the one Itala made was undoubtedly the best I have ever tasted. In Peru, this dish is usually accompanied by ice-cold beer.

Corvina Fish Ceviche

SERVES 4

2 medium *camotes* (sweet potatoes)

1 onion, thinly sliced

Salt

2 ears of choclo corn (Peruvian corn)
 or soft white corn (available frozen
 from Goya)

18 ounces freshly caught fillet of
 corvina or sea trout (weakfish)

2 cups freshly squeezed lemon juice
 (from 9 to 10 lemons)

Freshly ground black pepper

½ cup chopped fresh cilantro

Lettuce leaves

1 hot chili, thinly sliced, for garnish

1 Bring some water to a boil in a large saucepan. Add the camotes and boil for 25 to 30 minutes, until tender. Place the sliced onion in a bowl of salted water. Let sit for a few minutes to remove the bitter taste. Drain and set aside.

2 Place the corn in a pot with boiling water and cook until tender, 25 to 30 minutes.

3 Cut the corvina fillet into pieces of about ½ inch. Place the pieces of fish fillet in a pie dish and pour the lemon juice evenly over the fish. Season with salt and pepper. Allow the fish to marinate for 10 minutes (but no more, because it will be overcooked from the acid from the lemon).

4 Remove the pieces of fish from the lemon juice and drain very well. Spread the onion on top of the fish, and top with the chopped cilantro.

5 Drain the camotes and the corn and cut each into thick slices. Place some lettuce leaves on a plate to cover it, then arrange the pieces of camote and the corn on one side and the seasoned fish on the other. Garnish with the hot chili and serve.

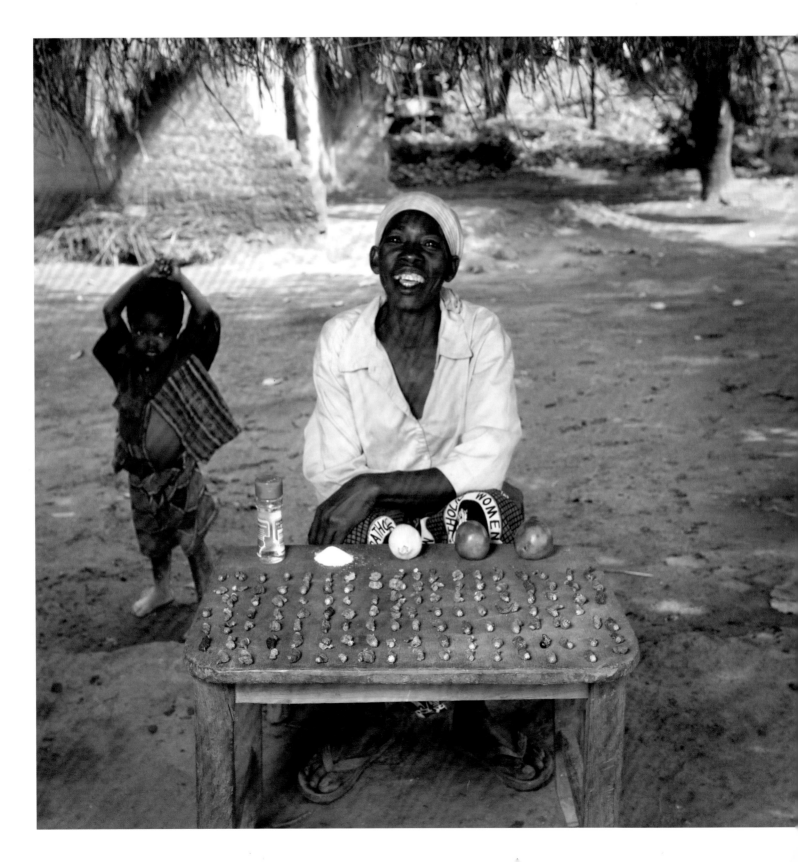

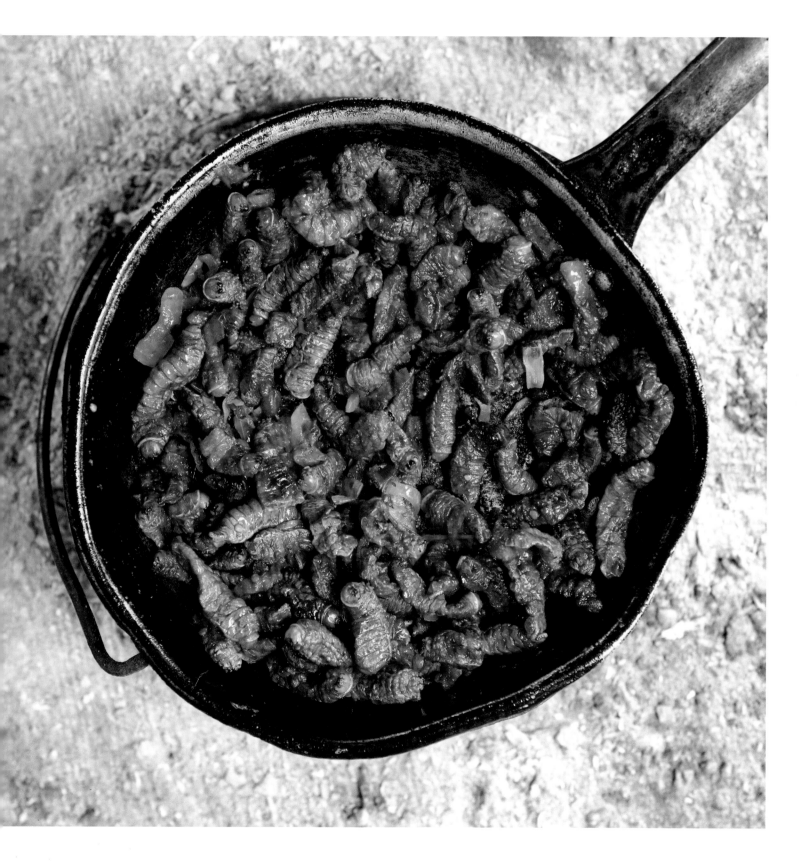

Regina Lifumbo

53 YEARS OLD

In Regina's small village there aren't supermarkets, bars, or restaurants, but only a tiny street market where farmers and hunters sell their products and game. The choices are limited; there are only a few types of vegetables available and even fewer types of meat. Out of tradition, or rather, necessity, the village people eat anything that can be hunted, including mice, snakes, and cockroaches. Each hut has a small fire, which is always kept lit because it is the only way to cook and warm things. Regina was born and raised here, having met her husband when she was nineteen. They had six children, who have given them eleven grandchildren in turn, two of whom unfortunately died of malaria when they were young.

In Malawi and the neighboring countries, what they call "caterpillar" is actually the maggot of an insect similar to our moth. The villagers catch and dry the maggots to use them as food all year long. Each village has its own recipe, and I had the chance to taste them in a sauce of tomatoes and onions. Cooking with Regina was one of the most emotional experiences of my life and changed me forever.

Finkubala

Caterpillars in Tomato Sauce

SERVES 4

4¼ pounds dried caterpillars
2 tablespoons canola oil
1 onion, chopped
2 tomatoes, diced
1 teaspoon salt

1 Soak the dried caterpillars in several cups of water for about 5 minutes in order to soften them. (Be careful not to soak them for too long, because they might lose their consistency and melt when cooking.) Drain and let them air-dry.

2 In a large sauté pan, heat the oil over low heat. Add the onion and tomatoes and cook for 10 minutes, or until the vegetables have softened.

3 Add the caterpillars to the pan and season with the salt. Continue cooking for 15 minutes, stirring continuously, until the outsides of the caterpillars are crisp.

4 Serve with rice or mashed root vegetables, or if you want to do it as they do in Malawi, serve it on a leaf and eat with a piece of tree bark.

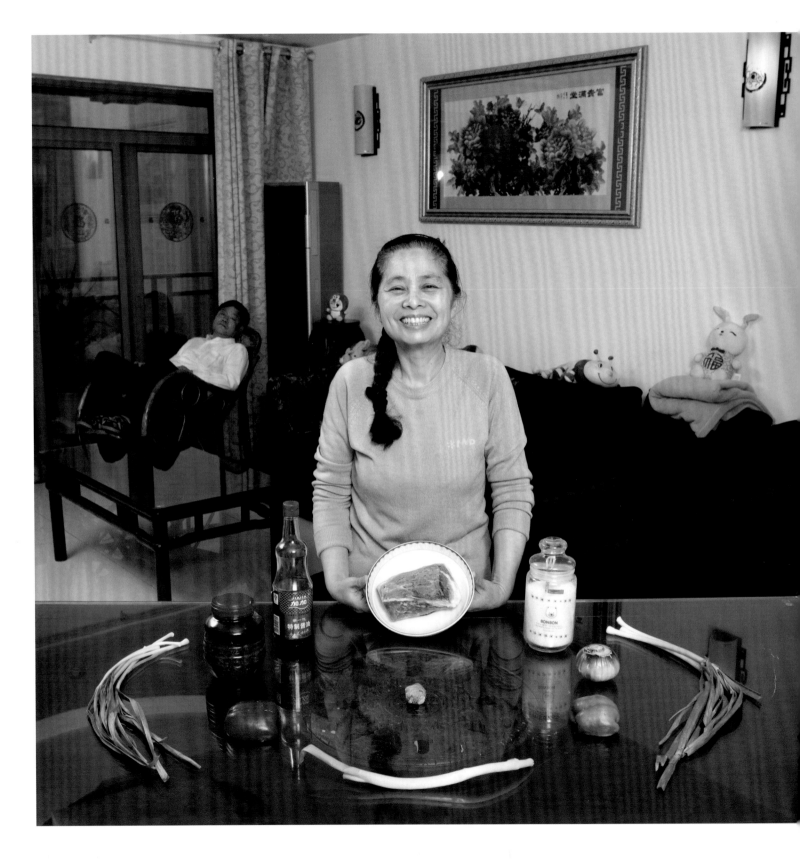

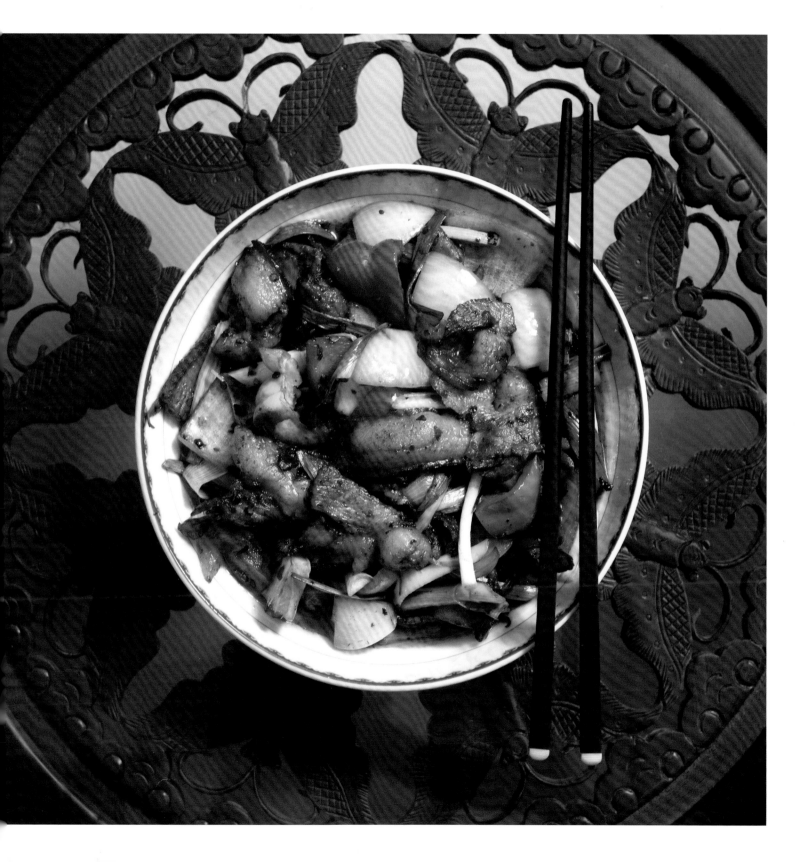

Pan Guang Mei /

62 YEARS OLD

Guang Mei has one son and one grandchild. She was born in the countryside of Sichuan, and now she lives in Chongqing, a city of more than thirty million people and one of the five biggest cities in the world. She grew up in a tiny house, where the kitchen was a sort of camping stove placed on a table. Now she lives with her husband on the nineteenth floor of a skyscraper in the southern part of the city, and her kitchen is as big as her first house.

The word *rou* (the third word in the recipe name) means "meat cooked again in the wok" in Chinese, and, indeed, the meat has to be cooked twice: the first time in boiling water and the second in a wok with some vegetables. Folks in China know that eating pork every week is good, but in moderation and provided that you accompany the pork with plenty of vegetables (and possibly that you cycle every day to the market to shop). This is how you keep slim, according to Guang Mei.

Hui Guo Rou

Twice-Cooked Pork with Vegetables

SERVES 2

1 (14-ounce) pork belly, skin on

2 (1-inch) pieces of fresh ginger, peeled and thinly sliced or shredded

2 bunches of green onions, trimmed and chopped into 2-inch pieces

3 tablespoons vegetable oil

2 tablespoons sugar

1 tablespoon hot chili sauce or hot chili paste (*doubanjiang*)

4 teaspoons soy sauce

½ red bell pepper, cut into 1-inch dice

½ green bell pepper, cut into 1-inch dice

1 large red onion, cut into 1-inch dice

1 Place the pork belly in a wok or large saucepan; add water to cover the meat completely. Add half of the ginger and half of the chopped green onions. Bring to a boil, lower the heat to a simmer, and cook for 30 minutes, or until the pork is tender.

2 Drain the pork, remove the skin, and cut the pork into thin slices.

3 Wipe out the wok. Add 1 tablespoon of the oil and warm over high heat until the oil is very hot. Add the rest of the ginger and cook for 1 minute. Add the sliced pork and cook for 5 minutes, stirring often. Remove everything to a dish.

4 Wipe out the wok again and add the remaining 2 tablespoons oil and the sugar over low heat. When the sugar is melted and begins to caramelize, add the hot chili sauce and the soy sauce. Cook for 1 to 2 minutes, then add the sliced pork, the diced bell peppers, the diced red onion, and the remaining chopped green onions. Heat everything together for 5 minutes. Serve immediately.

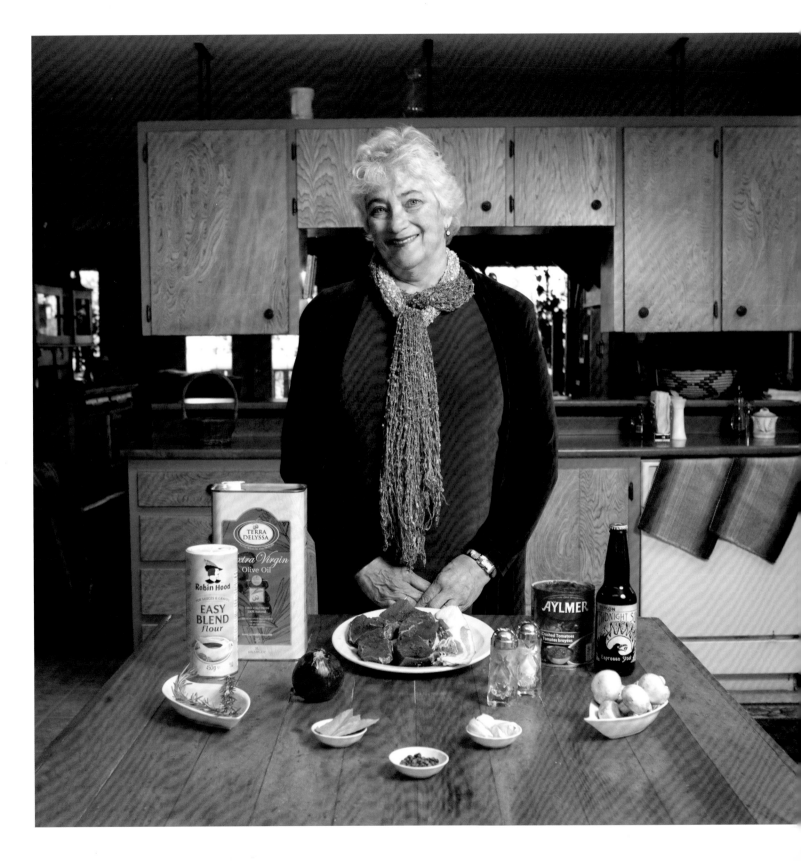

Kathy O'Donovan

64 YEARS OLD

"My son chased this bison," Kathy proudly says, showing me a dish with a dozen pieces of dark meat. She has spent all of her sixty-four years in the Yukon, one of the northern regions of Canada. "Then," she continues, while cutting the meat into pieces, "we butchered it a few days ago. You are lucky; it hasn't been frozen. The taste of the meat is much better when the meat is fresh."

Kathy has two daughters and a son, and in only eight years they have given her seven grandchildren. She is the one who spends the most time with the children. "My children and their partners work and they often leave the children here with me, sometimes at night, too. If I listened to the kids, I would cook fried things all the time, but their parents want me to cook healthfully for them. I try to do so, but three of them are a bit plump, anyway," she says, giggling.

Bison Under the Midnight Sun

SERVES 6 TO 8

4½ pounds boneless thigh of bison,
 or top round beef

25 ounces dark beer or stout

Salt and freshly ground black pepper

20 juniper berries

2 tablespoons olive oil

8 ounces bacon (8 to 10 slices)

4 garlic cloves, minced

2 to 3 bay or laurel leaves

1 tablespoon chopped fresh rosemary

1 medium red onion, roughly chopped

½ cup chopped tomatoes (canned
 or fresh)

2 tablespoons all-purpose flour

6 large white button mushrooms,
 trimmed and sliced

1 Combine the bison, beer, salt and pepper to taste, and 10 of the juniper berries in a large bowl narrow and deep enough for the meat to be completely covered. Cover and refrigerate overnight.

2 Preheat the oven to 325°F. Remove the meat from the bowl, reserving the marinade. Pat the meat dry and cut it into 1½-inch cubes.

3 In a large skillet, heat the olive oil over medium-high heat. Add the bison and cook for 3 minutes. You want to heat the meat, not brown it.

4 Transfer the warm meat to a small roasting pan or an ovenproof pot fitted with a lid. Begin layering the meat, separating each layer from the other with the slices of bacon. Season each layer with the garlic, bay leaves, rosemary, and the remaining 10 juniper berries. Top the last layer with the red onion.

5 Stir the chopped tomatoes into the reserved beer marinade, then pour the mixture over the meat. Make sure the liquid gets absorbed by the layers of meat.

6 Cover the pan and bake in the preheated oven for 3½ hours. Halfway through the cooking time, check the pan to make sure the liquid has not already been absorbed. If it has, add 1 to 2 cups of water, if necessary.

7 After the bison has cooked for 3 hours and 15 minutes, combine the flour with ¼ cup of cold water in a small bowl. Stir until there are no lumps and the flour is completely dissolved and add it immediately to the stew, stirring well to combine. Sprinkle the mushrooms over the top of the meat, return the cover, and continue cooking for 15 minutes more. Season with salt and pepper.

8 Now your bison is ready to be eaten! In Canada this bison casserole is often accompanied with ice-cold beer, but I would also suggest a nice red wine.

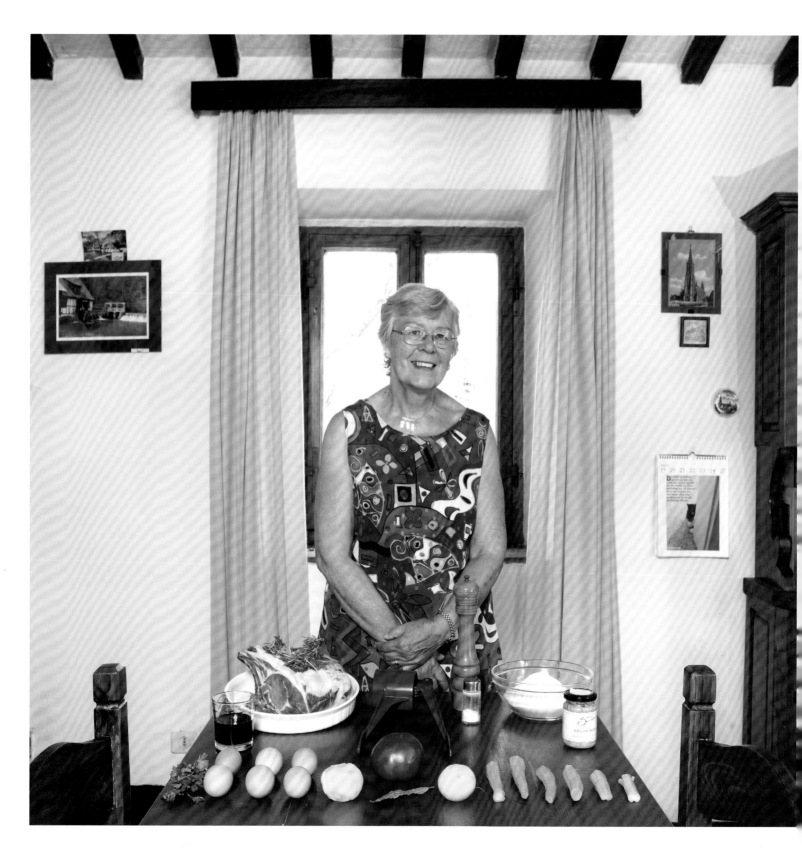

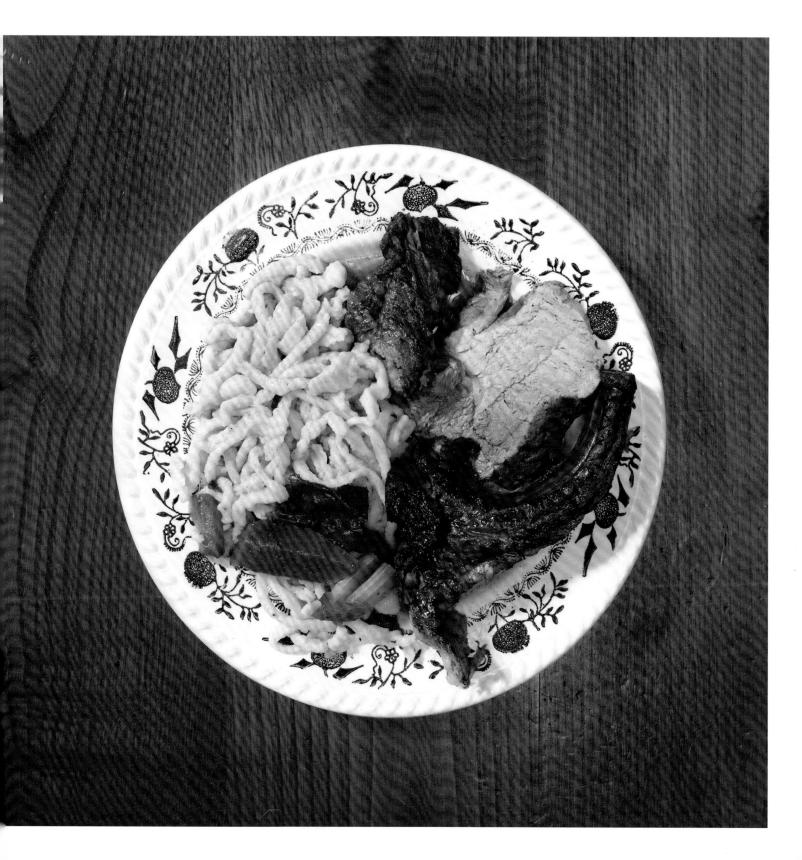

Inge Heimann

67 YEARS OLD

Inge and her Italian husband have four grown children and two granddaughters. Inge was happy when her youngest granddaughter was born, because her other granddaughter is a teenager and doesn't spend much time with her anymore. Inge lives with her husband in a beautiful house in the mountains, a bit far from the city, and to do the shopping, she needs to drive about 10 miles away. On the day I was to visit with her, she couldn't go to town, so she ordered the ingredients from her local shop and I just stopped there on my way to pick up the bags. I arrived in the middle of the morning and we cooked together for a couple of hours, drinking some cold beer. Then we sat at the table to enjoy our meal and chatted until four in the afternoon. It was a lovely visit!

Schweinebraten mit Spätzle

SERVES 6

FOR THE SCHWEINEBRATEN

1 (4½-pound) bone-in pork rib roast

⅓ cup Dijon mustard

Salt and freshly ground black pepper

1 sprig fresh rosemary

3 tablespoons olive oil

2 onions, chopped

1 bay leaf

1 celery stalk, roughly chopped

4 carrots, roughly chopped

1 tomato, chopped

½ cup fresh flat-leaf parsley leaves

½ cup red wine

1½ tablespoons all-purpose flour

FOR THE SPÄTZLE

3 cups all-purpose flour

6 large eggs, lightly beaten

Salt

1 Make the roast: Preheat the oven to 475°F.

2 Smear the rib roast with the mustard. Sprinkle with salt and pepper, then make small slits in the meat and insert a few rosemary leaves into each slit. (Or tie the meat with kitchen twine and insert the rosemary under the twine.)

3 In a large pot or Dutch oven, heat the olive oil and add the rib roast. Brown the meat on all sides. When the meat is well browned, add the onions and the bay leaf.

4 After 10 minutes, add the celery, carrots, tomato, and parsley leaves. Cook over medium heat for 5 minutes, then add the wine and ½ cup of water. Let simmer for 5 more minutes. Transfer the meat with the vegetables and the sauce to a shallow baking pan and place in the oven.

5 Roast for about 20 minutes and then lower the temperature of the oven to 400°F. Add 2 cups of hot water mixed with the 1½ tablespoons flour to the pan. Cook for 60 to 75 minutes more, until the internal temperature of the pork reaches 145°F on a meat thermometer.

6 Remove the pork from the oven and allow it to rest for 10 to 15 minutes before serving.

7 Make the Spätzle: Put the flour in a large bowl and make a well in the center. Pour the eggs into the well, along with 2 teaspoons of salt and 1 cup of water. Stir everything with a wooden spoon until the dough becomes creamy (the dough shouldn't be too hard because you will need to make it pass through the holes of a Spätzle maker (aka *Spätzle-Schwob*).

8 Fill a large pot with water, add a pinch of salt, and bring to a boil. Fill a Spätzle maker with the dough and press it so that the dumplings fall in the boiling water. Let them cook for 3 to 4 minutes. Remove them from the water with a small strainer or a slotted spoon. Place them in a soup dish. Repeat until you finish the dough.

9 To serve, place 2 slices of pork and a generous portion of dumplings on each dinner plate. Garnish with the sauce obtained from the meat and serve.

You will need a Spätzle maker, aka Spätzle-Schwob, to make this dish.

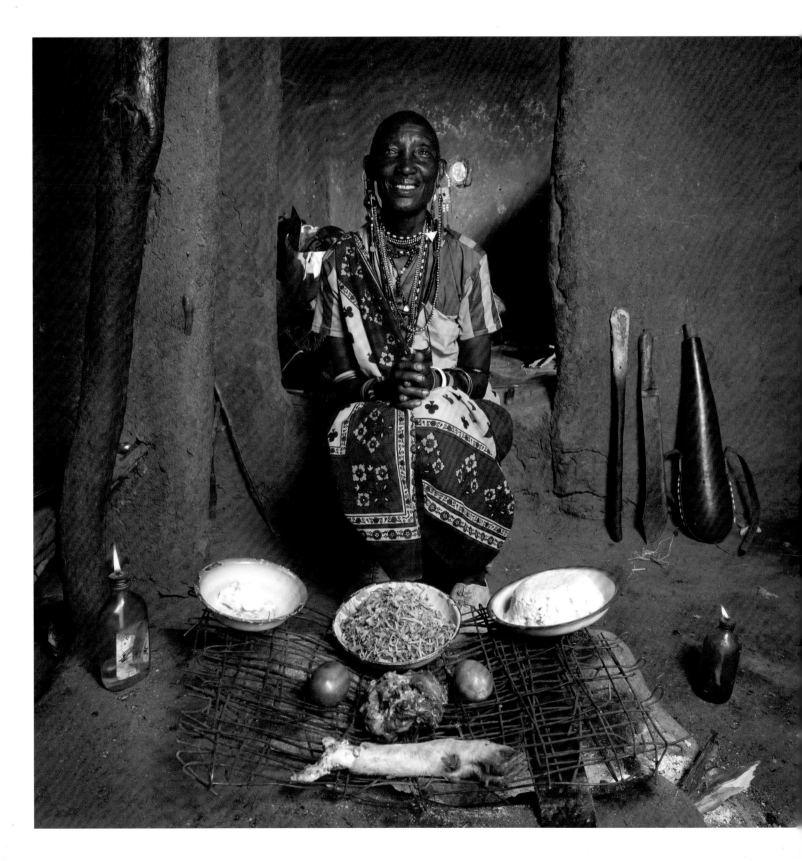

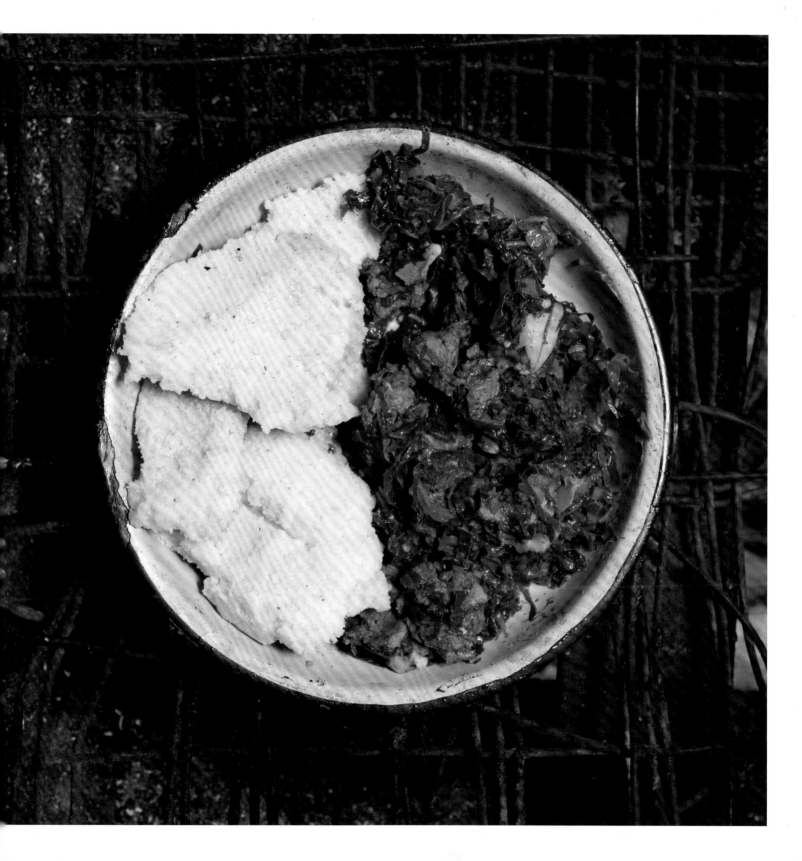

Normita Sambu Arap

65 YEARS OLD

Normita lives in a hut made of mud and straw in a Maasai village in the south of Kenya. Her kitchen is nothing more than a small cooking area on the ground made of four stones and a metal grill placed on top. She lights a fire every morning and keeps it going all day long. In her village there are 250 people and more than 500 animals, including cows, goats, and dogs. She is the ninth wife of the chief of the village and also the oldest woman in her community. Cooking, collecting water from the river, and gathering wood for the fire have always been her responsibility. She lives in the same village as her nineteen grown-up children and more than forty grandchildren. Basically, all the people in the village are considered family. Oltepessi is probably one of the hardest places to live that I have ever visited, but at the same time it is one of the most beautiful and the wildest. Every day I spotted elephants, giraffes, lions, zebras, and many other animals living freely in the fields surrounding the village.

Ugali (a sort of white corn polenta) is one of the most popular foods in Africa. In this area of Kenya, it is part of the everyday meal as a base for meat, vegetables, or fish.

Mboga and Ugali

White Corn Polenta with Vegetables and Goat

SERVES 4 TO 6

½ cup kosher salt

1½ pounds goat shoulder meat, cut into 1-inch pieces

1 leg of goat

1½ ounces beef fat/tallow/suet, finely chopped

2 large tomatoes, cubed

1½ to 2 pounds *sukuma wiki* (collard greens) or kale, cut into strips

Salt

2 cups white corn flour

1 Combine the kosher salt with 2 quarts of water in a large bowl. Put all of the meat into the bowl, cover with plastic wrap, and refrigerate for at least 4 hours. Remove the meat from the salted water, rinse lightly, and pat dry.

2 Place the beef fat in a large saucepan over low heat. When it melts, add the tomatoes and let cook for 8 to 10 minutes, until the tomatoes break down into a sauce.

3 Add the meat and about one-third of the sukuma wiki. Reduce the heat enough to maintain a slow simmer, cover the pan, and cook the meat for 1½ hours. Add the remaining sukuma wiki, cover, and cook for 1 hour more, or until the goat is tender. Season with salt.

4 Bring 1 to 2 teaspoons salt and 4 cups of water to a boil in a heavy-bottomed saucepan. Pour in the corn flour slowly, stirring constantly, smashing any lumps with a spoon, until the mush pulls away from the sides of the pan and becomes very thick. Remove from the heat and allow to cool somewhat.

5 When the meat and vegetables are cooked, place them on the same dish with the ugali, and serve.

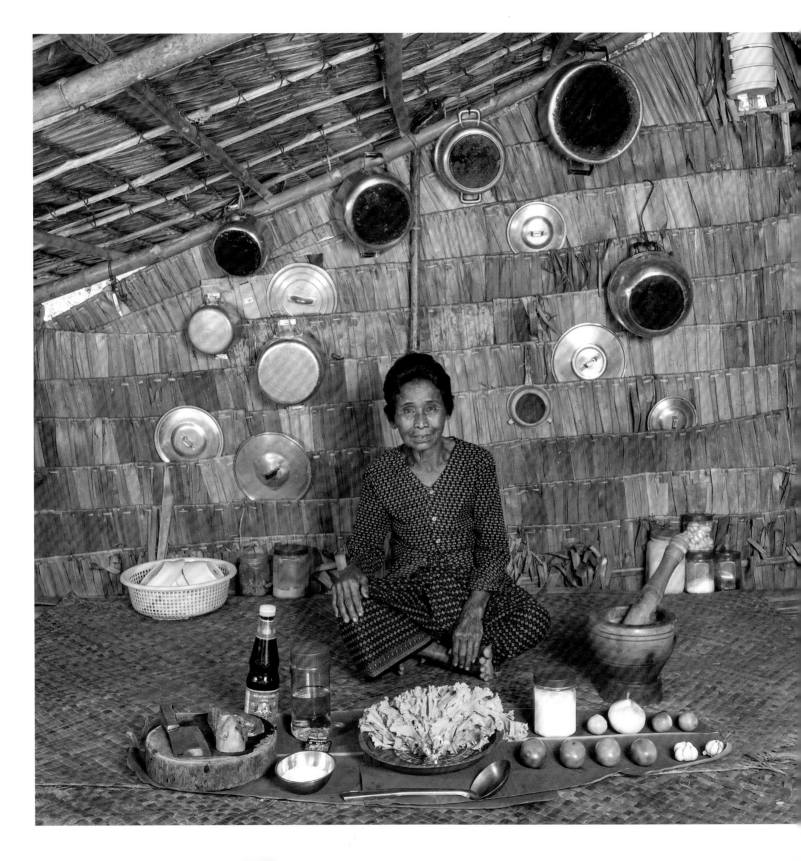

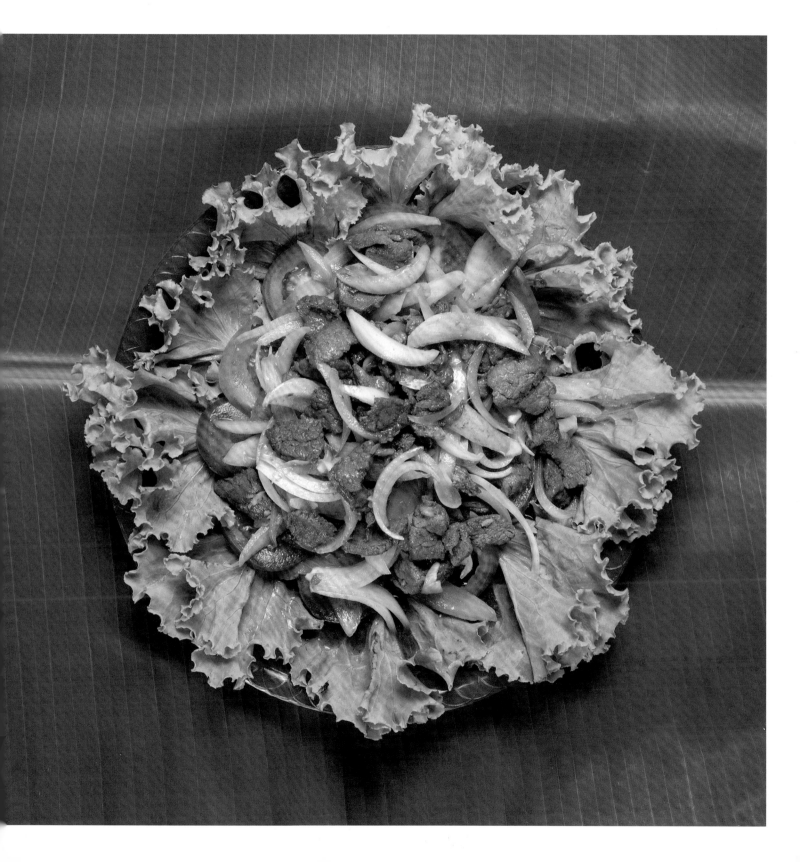

Gnep Tan

73 YEARS OLD

I didn't spend much time in Cambodia; I was just passing through and had only a few days and contacts at hand. When I arrived in the area of Angkor Wat to visit the temple, I asked the driver of the *tuk-tuk* who had brought me there for help in finding a granny for my project. He said, "Of course, I can find a granny. I can take you home if you want." Forty minutes later, after passing through at least twelve miles of jungle, we arrived at the house of his mother, Gnep. It was a house on piles, about six feet above the ground. "During the wet season, the level of the nearby lake rises at least three feet," she explained. Her house, or rather hut, is entirely made of intertwined pieces of wood and banana leaves. There are no windows or doors, no electricity or running water, but, despite all this, her house is perfectly tidy, and even under pouring rain not a drop gets inside.

Gnep has spent all her seventy-three years in this tiny fishing village. I tried more than once to ask her the number of her children and grandchildren, but she never gave me a precise number. She always answered, "A lot."

Lok Lak

SERVES 1

FOR THE MARINADE

½ teaspoon sugar

½ teaspoon salt

½ teaspoon freshly ground black pepper

1 teaspoon vegetable oil

1 tablespoon soy sauce

2 garlic cloves, minced

5 ounces beef sirloin, very thinly sliced

FOR THE CHILI SAUCE

½ teaspoon salt

½ teaspoon sugar

½ teaspoon freshly ground black pepper

½ teaspoon minced garlic (1 medium clove)

1 to 2 tablespoons vegetable oil

½ onion, sliced

A few lettuce leaves, for serving

½ tomato, thinly sliced, for serving

½ lime

1 Make the marinade: Combine the sugar, salt, pepper, oil, soy sauce, and garlic in a mixing bowl. Add the meat and coat thoroughly. Marinate for 30 to 60 minutes.

2 Make the chili sauce: Mix the salt, sugar, pepper, and garlic in a small bowl.

3 Heat the oil in a wok, then add the onion and sauté for 5 minutes. Add the marinated beef and stir-fry for about 3 minutes, or until cooked through.

4 Prepare a serving plate with a bed of lettuce and slices of tomato. Just before serving, squeeze the lime half over the chili sauce and stir lightly. Serve the meat on the lettuce with the chili sauce on top. (The meat is eaten wrapped in a lettuce leaf.)

For a little more punch, add the chili sauce to the marinade rather than when serving, and marinate for an extra 30 minutes.

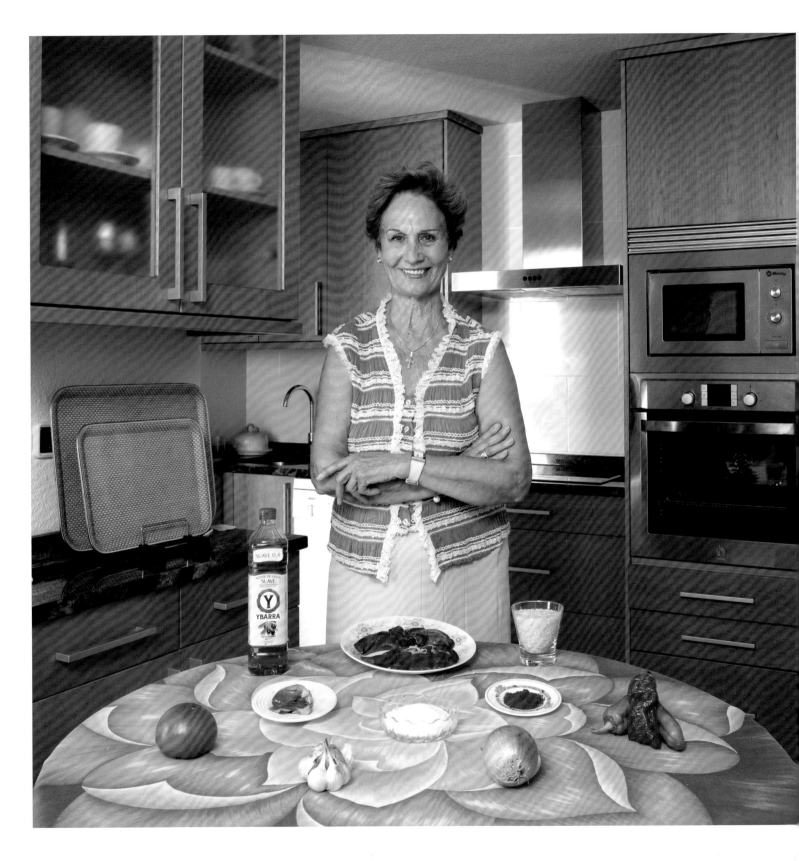

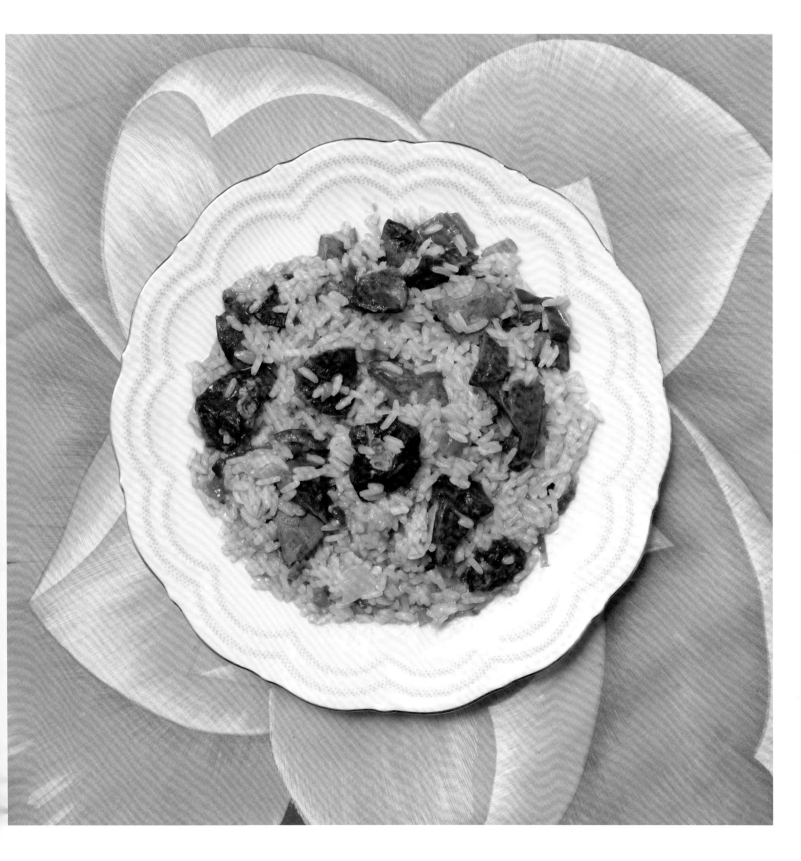

Carmina Fernandez

73 YEARS OLD

Carmina and her husband live in a large apartment on the fifth floor of a beautiful building in the city center—a great location for keeping their fridge stocked. "It's nice to buy your vegetables, bread, meat, and everything you need from the small shops in this area. You can establish a relationship with the owners; it's almost as if they are part of the family. They know our habits, our tastes, and often we do not even need to tell them what we want—they know it beforehand!" Carmina says. On the day I met her, she cooked *asadura de cordero lecca con arroz*, a sort of paella with lamb organs that is traditional in Cistierna, in northern Spain, which is where she grew up. I was very skeptical of this dish (disturbed by the idea of eating the lamb guts, in particular), but as I tasted it, all my biases faded away. Maybe the ingredients would scare some, but this typical dish from Madrid is very good!

Asadura de Cordero Lecca con Arroz

Milk-Fed Lamb Offal with Rice

SERVES 4 TO 6

¼ cup olive oil

2 milk-fed lamb hearts, 8 ounces lamb liver, and 8 ounces lamb lungs or kidneys, trimmed well and cut into 1-inch pieces

½ yellow onion, cut into ¾-inch pieces

½ green bell pepper, cut into ¾-inch pieces

½ red bell pepper, cut into ¾-inch pieces

½ large tomato, cut into ¾-inch pieces

½ cup dry white wine

1 teaspoon paprika

Salt

1½ cups long-grain rice

1 garlic clove, crushed

1 In a medium or large skillet with a lid, heat 3 tablespoons of the olive oil over medium-high heat. When the oil is hot, add the lamb hearts, liver, and lungs (or kidneys). Sauté the meat quickly, 3 to 4 minutes. Remove the meat to a plate and tent with foil to keep warm.

2 Reduce the heat to medium and heat the remaining 1 tablespoon olive oil in the same pan. Add the onion, green bell pepper, red bell pepper, and tomato and sauté until the onion is translucent and the peppers are tender, about 10 minutes. Add the white wine and paprika, season with salt, and simmer for 3 minutes, to cook off the alcohol.

3 Add the rice and 3 cups of hot water to the pan. Raise the heat to medium-high, bring to a boil, then reduce to a simmer, cover, and cook until the water is evaporated and the rice is tender, 15 to 18 minutes.

4 Just before serving, add the garlic to the pan and stir to combine. Remove the pan from the heat, return the meat to the pan, stir to combine, and allow everything to sit for 2 minutes to absorb the flavors. Serve the asadura in soup dishes or bowls.

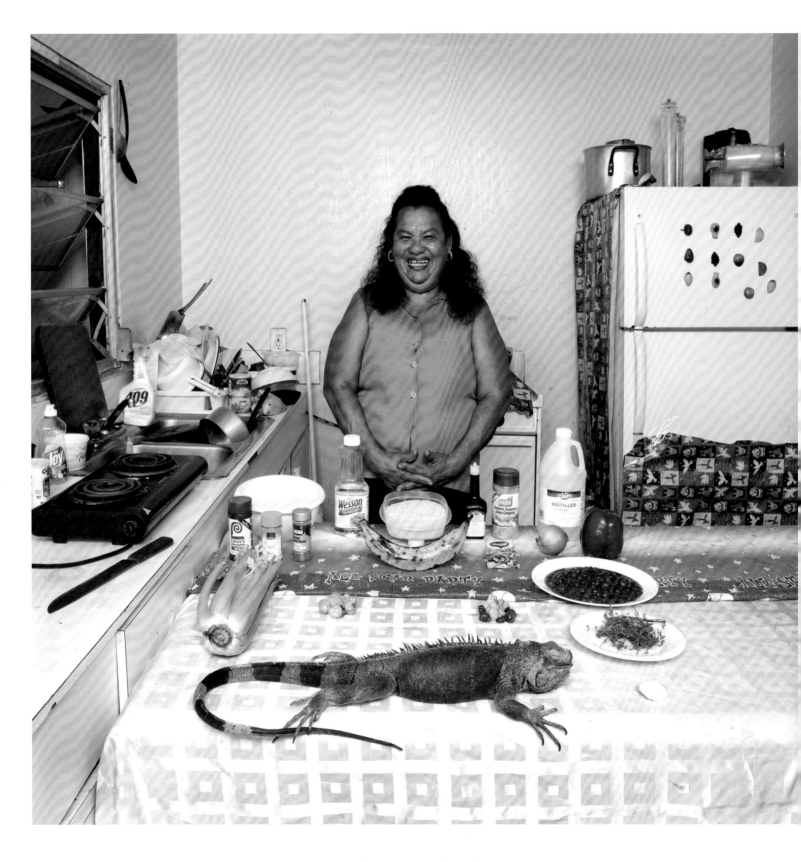

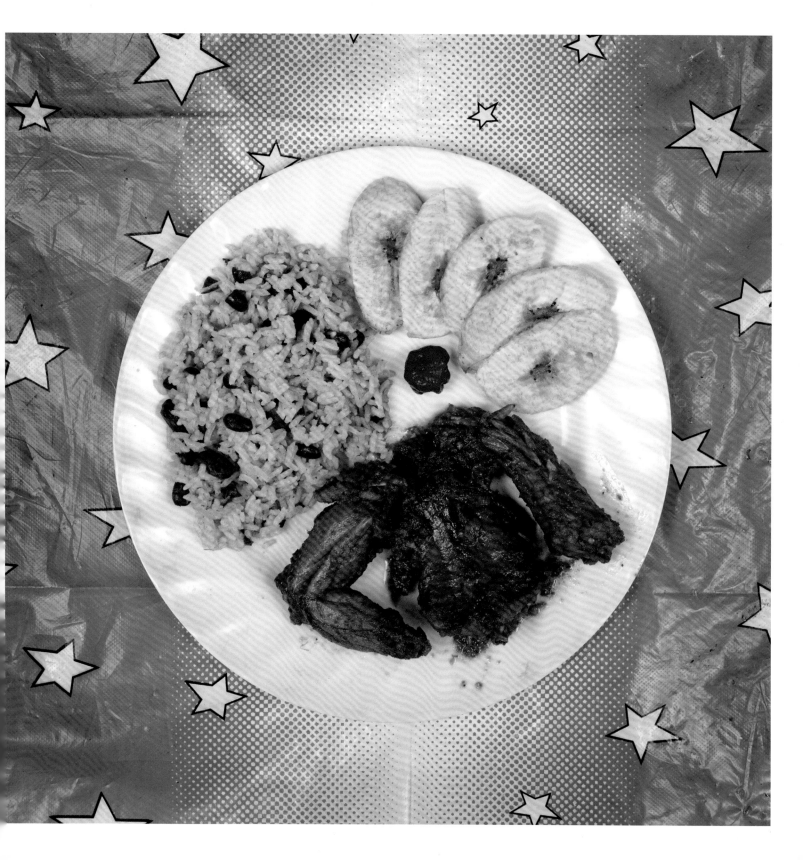

Maria Luz Fedric

53 YEARS OLD

Maria was born on a small Honduran island in the Caribbean Sea. She started working in restaurants when she was young, serving fried chicken to diners at a small café when she was only twelve. When she was sixteen, she went to work at a fish restaurant, and at the early age of twenty she decided to open her own business. "My restaurant was such a great success—one of the most popular in the whole area," she says. When she turned thirty, she met a man visiting from the Cayman Islands. They fell in love and married, so she closed her restaurant and moved with him to his "rich" island. She has been living as a housewife in George Town, in the Cayman Islands, ever since, but occasionally helps as a dishwasher in an Italian restaurant. She has two grown-up children and two young grandchildren, for whom she sometimes cooks one of the dishes of her place of origin: the Honduran iguana. (The most difficult step in preparing this dish is obviously to catch a fresh iguana—if you succeed in that, the rest of the recipe will be rather easy!)

Honduran Iguana with Rice and Beans

SERVES 4

1 fresh iguana (or one 2½- to 3-pound rabbit), cut into 8 pieces

50% distilled vinegar (for iguana only)

1 green bell pepper, chopped

1 onion, chopped

2 celery stalks, chopped

2 garlic cloves, minced

1 hot chili, minced

4 sweet chilies, minced

1 tablespoon Bragg liquid aminos seasoning or seasoning sauce of your choosing

Salt and freshly ground black pepper

2 tablespoons vegetable oil, plus more for frying

2 sprigs fresh thyme

4¼ cups coconut milk

1½ cups precooked red beans, or 1 (15-ounce) can, rinsed and drained

1½ cups long-grain rice

4 ripe plantains

1 If using rabbit, proceed to the third step.

2 Cut off the head; slit the iguana open down its belly, along its legs and tail; skin it completely; then remove the guts and wash the body cavity thoroughly with water. Cut the tail into bite-size pieces. Separate the legs from the body and cut the rest into 2 pieces.

3 Place the chunks of iguana meat in a bowl with some water and 50% distilled vinegar and let them soak for about 10 minutes. Wash again with water and dry.

4 Place all the vegetables, including the chilies, in one bowl, and the chunks of iguana or rabbit meat in another. Sprinkle the contents of each bowl with your favorite seasonings or spices. (I used 1 tablespoon of Bragg liquid aminos seasoning, and salt and pepper, for each.)

5 Heat the 2 tablespoons oil in a large, deep skillet with a lid over medium heat. When the oil is hot, add the seasoned vegetables and sauté them for 5 minutes. Add the meat and continue cooking for 15 minutes, or until nicely browned, turning the meat occasionally.

6 Add the thyme sprigs and cover the pan. Reduce the heat to low and let the meat and vegetables cook for 30 minutes. Then pour in 1¼ cups of the coconut milk, raise the heat to medium, and let simmer for 15 minutes more. Keep the meat and vegetables warm.

7 Meanwhile, in a large saucepan, combine the beans with the remaining 3 cups coconut milk. When the milk comes to a boil, add the rice and 1 teaspoon of salt. Cover and let the rice cook for 15 to 18 minutes. Remove from the heat and keep covered.

8 Peel the plantains and cut into ¼-inch-thick slices. Place ¼ inch of oil in a medium saucepan and heat until very hot, but not smoking. Gradually add the plantain slices and fry until golden brown, turning once. Carefully remove the plantains from the oil and drain on paper towels.

9 Serve the meat on a large platter with the gravy from the vegetables, the rice and beans, and the plantains on the side. Enjoy with an ice-cold beer.

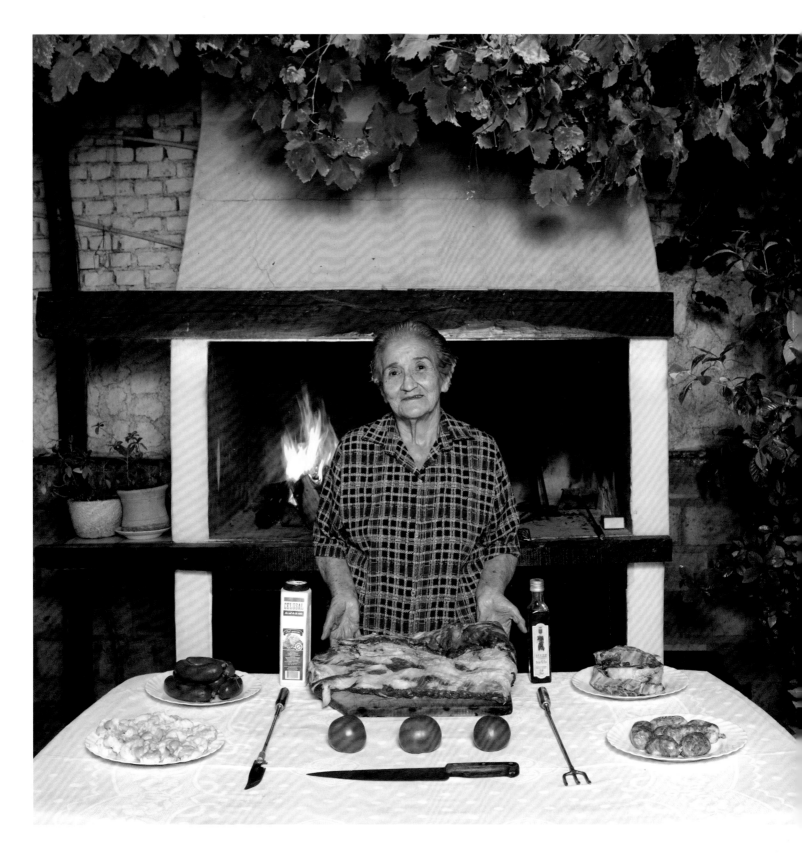

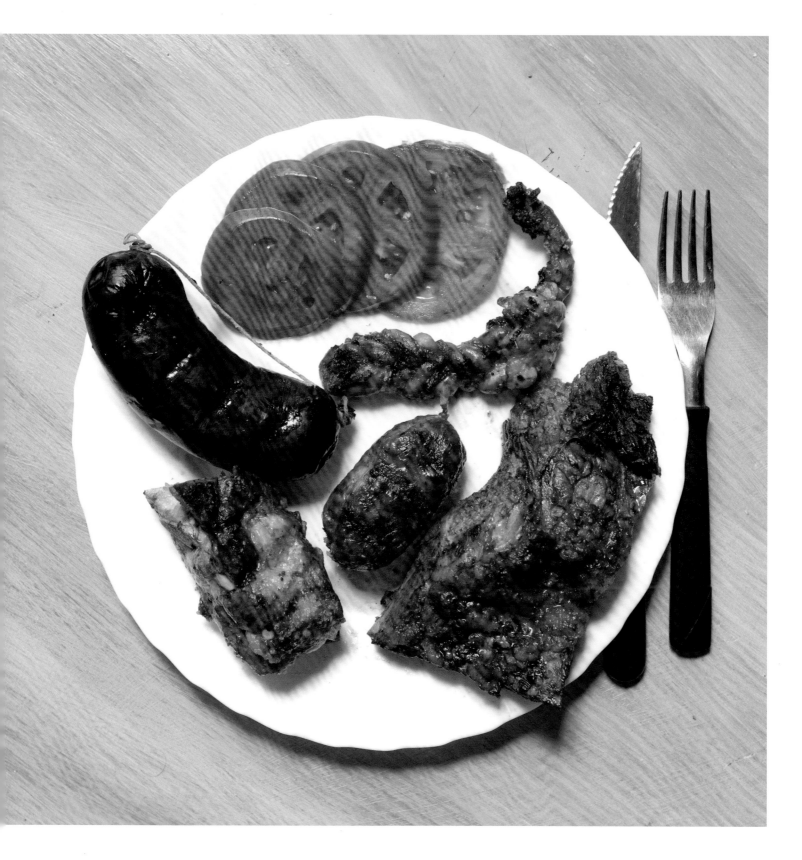

Isolina Pérez de Vargas

83 YEARS OLD

Isolina was born in Mendoza, at the foot of the Argentinian Andes, and was the fifth child in her family. When she was still very young, her parents divorced. Her mom kept the children with her, but, because she was poor, she eventually had to place them in foster care to five different families. Isolina married the wedding photographer of her town at the age of twenty-two and worked with him until five years ago, when he died. Now Isolina lives with one of her two children. Every Sunday the whole family gathers together at their house and she cooks meat for them. I met all of them—including her seven grandchildren and her two great-grandchildren—on a Sunday night when I was invited by one of her grandchildren, who hosted me in Mendoza. Before arriving there, I went to the market to buy some Italian wine to represent my country at the dinner table. What I didn't know is that Mendoza is the heart of very good Argentinian wine country and so my bottle wasn't a great success!

Asado Criollo

Mixed Meats Barbecue

SERVES 6

Canola oil

2 pounds *asado carnizero* (beef ribs)

1 pound *costillas* (pork spare ribs)

1 pound *chinchulin* (beef tripe)

Salt

6 *morsillas* (blood sausages)

6 chorizos (pork sausages)

2 plum tomatoes, sliced

1 Prepare your grill or cast-iron skillet by brushing with oil and heating to a low but constant heat, or prepare a good fire with hot embers. Season the beef ribs, pork ribs, and tripe with salt. Place the ribs and tripe, then the sausages, on the hot surface and let cook for about 1 hour (sometimes even more).

2 Serve the meat accompanied by the sliced tomatoes and good Argentinian wine.

This is a dish that many will make on a conventional charcoal or gas grill, adjusting the flame accordingly to cook slowly. You can make it however you like; what's key is that the meat be generously salted and cook slowly.

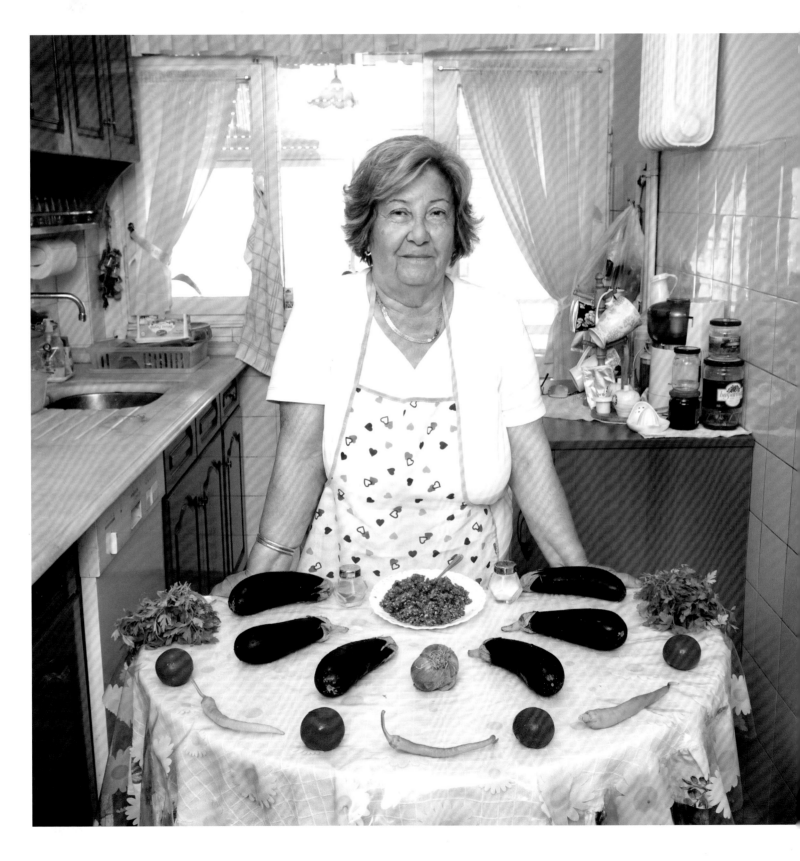

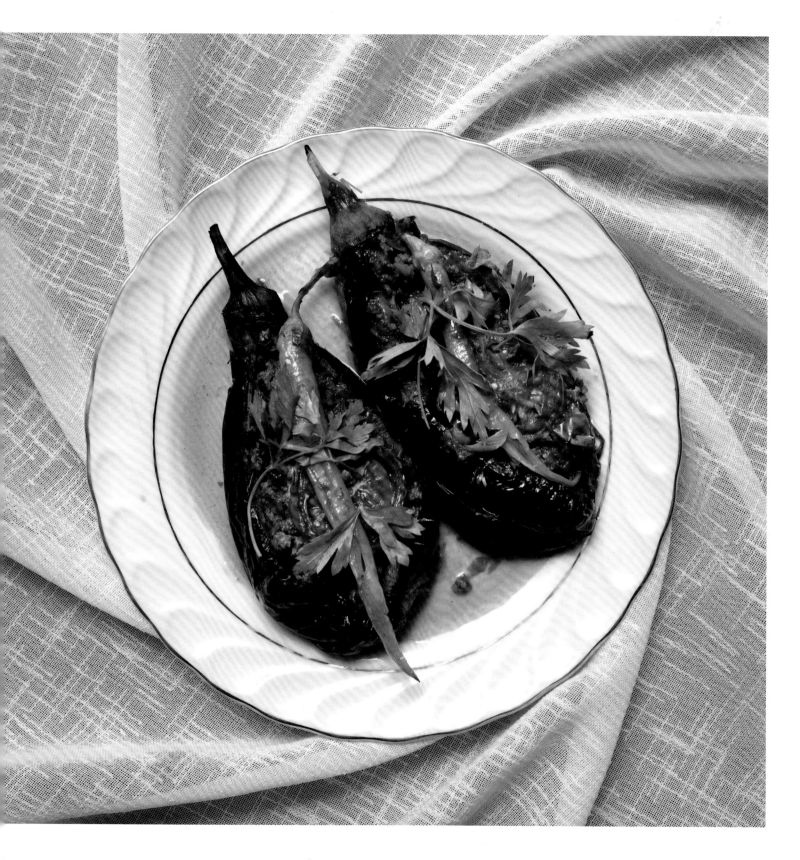

Ayten Okgu /

76 YEARS OLD

Ayten was born in Izmir, one of the most beautiful Turkish cities on the Mediterranean coast. "I loved growing up in Izmir, which has some of the best beaches in the world," she says. When she was about ten, she moved with her family to Austria, where she lived until she met her husband at the age of twenty, while traveling in Turkey. Her husband brought her back to her original land after their marriage and she has been living in Istanbul ever since, in a suburban and very quiet area in the Asiatic part of the city. She has two daughters and four grandchildren, two of whom are already eighteen. "Unfortunately, I don't see my older grandchildren so often. They live in the opposite part of the city and it takes me almost two hours to get there to visit them. They never come to this part of the city, since all the forms of entertainment are to the north of the Bosporus, on the European side," she says, looking forlorn. While I visited, she cooked me *karniyarik,* a typical Turkish dish, not one you might find in a restaurant, but a common home-cooked meal.

Karniyarik

Stuffed Eggplants with Meat and Vegetables

SERVES 4

4 medium eggplants

Salt

½ cup fresh flat-leaf parsley leaves

2 to 3 tablespoons vinegar

½ cup sunflower oil

1 tablespoon olive oil

1 onion, cut into small dice (about 1 cup)

3 small sweet green chilies, minced

1 pound ground beef

Freshly ground black pepper

4 tomatoes, 2 diced and 2 sliced

4 long green sweet chilies, for garnish (optional)

1 Peel the eggplants lengthwise in stripes of ¾ inch until only 50% of the total skin is left. Then, make vertical slits (but don't cut all the way through) in the peeled portions of the eggplant, in order to create openings for the stuffing. Sprinkle some salt inside and outside and let the eggplants sit for 15 to 20 minutes.

2 Wash the parsley in a bowl with water and the vinegar, then drain and chop it and set aside.

3 Pat the eggplants dry. Heat the sunflower oil in a large skillet. Add the eggplants and cook them on all sides until they are golden and softened, 10 to 12 minutes. Drain them on paper towels while you prepare the filling.

4 Heat the olive oil in a medium pan. Add the onion and chilies and sauté until golden. Then add the ground beef and season with salt and pepper. When the meat is no longer red, add half of the diced tomatoes. Cook over medium-low heat, covered, for 5 minutes. Uncover and continue cooking until all of the liquid is absorbed, 10 to 12 minutes. Remove from the heat, stir in the parsley, and set aside.

5 Preheat the oven to 350°F.

6 Using a spoon, create some space inside the opening of the eggplants for the filling. Stuff each with the mixture of vegetables and beef, patting firmly. Put the eggplants in a baking dish and top each with the sliced tomatoes and, if you like, a sweet green chili. Season with salt and pepper.

7 Pour ¾ to 1 cup of boiling water over the eggplants and top with the remaining diced tomatoes. Loosely cover with aluminum foil and bake for 20 minutes. Remove the foil and continue baking for 15 minutes, or until the filling is browned.

8 Serve the stuffed eggplants with the tomatoes and juice from the pan.

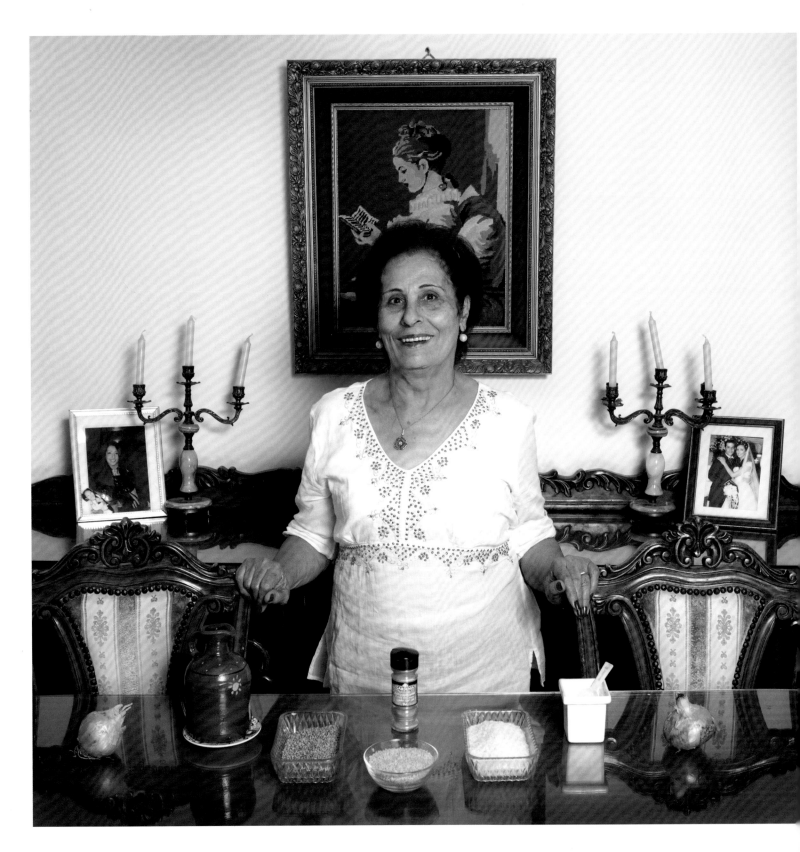

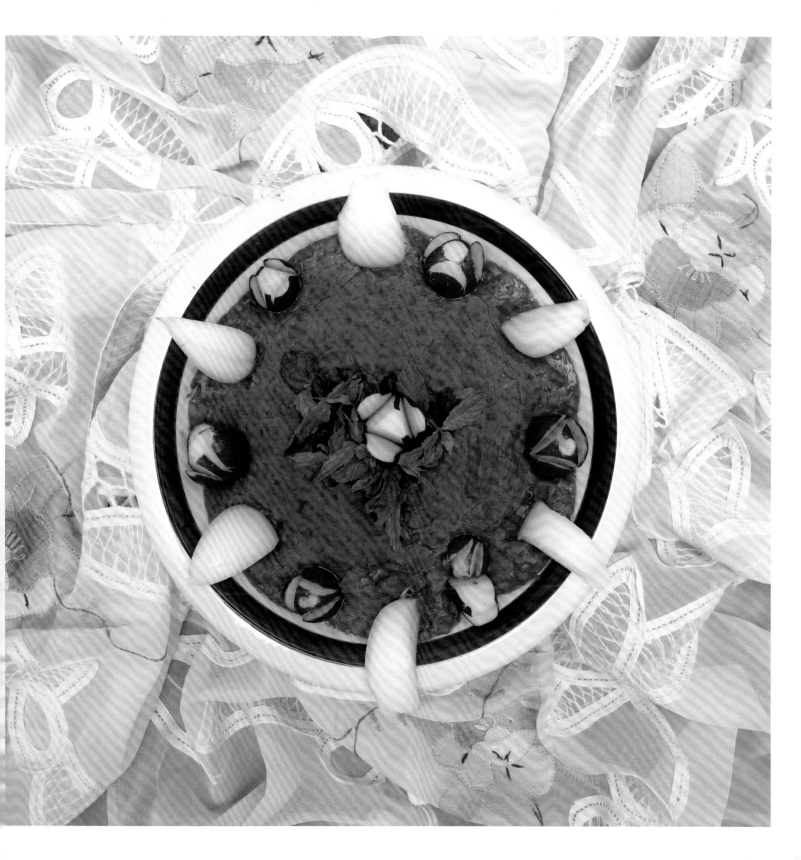

Wadad Achi /

66 YEARS OLD

"I am one hundred percent Lebanese." This is the first thing Wadad says in English when I ask her to tell me something about her life. She grew up in the north of Beirut, the Christian area. Now Wadad lives in the city center, a few steps from the sea and the biggest mosque in the city. Her two daughters are thirty and twenty-five years old, and she has two grandchildren. "My grandchildren are young and luckily they haven't experienced the war, but I'm worried that they are growing up here, where sooner or later a new conflict might break out," she says. I met Wadad at her house on a sunny afternoon. She warned me that she was not a good cook, at which point her husband stroked his large belly and said, "Gabriele, don't believe her; she's a big liar!"

Mujadara is the typical Friday dish in the Christian Lebanese communities, because it is vegetarian. There are different ways of preparing it; the uniqueness of Wadad's recipe is that at the end of the preparation, she adds some red radishes to decorate the dish. She says the taste of the radishes enhances that of the lentils.

Mujadara

Rice and Lentils

SERVES 4

1 cup dried brown or green lentils

3 to 4 tablespoons olive oil

2 yellow onions, finely chopped

1 cup long-grain rice

½ cup bulgur (cracked wheat)

Salt and freshly ground black pepper

Sliced onions, sliced radishes, and chopped mint, for garnish

1 Place the lentils in a medium saucepan and add water just to cover. The lentils should absorb all the water, so add more if needed while cooking. Bring to a boil, then reduce the heat to medium-low and simmer for 25 to 30 minutes, until the lentils are very tender.

2 While the lentils are cooking, heat the olive oil in a medium-size skillet. Fry the onions over medium-high heat until they have browned and are crispy, about 10 minutes.

3 When the lentils are tender and have absorbed all of the water, remove them from the heat and let cool slightly. Place them in a food processor or blender and puree them. Place the puree in a saucepan, add 3 cups of water, and bring the liquid to a boil. Add the rice and the bulgur, and season with salt and pepper. Reduce the heat to a simmer, stirring frequently. (It may be necessary to add more water if all of the liquid has been absorbed before the rice is tender.) After about 15 minutes, or 5 minutes before the rice is ready, add the fried onions.

4 When the rice is tender, serve the mujadara in soup dishes, garnished with onions, red radishes, and mint.

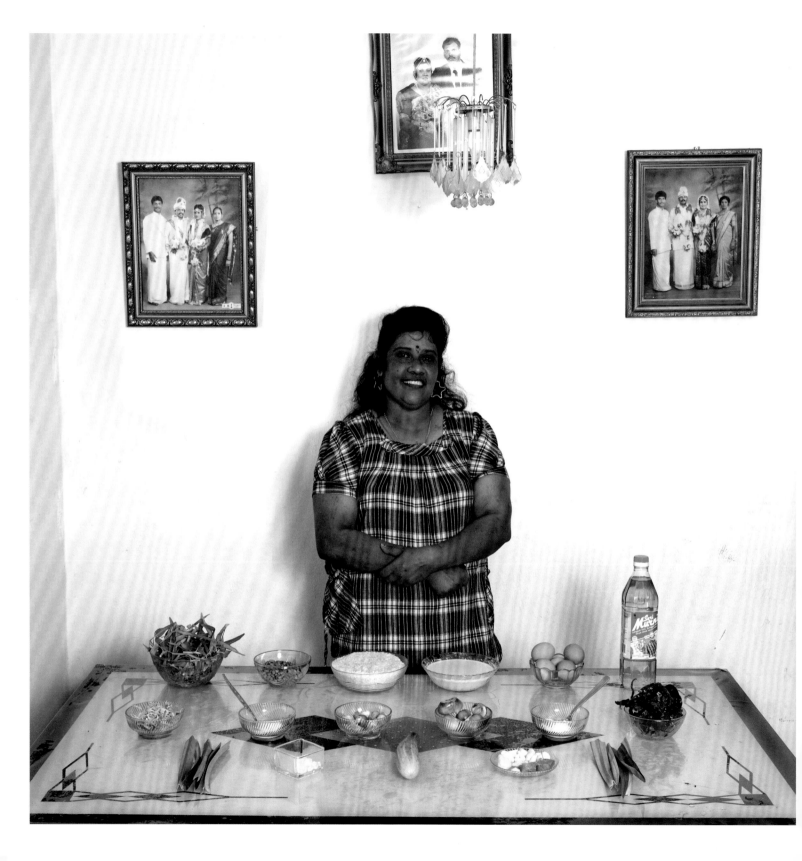

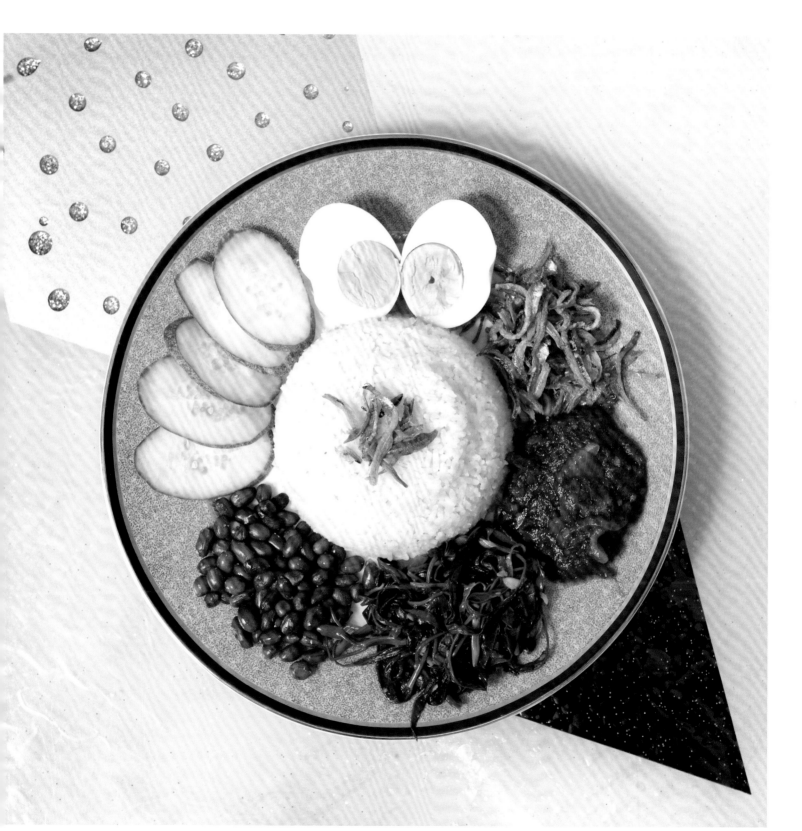

Thilaga Vadhi

55 YEARS OLD

On a wall in her kitchen, three photos of Thilaga's parents and relatives in their traditional Malaysian costumes keep her company while she cooks delicious dishes for her husband and her two children, which is at least twice a day. "My men work almost all day long. Lunch and dinner are the only moments we can spend together, and I am happy when I see them leaving the table satisfied with what they have eaten. That's the reason I love cooking for them," she says, smiling. I met Thilaga and her family on a nice evening at the end of March. They live in a big apartment on the seventh floor of a huge building in the south part of the city. (I almost got lost in the building because there were so many corridors and more than two hundred doors.) They were all waiting for me with a fantastic hot tea on the table. We chatted for more than an hour before I started cooking with Thilaga. The best thing that I learned from her is how to make good coconut rice, which is something that I really love! *Nasi lemak* is a traditional Malaysian dish that is served for breakfast, lunch, and dinner in restaurants, but it isn't difficult to prepare at home.

Nasi Lemak

Coconut Rice with Vegetables and Fried Dried Anchovies

SERVES 4 TO 6

FOR THE SPICE PASTE AND SHRIMP PASTE

15 dried red chilies, soaked in water

15 small red Asian shallots (or 5 regular shallots)

2 onions, finely chopped

7 garlic cloves, 5 roughly chopped and 2 minced

1 (1-inch) piece of fresh ginger, peeled and roughly chopped

¼ cup palm or vegetable oil

2 teaspoons dried shrimp paste

1 teaspoon salt

2 tablespoons granulated sugar

FOR THE RICE

2 cups jasmine rice

1 cup coconut milk

12 cubes rock sugar

3 pandan leaves (screwpine leaves), tied together in a knot

TO SERVE

3 tablespoons palm or vegetable oil

1 cup dried anchovies

1 pound spinach, roughly chopped

1 cup peanuts

Salt

4 hard-boiled eggs

1 medium cucumber

1 Make the spice and shrimp pastes: Combine the drained chilies, shallots, half of the onions, the 5 chopped garlic cloves, the ginger, and 1 tablespoon of the oil in a blender or food processor. Blend everything until you get a smooth paste. Place the shrimp paste and the 2 minced garlic cloves in a mortar and crush until smooth.

2 Heat the remaining 3 tablespoons oil in a medium skillet over low heat. Add the spice and shrimp pastes, stirring well to combine. Add the salt and simmer for 10 minutes, stirring occasionally. Then add the remaining chopped onions and the granulated sugar. Continue simmering for 10 more minutes.

3 Make the rice: Wash the rice in cold water and drain. In a medium pot, combine the rice with the coconut milk, rock sugar, and 2 cups of water, and stir to combine. Add the pandan leaves and bring to a boil. Cover the pot, reduce the heat to low, and cook for 18 to 20 minutes, until the rice is tender and the liquid has been absorbed. (If you have a rice cooker, you can achieve a better result.)

4 To serve: In a small skillet, heat 1 tablespoon of the oil over medium heat. Fry the dried anchovies until they are crisp. Drain on paper towels and set aside.

5 In a medium skillet, heat 1½ tablespoons of the oil. Add the spinach and cook until wilted, about 3 minutes. Set aside.

6 Lastly, heat the remaining 1½ teaspoons oil in a skillet. Add the peanuts and salt to taste. When the peanuts are well toasted, remove from the heat and drain on a paper towel to cool.

7 At this point, the rice should be cooked and the spice-shrimp paste should be ready. Cut the eggs in half, slice the cucumber, and place all of the ingredients on a dish, as shown in the photo.

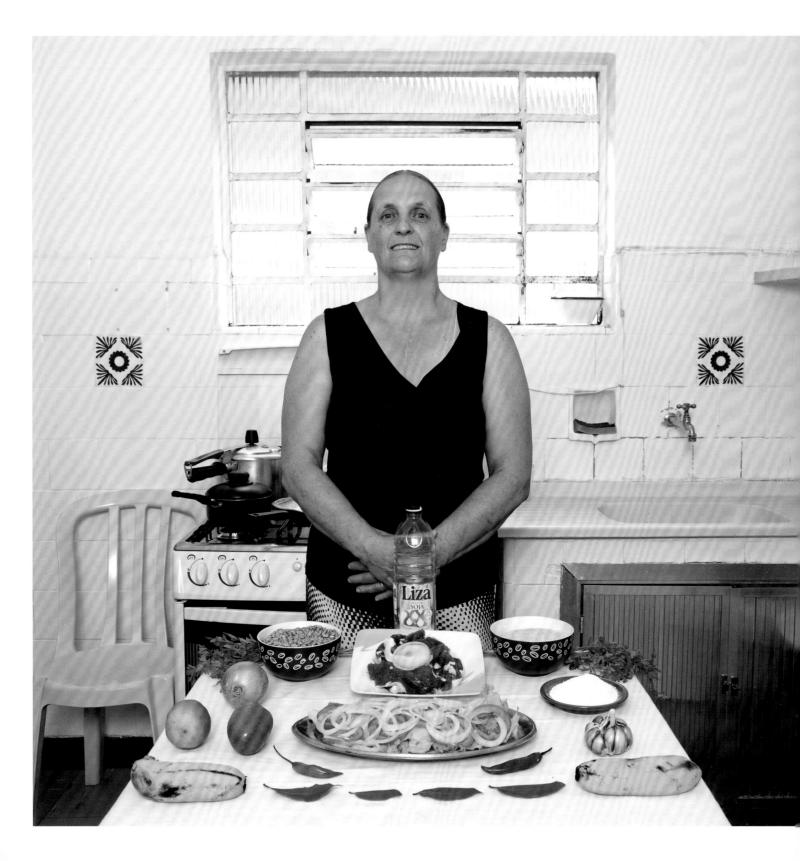

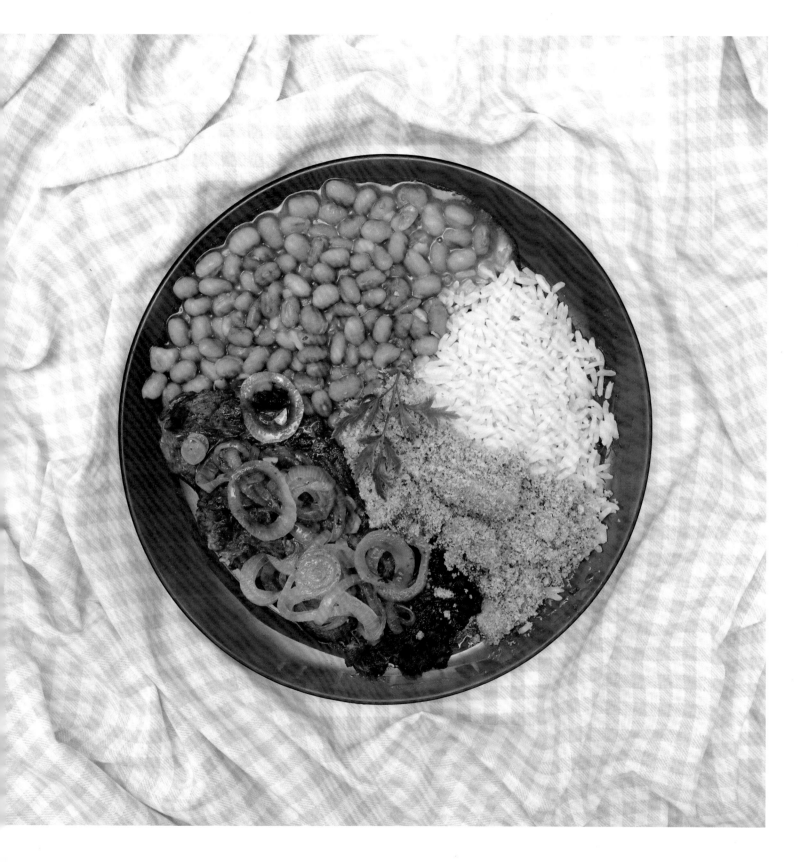

Ivonete Tortoretti Correa

64 YEARS OLD

Ivonete spent the first twenty years of her life in the Mooca quarter (the Italian district) of São Paulo, Brazil. She grew up walking in her pointe shoes, perfecting her pirouettes and pliés, and would always wear her tutu. Ivonete was a great classical ballet dancer and danced professionally in the main theater in São Paulo. When she turned twenty-two, she fell madly in love and married, and she had children soon after. It was then that she decided to stop dancing and devote herself to her family. "Everybody asks me if I have ever regretted this choice, but I always answer, 'No.' Being able to follow my children first and my grandchildren later has been the best ballet I could have seen. I now teach dancing to one of my grandchildren and I'm sure she'll become a better dancer than I was."

This recipe is one of the most common dishes in Brazil; indeed it is called *comida de todo día* (meaning "everyday food").

Comida de Todo Día

Rice, Farofa, Beans, and Meat

SERVES 4

2 cups dried pinto beans, soaked overnight

4 bay leaves

Salt

½ cup plus 3 tablespoons olive oil

7 garlic cloves, chopped (about 3½ tablespoons)

3 onions, 2 chopped (about 2½ cups) and 1 thinly sliced

Freshly ground black pepper

1½ cups long-grain rice

2 hot chilies, finely chopped

½ cup curly-leaf parsley, finely chopped

4 tablespoons (½ stick) unsalted butter

1¼ cups manioc flour

2 small bananas, peeled and chopped

1 pound sliced sirloin or skirt steak

1 Drain and rinse the soaked pinto beans well and place them in a large pot with fresh water to cover, with the bay leaves and 1 tablespoon salt. Bring to a boil, then lower the heat and simmer for 1 hour to 1 hour and 30 minutes, until the beans are tender. Allow the beans to cool in the liquid and do not drain. (You will use some of the cooking liquid.)

2 In a large pan, heat the 3 tablespoons olive oil and sauté 1½ teaspoons of the garlic and half of the chopped onions. When the onions become golden, drain the beans, reserving about ½ cup of the bean cooking liquid, and add to the onions along with the reserved cooking liquid. Stir to combine, season with salt and pepper, and set aside to keep warm.

3 In a medium skillet, heat 2 tablespoons of the olive oil over low heat, add half of the remaining garlic, and sauté until the garlic starts to turn golden brown. Add the rice, stirring until well coated. Gradually add 3 cups of hot water, ¼ cup at a time, stirring and allowing the rice to absorb the liquid before adding more (as if you were preparing a risotto). Season with salt and pepper. Cook until the rice is tender and the texture you like.

4 **Make the farofa:** In a large pan, heat 3 tablespoons of the olive oil and add the remaining chopped garlic, the remaining chopped onions, the chilies, and the parsley. Sauté until the onions are softened, about 5 minutes. Add the butter and when it melts, stir in the manioc flour. Let the farofa cook for about 5 minutes, then add the bananas. Cook for 3 more minutes.

5 Heat 1½ tablespoons of the olive oil in a skillet over medium-high heat. Season the meat with salt and add it to the pan. When the meat is cooked to your liking, remove from the pan to a warm plate.

6 In the same pan over medium-high heat, add the remaining 1½ tablespoons olive oil and sauté the sliced onion until crisp and brown. Sprinkle the crispy onion on top of the meat. Arrange the beans, rice, and farofa on the plate with the meat and serve.

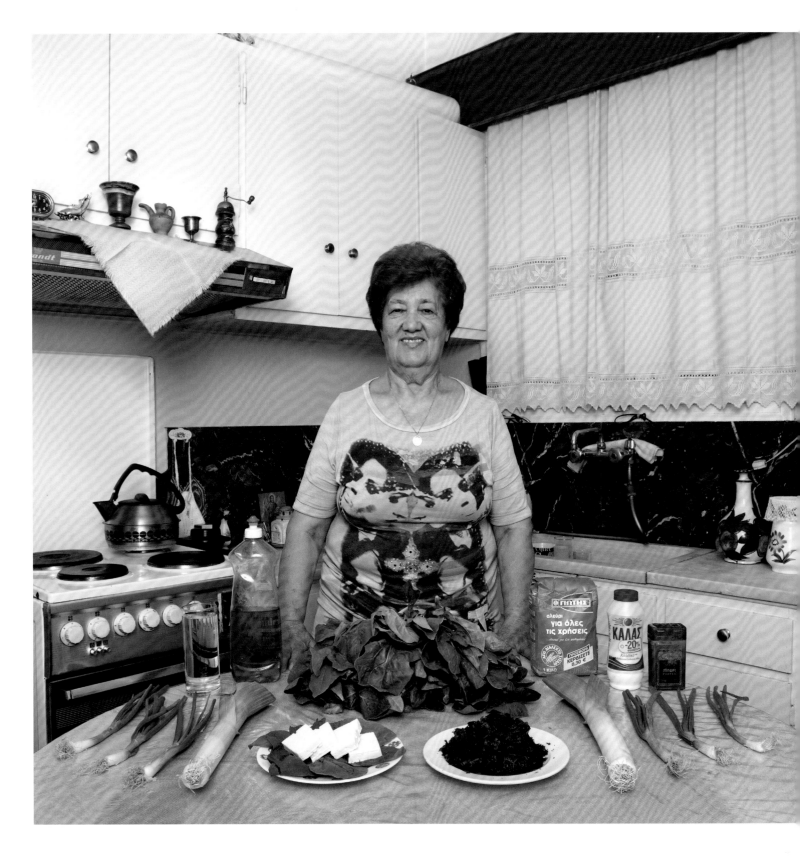

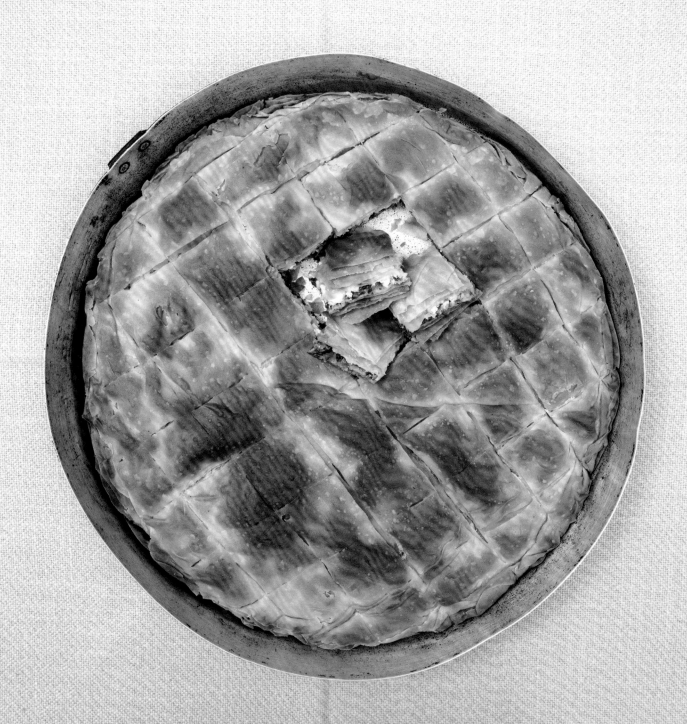

Foula Tsiora

67 YEARS OLD

Foula grew up in Kavala, a small town in northern Greece. When she turned eighteen, she moved to Athens to help her sister, who had been injured at work. Foula never left the capital city, and in 1974 she met a man who soon became her fiancé. On October 28, 1975, he proposed to her, and Foula said yes. "The twenty-eighth of October is a special day in Greece," she says. "We call it 'No Day.' On that day we celebrate when the Greek people said 'no' to dictatorship. But on that day, instead of following tradition, I said 'yes.' It was the best choice of my life." Foula claimed she is not a good cook, explaining that, having left home at eighteen, she was not taught properly by her mother. However, I must disagree: I tasted her *spanako-tiropita* and it was delicious!

Spanako-Tiropita

Spinach and Cheese Pie

MAKES 1 PIE (ENOUGH FOR 8 PEOPLE)

FOR THE FILO DOUGH

2½ cups all-purpose flour

Pinch of salt

2 tablespoons olive oil

FOR THE FILLING

6 green onions, finely chopped

2 leeks, finely chopped

2 tablespoons olive oil, plus more for assembling the pie

1 pound spinach

1½ pounds fresh or frozen nettles (or double the spinach for a total of 2 pounds)

½ cup chopped fresh dill

1 pound feta cheese, crumbled

2 eggs, lightly beaten

Salt and freshly ground black pepper

For rolling out the filo, use the thinnest rolling pin possible (a ¾-inch dowel is perfect). Roll out each piece of dough as thin as you can. For the traditional method of rolling filo, see Step 3 on page 31. If you are using premade filo dough, you will need a 1-pound package of #10 (country-style) filo dough.

1 **Make the filo dough (or use pre-made filo and skip this step):** In a large bowl, mix the flour, salt, olive oil, and ⅓ cup of warm water, turning the mixture with your fingers. Continue adding 2 more tablespoons of warm water a little at a time, combining well, until you've picked up all of the flour from the sides of the bowl. Turn the dough out onto a lightly floured work surface and knead for 10 to 15 minutes. You want a dough that is well combined and soft, but not sticky or soggy. Cover and let the dough rest for 15 minutes.

2 **Make the filling:** Place the onions and leeks in a large pot and sauté them in their own juices on low heat, stirring frequently. Once the onions start sweating, add the olive oil, along with the spinach and the nettles. Cook until the greens are wilted. Remove the pot from the heat and transfer the greens to a colander; allow to cool a bit. When the greens are cool enough to handle, finely chop them and squeeze out all the remaining liquid. Place in a large bowl and add the dill, feta, and beaten eggs. Mix well to combine, season with salt and pepper, and set aside.

3 Preheat the oven to 400°F, with a rack in the lower-third position.

4 **Open the filo:** Divide the dough into 10 equal pieces. Roll out 1 piece to a rough round shape, sprinkling the work surface and filo with flour or cornstarch to keep the dough from sticking. Roll the filo out into a round shape by decreasing the thickness with a rolling pin. Once you have a round that is the thickness of thick paper and approximately 12 inches in diameter, place the first sheet of filo in the bottom of a well-oiled round baking tray, about 10 inches in diameter, to take up the entire surface of the tray. Once in place, sprinkle with olive oil and spread the oil all over the filo with a soft brush. Repeat these steps with 4 sheets of the remaining dough. Then place the spinach mixture on the filo and spread evenly. Now cover with the remaining 5 sheets of filo, one by one, sprinkling and brushing with oil, as done for the bottom layers of the filo. Once the last layer of filo has been brushed with oil, lightly score through the top layers of dough only to mark out 8 serving-size pieces.

5 Bake for 50 to 55 minutes. Allow the pie to sit for a few minutes before serving.

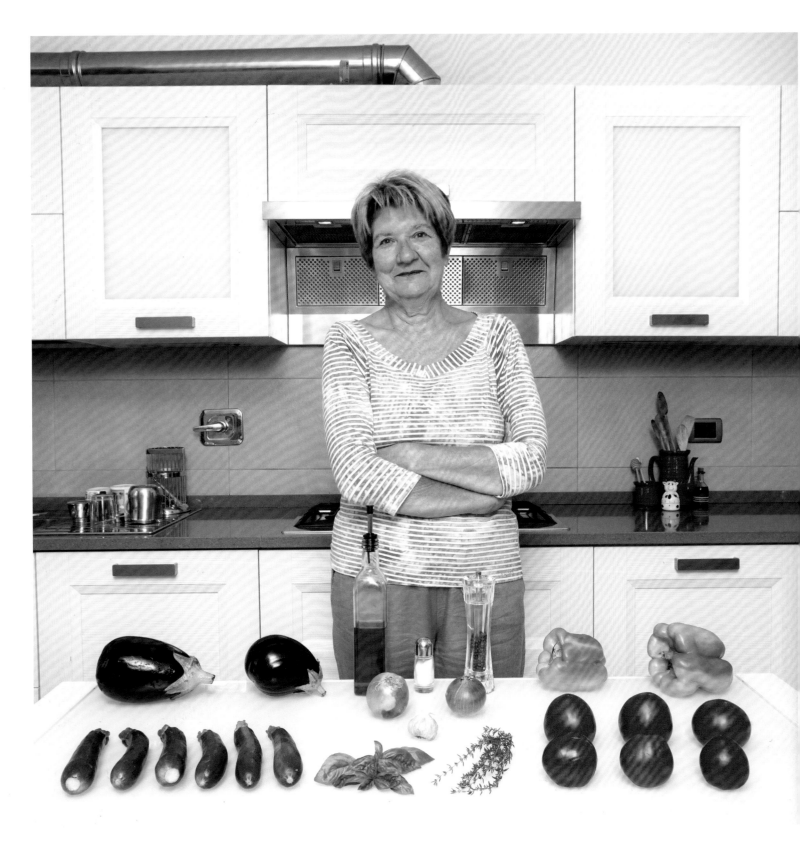

Anne-Marie Malfatto

65 YEARS OLD

Anne-Marie and her Italian husband had lunch waiting for me at their small villa built on the mountain side of Nice, one of the highest quarters of the city. From the living room window I looked out onto the seaside, which filtered through the top of the pine trees. "I grew up here, among the narrow streets of this city, playing petanque with my friends. When I was young, I enjoyed helping Mom in the kitchen and that's how I learned most of what I can cook now. Indeed, cooking is my greatest passion, along with traveling, which I do every year with my husband," she says, smiling. Anne-Marie has a thirty-six-year-old son and two young grandchildren, a boy and a girl. "My son lives with his family on the ground floor. It makes me happy, because I can see them every day and I can often spoil them with my cooking."

Anne-Marie suggests preparing the ratatouille the day before you want to eat it, so that the vegetables will be blended together and their taste will be enhanced.

Ratatouille

SERVES 4 TO 6

4 large ripe tomatoes

½ cup olive oil

4 garlic cloves, 3 whole and 1 minced

1 yellow (or green) bell pepper, sliced

1 large eggplant, cut into ¾-inch
 cubes

3 zucchini, cut into ¾-inch cubes

1 onion, cut into thin rings

Salt and freshly ground black pepper

1 teaspoon chopped fresh thyme

½ cup chopped fresh basil

1 Cut an X in the skin on the bottom of each tomato. Bring some water to a boil in a medium saucepan. Add the tomatoes to the water and cook for 30 seconds. Remove them with a slotted spoon and when cool enough to handle, peel them completely. Cut the tomatoes in half, remove the seeds, and dice the flesh.

2 Set 3 medium pans on the stove. Put 2 tablespoons of the olive oil and 1 garlic clove in each pan. Sauté the garlic over medium heat for 2 minutes, then add the bell pepper to the first pan, the eggplant to the second pan, and the zucchini to the third pan. Cover the eggplant and zucchini. The vegetables will give off their liquid as they cook, which will help them to begin to soften. Uncover and continue cooking until the liquid has cooked off. Each of the vegetables will need to cook for a different time, so check and stir them frequently until they are cooked to your liking. Once finished, remove each pan from the heat and set aside.

3 To make the sauce, heat the remaining 2 tablespoons olive oil in a small pot. Add the onion and cook until browned. One minute before the onion's frying is completed, add the minced garlic clove. Add the diced tomatoes and let everything cook for about 30 minutes. Season with salt and pepper, then add the thyme and basil. If the sauce has too much liquid after 30 minutes, continue to cook until it thickens.

4 Combine the cooked vegetables in 1 large skillet. Add the tomato sauce and stir well to combine. Cook for 10 minutes over medium-low heat and serve.

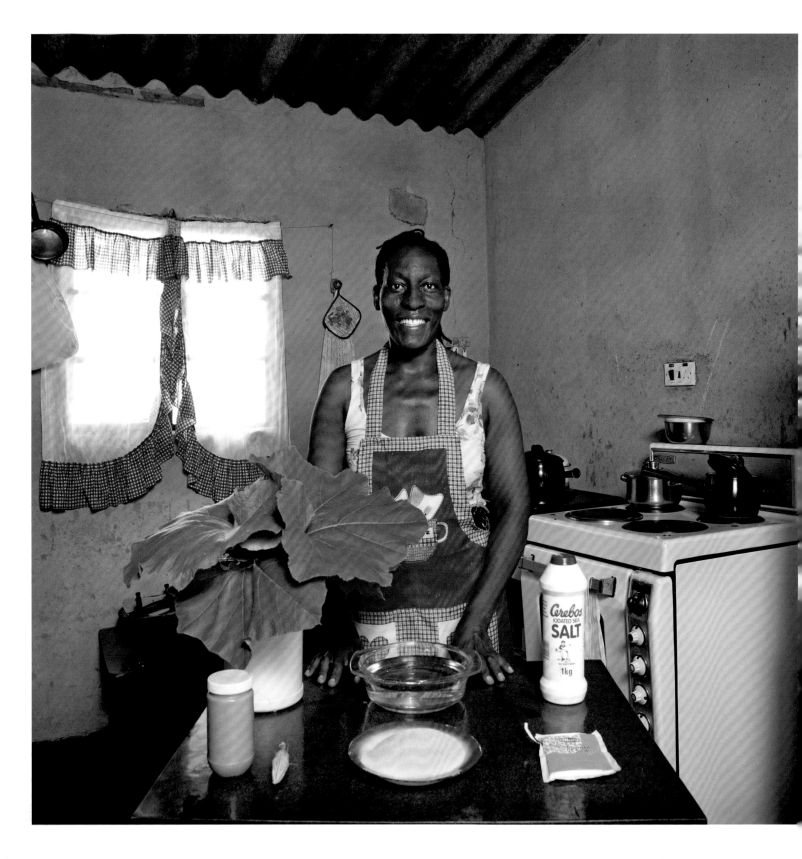

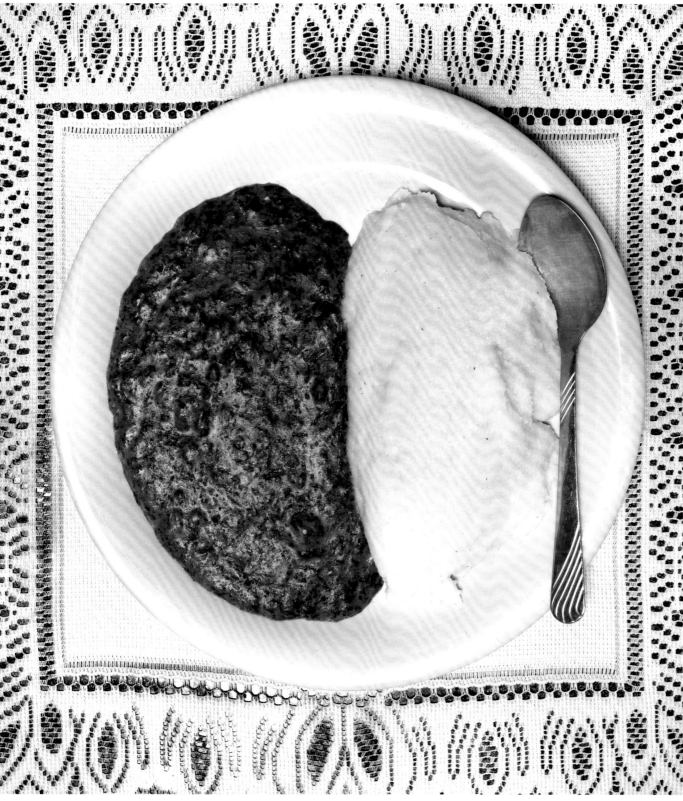

Flatar Ncube

52 YEARS OLD

Flatar has lived all her life in one of the most touristy areas in Africa. Victoria Falls is very close to her house, and so a few years ago she came up with the idea to transform her living room into a small restaurant for tourists. The sign on the street in front of her house reads: "Home Restaurant, Typical Food." Flatar cooks two or three different dishes a day, always using vegetables from her garden or locally raised meat, and a meal never costs more than five dollars. She lives with her husband, with whom she has three sons. She became a grandma eight years ago and since then her three grandchildren have spent almost every day at her house, and have even played with the children of the tourists that visit for lunch or dinner.

I tried one of Flatar's easiest recipes for one of the most popular Zimbabwean dishes: *sadza*. In Zimbabwe and in its neighboring areas of Africa, almost every dish is characterized by the presence of sadza, a kind of polenta made with white maize flour. You can serve it with vegetables, meat, and fish. To be honest, I was skeptical about trying this recipe, but I changed my mind once I discovered how great it tastes.

Sadza

White Maize Flour and Pumpkin Leaves Cooked in Peanut Butter

SERVES 4

2 tablespoons baking soda

16 pumpkin leaves, or 1 pound collard greens or turnip greens

¼ cup peanut butter

4 pumpkin flowers or zucchini blossoms

Salt

2 cups white corn flour

1 Bring a large pot of water to a boil with the baking soda.

2 Cut the pumpkin leaves into thin strips, stalks included. (If using pumpkin leaves, first remove the fibers by pulling out the little veins on the leaves and on the stalks.) Boil the leaves for about 5 minutes. Drain and let cool slightly.

3 Combine the peanut butter, pumpkin leaves and flowers, and a pinch of salt in a medium sauté pan. Cook for about 3 minutes over medium heat, stirring continuously. Remove from the heat and set aside.

4 Make the sadza: Bring 4¼ cups of water to a boil. Place the white corn flour in a medium saucepan and slowly add the boiling water, stirring constantly. Cook over low heat for a few minutes, stirring constantly and working the sadza up the sides of the pan to remove all of the lumps. If you think that the sadza is getting too solid, pour in some more water or, vice versa, if it is too wet, add some more flour. Serve the dish alongside the vegetable mixture immediately, as the sadza gets very stiff if it sits.

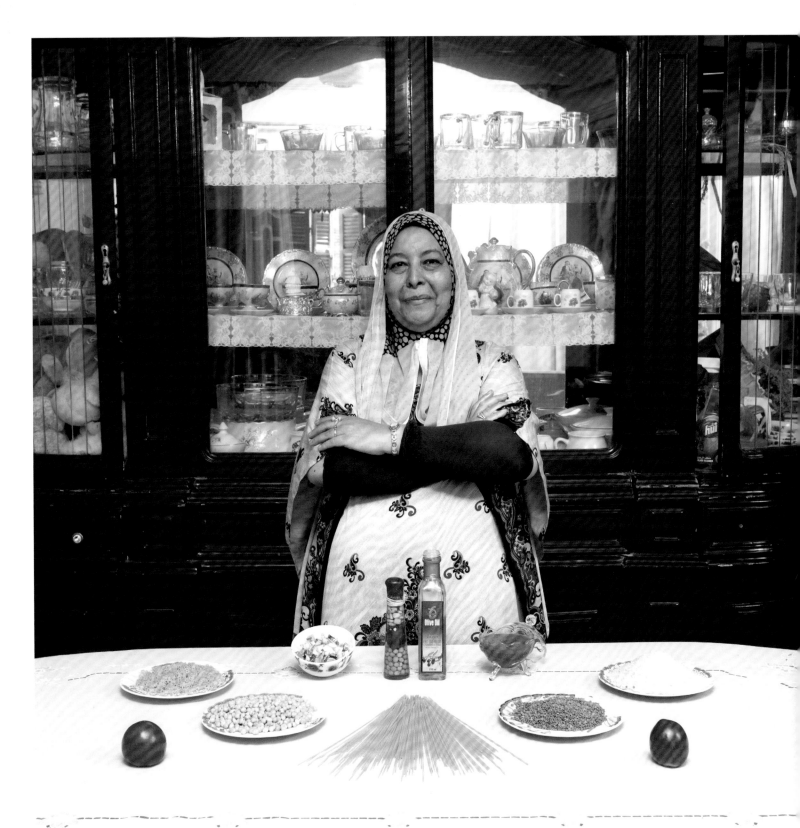

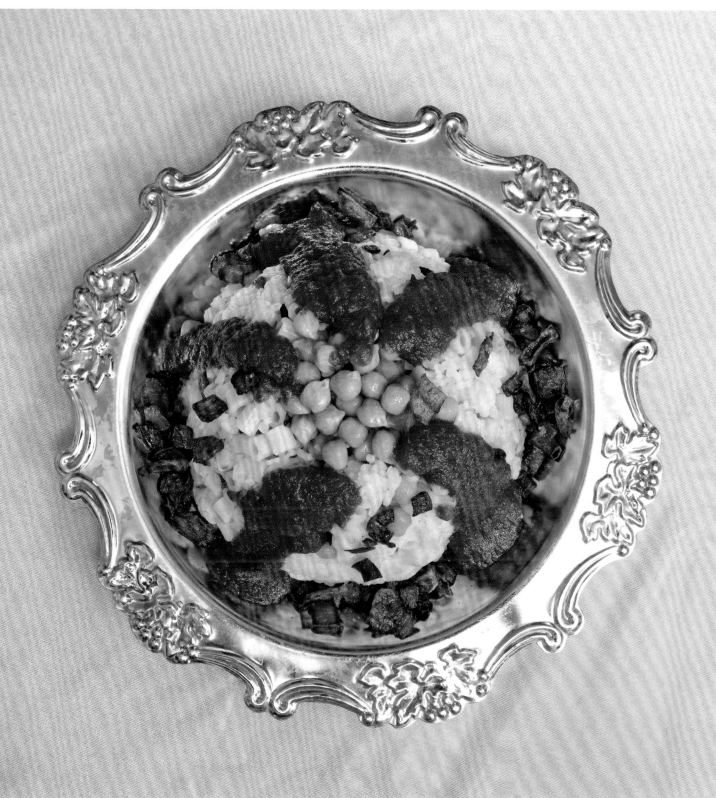

Fifi Makhmer

62 YEARS OLD

/

Fifi was born in the desert, four hours to the south of Cairo, in a village along the Nile River. That's where she spent the first twenty years of her life, until she got married and moved to the city. "I liked living in the desert and sometimes I miss the tranquility of my village, but, to be honest, living in the city is much better. I have air-conditioning here!" she says. Fifi lives with her husband and two of her three children in a small house in the eastern outskirts of the capital city. Her oldest son got married two years ago and made her a grandmother. She has always been a housewife and cooked for the whole family. Her children say she is the best cook ever, while she says she doesn't know much about cooking and can only prepare simple dishes. I spent almost the whole day with Fifi and her family. We cooked together for more than an hour and even if nobody could speak in fluent English, we communicated well enough for her to teach me how to prepare her favorite recipe.

Koshari

Pasta, Rice, and Legume Stew

SERVES 4 TO 6

½ cup medium- or short-grain rice (known as "rice *misri*" in Egypt)

2 ounces dried spaghetti, broken into 1-inch pieces (about ½ cup pieces)

½ cup ditali pasta or elbow macaroni

½ cup brown lentils, rinsed

2 tablespoons olive oil

1 large onion, roughly chopped

½ cup canned chickpeas, rinsed and drained, plus more for garnish

2 teaspoons ground cumin

½ teaspoon cayenne pepper

½ teaspoon ground ginger

¼ teaspoon ground coriander

Salt

Crushed tomatoes or tomato sauce of your choice, for garnish

1 Bring a large pot of water to a boil. Add the rice, spaghetti, and ditali, and cook until very tender, about 20 minutes. Drain.

2 At the same time, combine the lentils and 4 cups of water in a medium saucepan and bring to a boil. Reduce the heat to medium-low and simmer the lentils until they are tender, about 20 minutes. Drain.

3 Heat the olive oil in a skillet. Add the onion and fry until crispy. Using a slotted spoon, remove the onion from the pan and place it on a plate lined with paper towels. Set aside.

4 Meanwhile, combine the rice, spaghetti, ditali, lentils, chickpeas, and spices in a large bowl. Season with salt.

5 While the mixture is still warm, transfer it to a ring mold or a shaped pudding mold, pressing it into the pan to make it compact. Cover the pan with a large plate and invert to transfer the koshary to the plate. Garnish the pie with crushed tomatoes, additional chickpeas, and the fried onions.

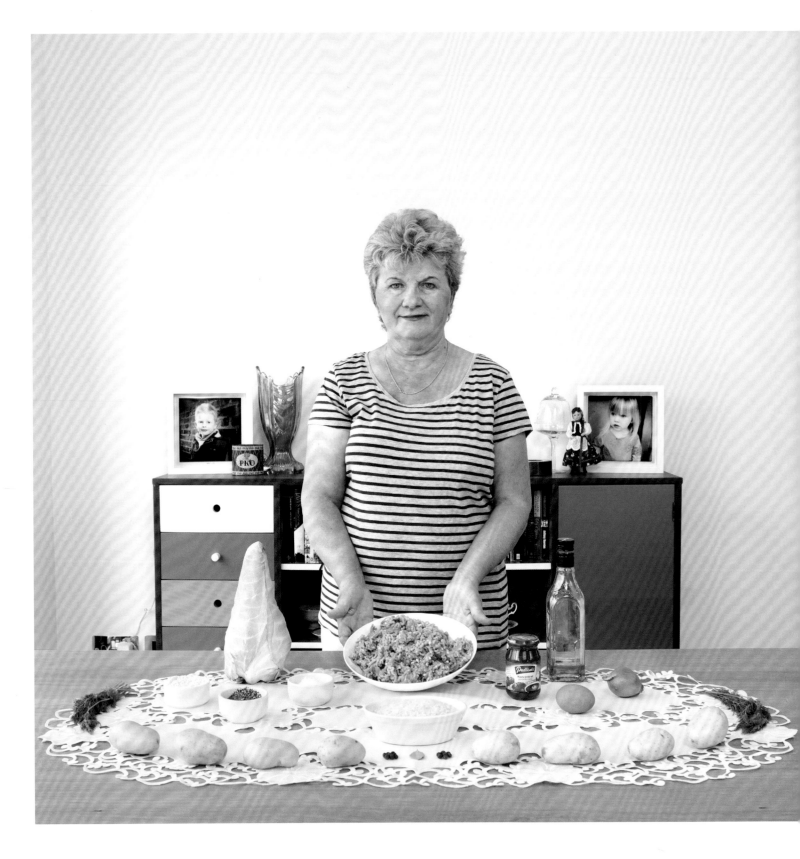

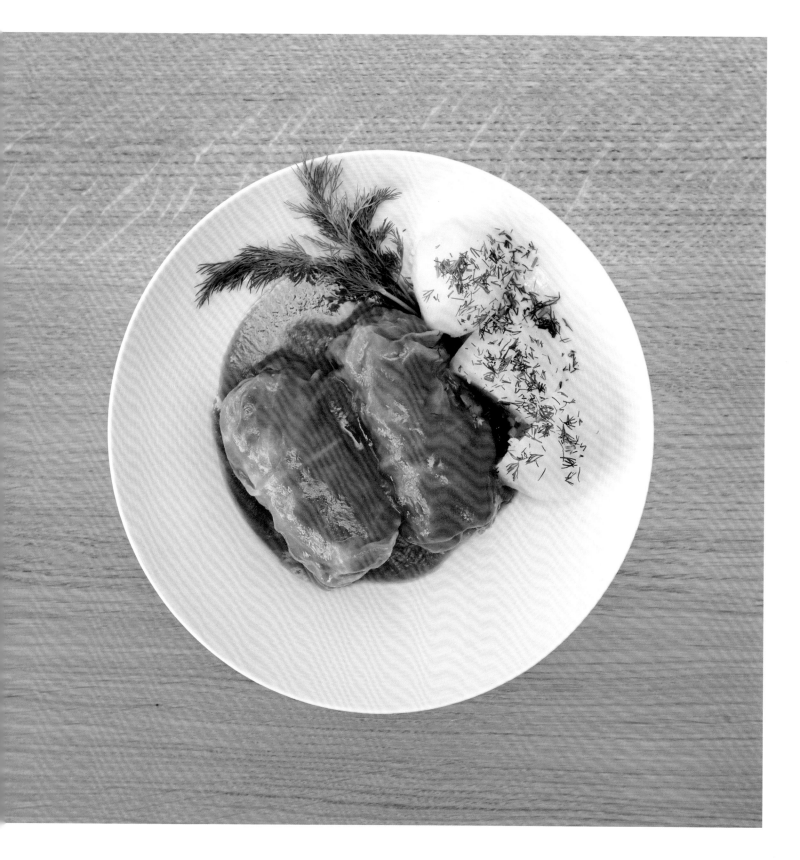

Ewa Tadel /

63 YEARS OLD

Ewa is the grandmother of three lively grandsons and one grand-daughter. Two of them (in pictures on the sideboard) live in the UK in a village near Bath. She misses them a lot and often talks to the photographs. For the last thirty-five years, Ewa has lived in the same house with a small kitchen, where she spends most of her days producing food. She always cooks a big breakfast, and for lunch she makes several dishes: one for her husband; one for her ten-year-old grandson, Olek, who visits almost every day after school; and one for her busy working daughter, Dorota. In the evening, friends will often pop in and there is always enough food for everybody.

Every year before Christmas and Easter, Ewa reopens her catering business and takes orders for traditional festive food. The whole house smells of pâté, fried fish, and cake, which she and her husband then deliver locally to satisfied clients. In Ewa's house, every-one is always welcome and you can be sure that you will be well fed. I spent almost the whole day at Ewa's house and cooked with her all morning. She gave me some good recipes and the best one is this one for sure!

Gołąbki z Ryżem i Mięsem

Cabbage with Rice and Meat

SERVES 6 TO 8 (2 ROLLS PER PERSON)

1 large head of green cabbage
 (about 4 pounds)

1 cup uncooked rice

Salt

1 tablespoon olive oil, plus more to
 coat the pan

1 large onion, chopped

2 pounds minced pork

1 large egg

2 pinches (⅛ teaspoon) of freshly
 ground black pepper

2 tablespoons chopped fresh dill,
 plus more for garnish

1 bay leaf

10 whole black peppercorns

8 potatoes, halved

1 cup (8 ounces) plain tomato sauce

2 tablespoons unsalted butter

Spices of your choosing, for the sauce

2 tablespoons cornstarch

1 Core the cabbage and place the head bottom up in a large heatproof bowl. Pour very hot water into the cabbage and let sit for a few minutes. Drain the liquid and separate the leaves from the head. Remove all the leaves that are intact and big enough to stuff, and set aside; save the smaller pieces.

2 Combine the rice with 2 cups of water in a medium saucepan. Bring to a boil, then reduce to a simmer and cook for 18 minutes. Remove from the heat, fluff the rice with a fork, replace the cover, and set aside.

3 In a large pot, bring 4 quarts of water and 2 teaspoons of salt to a boil. Add a few cabbage leaves at a time and cook them for 2 minutes. Drain and pat them dry.

4 Heat the olive oil in a sauté pan over medium heat. Add the onion and cook until it browns, 5 to 6 minutes.

5 Combine the pork and cooked rice in a bowl. Add the egg, 1 teaspoon of salt, the pepper, and the 2 tablespoons dill. Lightly work the mixture until everything is just blended. Add the pork and rice mixture to the pan with the onion, stir to combine, and let cook for 1 more minute. Remove from the heat. Lay the cooked cabbage leaves, with the inside of each leaf facing up, on a clean work sur-face side by side. Add some filling to the center of each leaf. Turn the sides in and roll the leaf into a bur-rito shape. Press the leaf ends into the roll. Repeat to make 16 rolls.

6 Coat the bottom of a large pot with olive oil, then layer in the stuffed cabbage. Add the bay leaf and pepper-corns. If you have extra smaller cabbage leaves, lay them on top. Place the pot on the stove and cook for about 5 minutes over low heat. Pour 2 cups of boiling water over the top of the rolls, cover the pan, and continue to cook, over low heat, for 1 hour.

7 While the stuffed cabbage is cook-ing, boil the potatoes in a large pot until they are tender.

8 In another saucepan, over low heat, combine the tomato sauce, 1 cup of the cooking liquid from the cabbage, the butter, and whatever additional seasonings you prefer. Place the cornstarch in a small bowl and add ¼ cup of cold water, stirring until the cornstarch has dissolved. Add this mixture to the tomato sauce and simmer, stirring, for 2 minutes.

9 Pour the sauce over the stuffed cabbage and cook for 5 minutes more. To serve, place 2 stuffed cab-bages and some potatoes on each dish and garnish with extra dill.

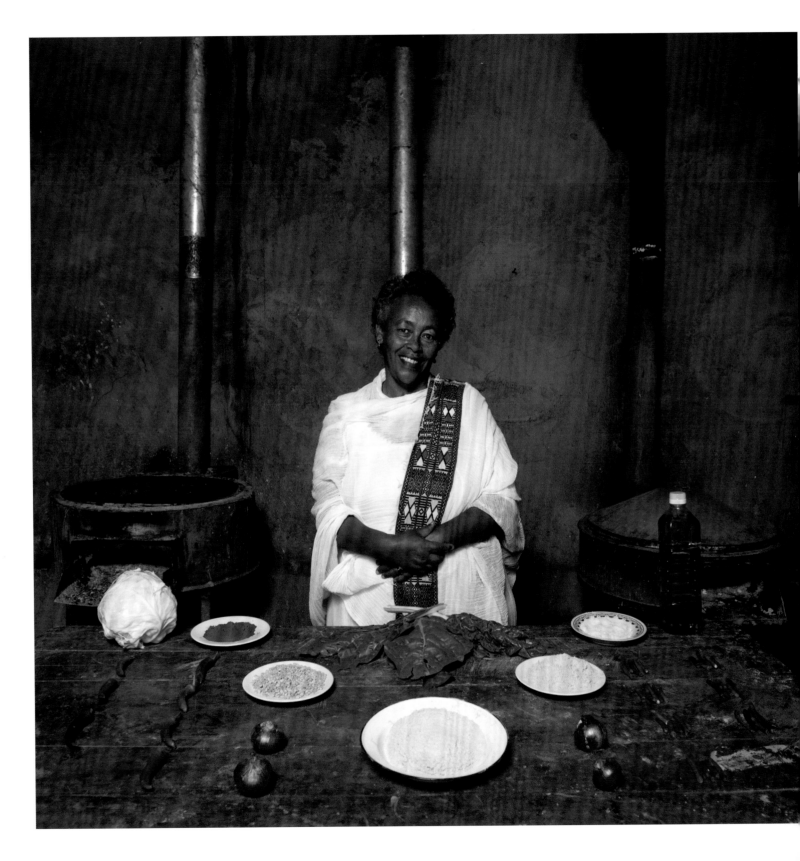

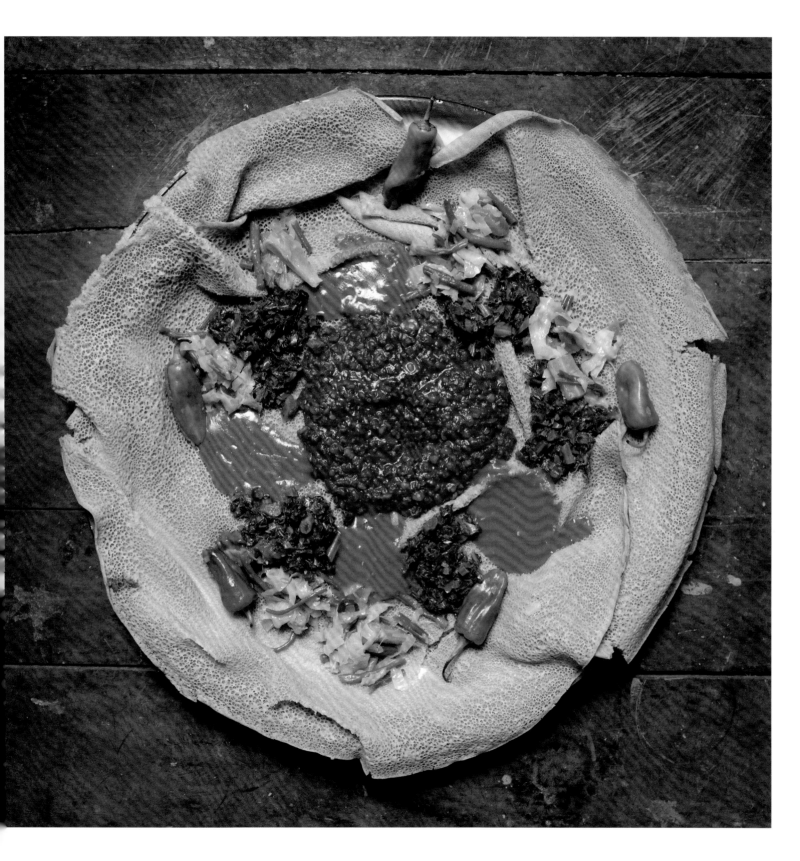

Bisrat Melake

60 YEARS OLD

Bisrat was born in Dessie, a village in northern Ethiopia, where she attended the small local school until she was twenty. She moved to Addis Ababa to go to college, but she never obtained a degree, since she quit her studies to get married. She has been a housewife and, occasionally, her husband's assistant in his garage. Bisrat has four grown sons but only one grandchild, and she hopes the number of grandchildren increases soon! I was invited by one of her children to have lunch with him and his family, which is how I first met Bisrat. On that occasion I spoke with her about this book and I asked her to be part of it. She loved the idea, and the next day I was at her house to try her fantastic food! The house where she lives is modern, big, clean, and well furnished. But to make her famous *injera,* a typical Ethiopian dish, she uses a traditional backyard kitchen.

Injera with Curry and Vegetables

SERVES 4 TO 6

FOR THE CURRY

3 to 4 tablespoons vegetable oil

1 red onion, finely chopped

3 sweet green chilies, chopped

½ cup shiro powder (chickpea powder)

1 cup yellow split peas, rinsed well and drained

Salt and freshly ground black pepper

FOR THE GREENS

1 pound cauliflower leaves or collard greens, chopped

3 tablespoons vegetable oil

1 red onion, chopped

Salt and freshly ground black pepper

FOR THE CURRY SAUCE

3 tablespoons vegetable oil

1 red onion, chopped

2 garlic cloves, minced

1 teaspoon *berberé* (red chili powder)

½ cup shiro powder

FOR THE SALAD

½ head Savoy cabbage

25 string beans

2 to 3 tablespoons vegetable oil

1 teaspoon berberé (red chili powder)

Salt and freshly ground black pepper

1 package injera bread

5 sweet green chilies

1 Make the curry: Heat the oil in a saucepan over medium-low heat. Add the onion and chopped sweet chilies and cook for 4 to 5 minutes. Add 3 cups of water and let cook for about 10 minutes. Then, gradually whisk in the shiro powder, and when completely combined, add the split peas. Mix well, cover with a lid, and cook over low heat for about 1 hour, stirring every now and then. When the split peas are very tender, season with salt and pepper.

2 Make the greens: Boil the cauliflower leaves in water for 10 to 15 minutes, until the leaves are wilted. Drain well and set aside. Heat the vegetable oil in a medium saucepan and add the chopped onion; sauté for 5 minutes. Add the cooked leaves and sauté everything together for about 15 minutes, or until the greens are cooked to your liking. Season with salt and pepper to taste.

3 Make the curry sauce: Heat the oil in a medium saucepan and sauté the onion and garlic over medium-low heat for 3 to 4 minutes. Add the berberé and 2 tablespoons of water, stir to combine, and simmer for 4 to 5 minutes.

Add 2½ cups of water and gradually whisk in the shiro powder. Whisk until the powder is completely combined, and let simmer, stirring occasionally, until the sauce resembles a thick smooth batter, about 15 minutes. (The shiro will thicken a bit more as it cools.) If the mixture becomes too thick, add hot water, 1 teaspoon at a time.

4 Make the salad: Slice the cabbage into strips and chop the beans. Boil the vegetables together in some water for 5 minutes or to suit your taste; drain the vegetables. Heat the oil and the berberé in a pan over medium-low heat. Add the vegetables and sauté them for about 10 minutes. Season with salt and pepper.

5 Once all the ingredients are ready, spread a large piece of injera on a plate as shown in the photo and add large spoonfuls of the 2 curries, the cooked greens, and the salad; garnish with the whole green chilies and serve. Ethiopian people eat it with their hands, tearing off pieces of injera and using it to scoop up the sauces and vegetables.

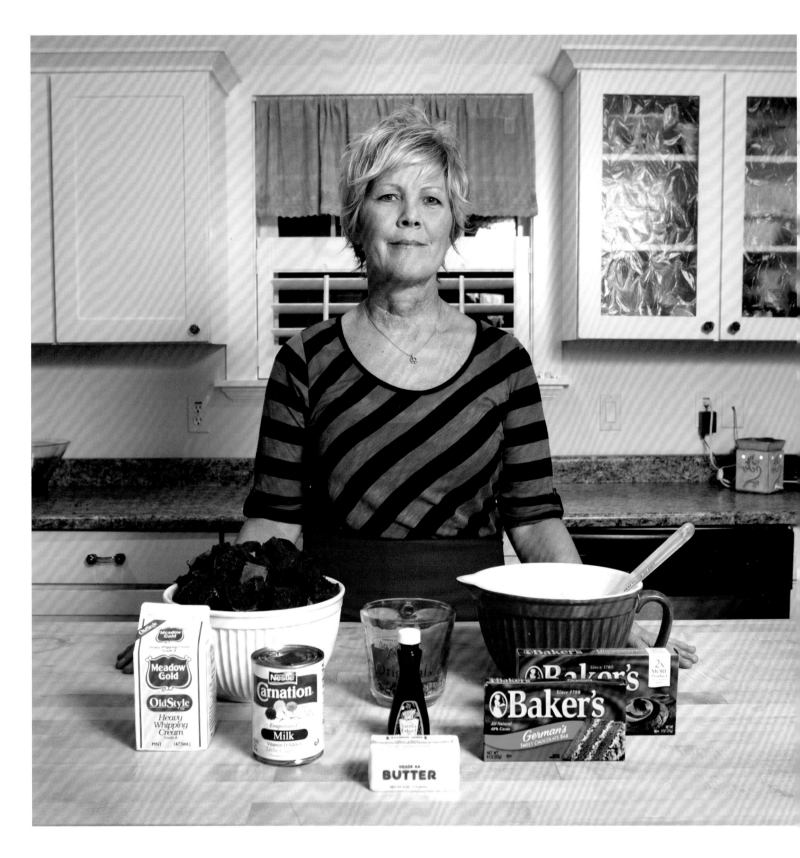

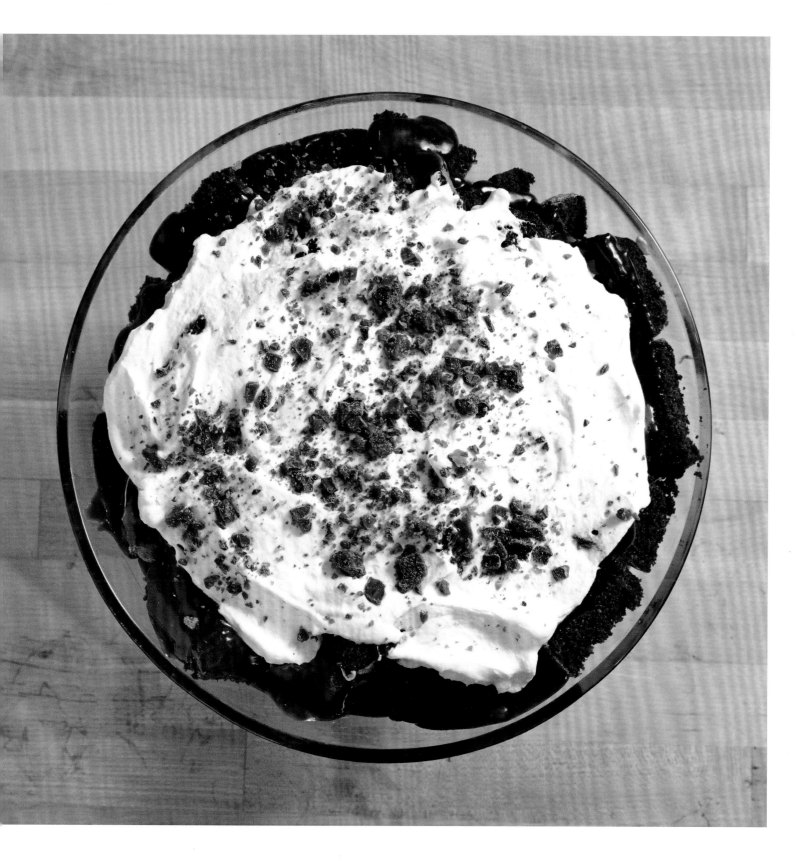

Melanie Hill

50 YEARS OLD

Melanie is the grandmother of two granddaughters, three and five years old, and lives in a small town to the south of Salt Lake City. All the members of her family are Mormon, like most of the folks in that area. She lives with her husband in a beautiful three-story house with a large kitchen. While she spends a lot of time cooking, she isn't so keen on it (so she says) and often serves semi-prepared meals.

The dinner we had together with her family had been previously ordered and was delivered an hour before we sat at the table. Melanie served turkey with a fruity sauce, mashed potatoes, corn on the cob, salad, and other delicious nibbles. We all sat at the table for a couple of hours, eating and talking about my travels. I felt like part of the family. Then, at the end of the dinner, Melanie served this trifle, the only thing that she had made herself. It was so good, I had seconds!

Chocolate Toffee Trifle

SERVES 8 TO 10

1 box chocolate cake mix (such as Pillsbury)

8 tablespoons (1 stick) unsalted butter

3½ ounces unsweetened chocolate

10½ ounces German chocolate

1 cup evaporated milk

1 teaspoon pure vanilla extract

1¾ cups heavy whipping cream

10 crushed Mou candies (toffee candies)

1 Prepare and bake the chocolate cake in a 9-by-13-inch pan according to the package instructions. When the cake is completely cool, cut it into 1-inch cubes.

2 Melt the butter, unsweetened chocolate, and German chocolate in a small pot over low heat. Once the butter and chocolate have melted, remove from the heat and add the evaporated milk and vanilla. Blend everything until it is very smooth. Set aside to cool.

3 In a chilled medium bowl or in the bowl of a stand mixer, whip the heavy cream to soft peaks.

4 Lay one-third of the cake cubes in the bottom of a 3-quart glass bowl. Top the cake with one-third of the chocolate cream and one-third of the whipped cream. Continue layering in this manner, ending with a top layer of whipped cream. Sprinkle with the crushed candies and serve.

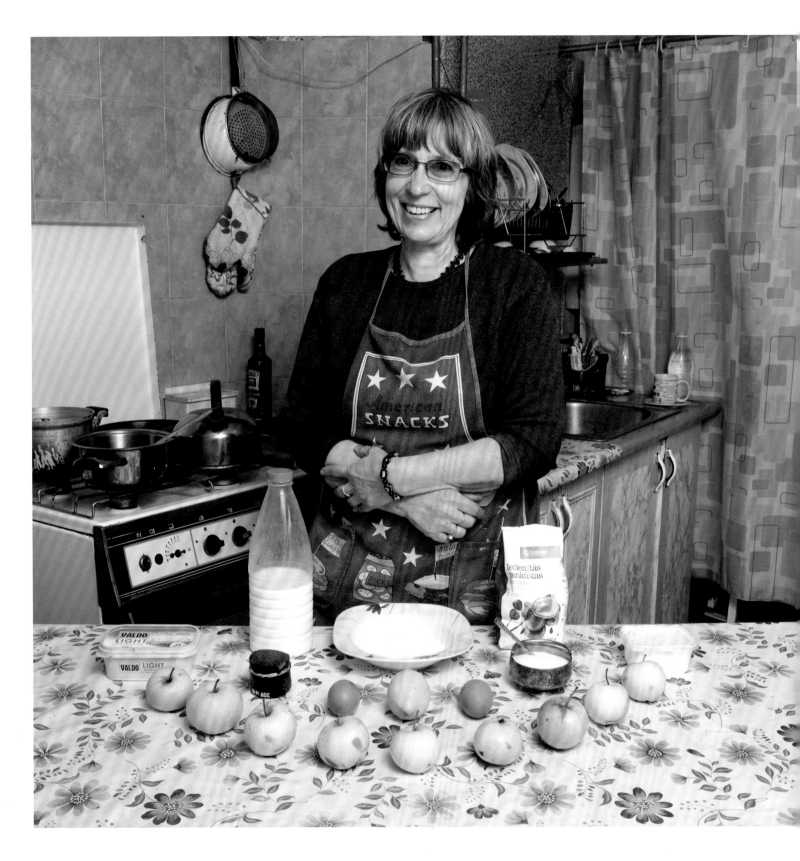

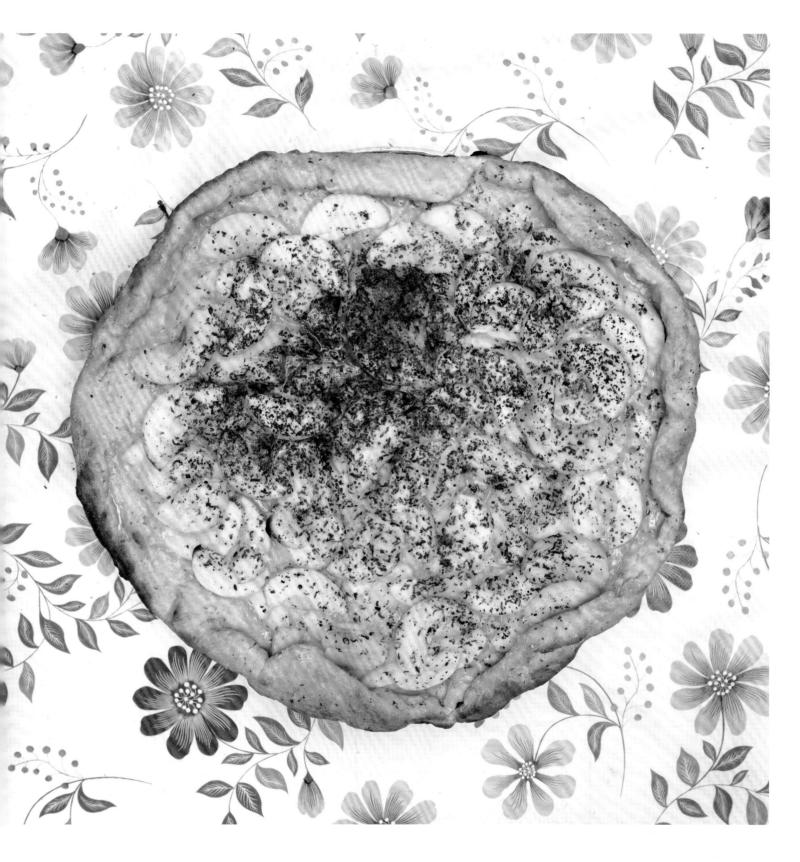

Natálija Kaze

65 YEARS OLD

Natálija grew up among her father's science books and eventually earned a degree in theoretical physics. She collaborated for most of her adult life with several inventors and registered some patents in her name. Then, after the fall of the Soviet Union, when science in Latvia was privatized, she started teaching foreign languages, mainly English. She married twice, at the age of twenty and at thirty-three, and she now lives in a big house with her husband.

I arrived at Natálija's house unannounced with her son, who was hosting me. When I asked if I could cook with her, she answered: "Yes, of course! I don't have the right ingredients to make any special recipe, but I will improvise with what I have in my fridge." And so, she did—Natálija's sweet pizza is her own specialty and the recipe is unknown to the rest of her country (or at least that's what she says!).

As Natálija explained, her secret is that no two batches are ever the same, and so the taste and softness of the pizza are always different.

Abolu Pirags

Sweet Pizza with Apples and Chocolate

SERVES 6

1½ cups plus 3½ tablespoons all-purpose flour, plus more as needed

6 tablespoons sugar

1 large egg

½ cup sour cream

4 tablespoons (½ stick) unsalted butter, melted and slightly cooled

2 to 3 apples, such as Golden Delicious, unpeeled

Juice of 1 lemon

1 cup whole milk

Dark chocolate, for grating

1 Combine 1⅓ cups plus 2 tablespoons of the flour and 1 tablespoon of the sugar in a medium bowl.

2 In a small bowl, whisk the egg and sour cream together. Add the slightly cooled melted butter and whisk until smooth. Add the egg mixture to the flour and sugar, stirring well until the dough just comes together.

3 Turn the dough out onto a floured work surface. Gather it together with your hands (if it is too sticky, add 1 tablespoon of flour) and gently work it into a smooth ball. Cover with plastic wrap, and chill for 30 to 45 minutes.

4 While the dough chills, core and slice the apples paper thin. (There should be about 3 cups.) Place in a bowl with the lemon juice and toss gently.

5 In a small saucepan, mix the remaining 5 tablespoons sugar, the remaining 1½ tablespoons flour, and the milk. Place over low heat, stirring constantly, until the mixture begins to thicken and lightly coats the back of the spoon, about 5 minutes. Remove from the heat and set aside to cool slightly.

6 Preheat the oven to 375°F and place a rack in the lower-third position.

7 To assemble the pizza, remove the dough from the refrigerator. Place it on a baking sheet lined with a silicone baking mat (Silpat) or a large piece of parchment paper lightly dusted with flour, and roll it out into a 12-inch circle, ⅛ inch in thickness. (The dough will be very soft and it is essential that it not be overworked.)

8 Cover the dough with the sliced apples, leaving a 1¼-inch border all around. Roll the edges up so that they form a rim around the apples. Slowly pour the creamy milk mixture evenly over the apples, reserving 1 tablespoon to brush the edges of the pizza. Grate some dark chocolate over the top.

9 Bake the pizza for 25 minutes. Adjust the position of the rack to the center of the oven and continue baking the pizza in that position for another 15 to 20 minutes. The crust should be golden and the apples tender.

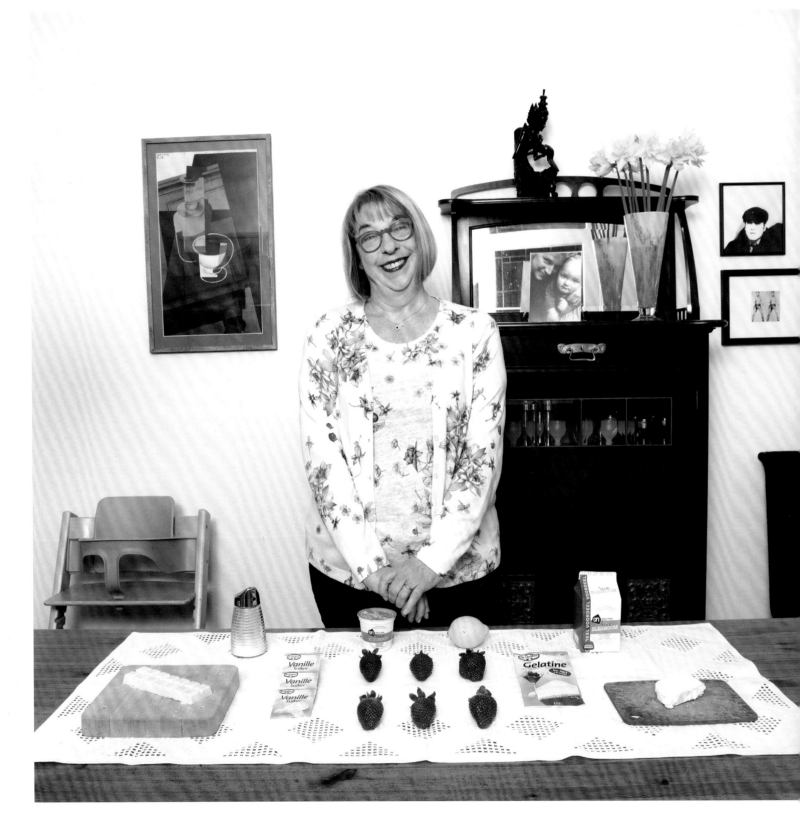

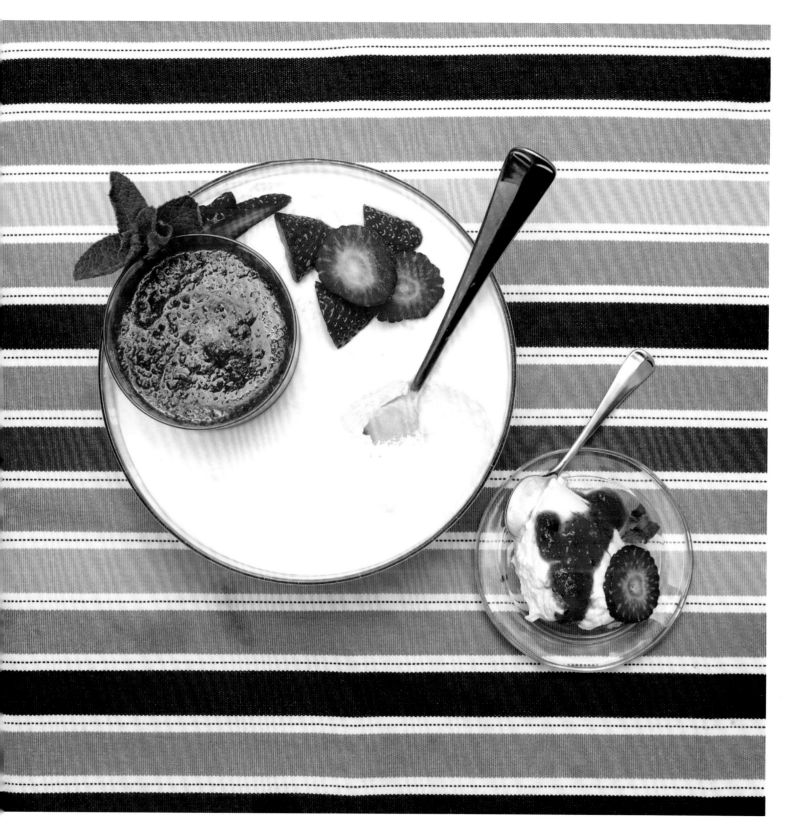

Tineke Reijndorp

64 YEARS OLD

Tineke married her husband in 1975 and became the proud mother of twins, Olga and Paul, two years later. Although she quit her job to focus on raising her children, she cultivated many hobbies, including sewing, photography, and baking cookies, once they went to school. But her favorite will always be cooking. "There's no bigger gift than your good food being enjoyed by your loved ones," says Tineke, when I meet her at her home on a sunny but cold Saturday evening. She lives in a nice two-story house that is close to the center of The Hague with her husband, Guus. I spent almost the whole evening cooking with them and she gave me her secrets to making the best goat cheese mousse.

While the dessert isn't typically Dutch, Tineke found the recipe at her local liquor store, and, over time, has personalized and perfected it. Her whole family requests it again and again. (Her little granddaughter even ducked under the table to finish her plate!) In the strawberry sauce, which is essential to balance the flavors of the mousse and is very easy to make, Tineke also uses the strawberry leaves to add freshness to the dish.

Goat Cheese Mousse with Strawberry Sauce

SERVES 8

FOR THE MOUSSE

½ cup grated or chopped white chocolate

1½ to 2 tablespoons vanilla sugar

3.6 ounces fresh soft goat's cheese (such as French chèvre)

2½ cups heavy cream

1½ sheets (about 1 teaspoon powdered) unflavored gelatin

FOR THE SAUCE

Juice of 1 lemon

2 tablespoons sugar, plus more to taste

1 full cup fresh strawberries, stems removed, leaves left on, plus more for garnish

2 tablespoons chopped fresh mint leaves

1 Make the mousse: Mix together the white chocolate and the vanilla sugar. Cut the goat's cheese into little chunks. In a saucepan, heat ½ cup of the cream over low heat and add the chocolate-vanilla mixture. Add the cheese and let it melt.

2 Meanwhile, dissolve the gelatin sheets by letting them soak in 1¼ cups of cold water for about 5 minutes. Gently wring out all of the water. If using powdered gelatin, sprinkle it over 2 tablespoons of cold water. Stir to combine, then add 2 tablespoons of boiling water, stirring for 1 to 2 minutes.

3 Remove the melted chocolate-cheese mixture from the heat. Add the gelatin and stir to combine. Pour the mixture into a large bowl and let cool and set to a thick, creamy consistency, about 30 minutes.

4 Meanwhile, whip the remaining 2 cups cream to soft peaks. Make sure not to overbeat; the cream should not be too stiff. Gradually fold the cream into the chocolate-cheese mixture. Pour into ramekins or cups of your choice and let cool for at least 2 hours in the refrigerator.

5 Make the sauce: Combine 2 tablespoons of hot water with the lemon juice. Add the sugar, stirring to dissolve, and let cool slightly. Roughly chop the strawberries, leaves included. Add the strawberries and the lemon mixture to a food processor or blender and mix until you have a creamy, foamy red sauce. Add more sugar, if desired.

6 To serve, unmold the mousse by dipping the ramekins halfway into a bowl of hot water and inverting them onto dessert plates. Top with the strawberry sauce and a few strawberries, and sprinkle with the chopped mint leaves. *Smakelijk eten!* (Bon appétit!)

Vanilla sugar is granulated sugar combined with the seeds scraped from a vanilla bean. The seeds are kept in the sugar in an airtight container for 2 weeks so that the sugar takes on the flavor of the vanilla (the longer the storage, the fuller the flavor). You can make your own by simply storing a vanilla bean in a jar of sugar.

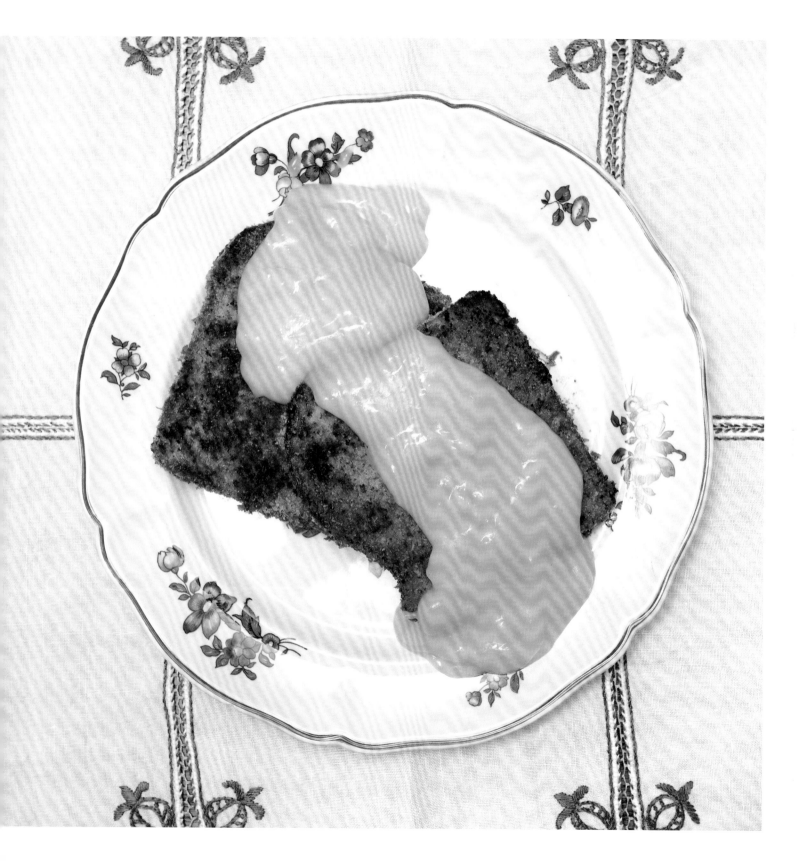

Doris Russel

86 YEARS OLD

Doris was born in 1928 in a big house in the country, outside of Cologne, Germany. Doris is the daughter of a squire and later married a squire, but early on she became a widow with a son. She managed the estate all by herself until she remarried and had a second son. Doris now has four grandchildren, with whom she spends most of her time. Her home has always been the epicenter of a large circle of friends of all ages and nationalities. She loves simple and efficient cooking and entertaining friends for lunch or dinner. From the outside, her house looks like a castle, with a canal running around the external walls. Arriving there, I felt like I was traveling back to the past, and I almost expected to find a knight at the door to welcome me! This is one of the most popular desserts in the northwestern region of Germany. Though in many countries it is known as "French toast," here it is called "the poor knight's meal," or *arme Ritter*, after a fourteenth-century knight. A wonderful treat for any member of your family's royal court!

Arme Ritter (The Poor Knight's Meal)

SERVES 4

6 eggs

2 cups whole milk, at room
temperature

½ cup plus 2 tablespoons sugar

¼ teaspoon ground cinnamon
(optional)

1 cup fine breadcrumbs, toasted

1 (1-pound) loaf of fresh white bread,
crust removed, sliced ⅓ inch thick

3 to 4 tablespoons butter

1 cup white wine

2 tablespoons all-purpose flour

1 To make the fried bread, in a medium shallow bowl, whisk 2 of the eggs together with the milk, the 2 tablespoons sugar, and the cinnamon, if you like. In another medium shallow bowl, beat 2 of the remaining eggs together. Mound the breadcrumbs on a plate.

2 Dip a slice of bread into the bowl with the milk-egg mixture and leave it there until the bread is well saturated with the liquid. Allow the excess to drip off, then dip the bread into the beaten eggs. Lastly, coat both sides of the bread with the breadcrumbs. Repeat with all the remaining slices of bread.

3 In a large skillet, melt the butter over medium heat. Fry the coated slices, in batches, until golden brown, adding more butter as needed. Keep warm while preparing the cream.

4 To make the cream, whisk the remaining 2 eggs and add them to a medium saucepan with the white wine, ½ cup of water, the flour, and the ½ cup sugar. Whisk until well combined. Place the pan over medium-low heat and bring the mixture to a simmer, stirring gently with a wooden spoon. Let cook for 10 to 12 minutes, until the cream thickens enough and coats the back of the spoon. The cream will continue to thicken as it cools.

5 To serve, place 2 slices of fried bread on each dish and pour some cream on top.

Giovanna Stoll Simona

68 YEARS OLD

Giovanna is the mother of a dear friend of mine, who invited me to visit her on a Saturday afternoon at the end of September. She has a great three-story villa on the lake with spacious rooms decorated with art, musical instruments, and beautiful objects. Giovanna and her husband, Ueli, welcomed me as if they had known me forever, and I immediately felt at home. They have been married for more than forty years and have done so many exciting things together. "We traveled the world, we obtained a skipper's license and bought a boat, started singing in a choir; in a word, we have never been bored since we got together," they said, smiling. It took Giovanna a while to decide what to cook. She wanted her recipe to be as representative as possible of her country. After a long chat, we decided on her cake with walnuts and mountain honey, for which she only used fresh ingredients from the Swiss Alps.

Tart with Walnuts and Mountain Honey

MAKES 1 (10-INCH) TART

FOR THE PASTRY

3 cups all-purpose flour

⅓ cup granulated sugar

⅓ cup confectioners' sugar

Pinch of salt

½ pound (2 sticks) cold unsalted butter, cut into small cubes, plus more for the pie dish

3 egg yolks

Zest of 1 lemon

1½ teaspoons whole milk

½ teaspoon pure vanilla extract

FOR THE FILLING

2½ cups walnut pieces

1 cup granulated sugar

2 tablespoons mountain honey

⅔ cup heavy cream

TO ASSEMBLE THE TART

1 egg yolk, beaten

Walnut pieces, for decorating

1 **Make the pastry:** Combine the flour, both sugars, and salt in a large mixing bowl. Cut the butter into the flour mixture until the mixture resembles coarse meal. In a small bowl, combine the egg yolks, lemon zest, milk, and vanilla.

2 Pour the egg mixture into the flour-butter mixture and work the ingredients with your hands to obtain a smooth but compact dough. Divide the dough into 2 pieces: one piece, two-thirds of the dough; the other, one-third. Create 2 flat disks, wrap them separately in plastic wrap, and put them in the fridge for at least 1 hour.

3 **Make the filling:** Pulse the walnuts in a food processor until they are the size of rice grains. Set the walnuts aside.

4 Place the sugar and ¼ cup of water in a medium saucepan over medium-high heat. Let the sugar melt, without stirring, and continue to cook until the liquid becomes a deep amber color. (Do not leave the sugar unattended. Once the sugar begins to caramelize, it will darken very quickly, become too thick, and burn.)

5 As soon as the desired color is reached, reduce the heat to low, add the crushed walnuts to the caramel, and stir well. Pour in the mountain honey and let it melt. Stir in the cream. Cook everything together until the mixture thickens, about 5 minutes. Remove from the heat and let the caramel cool for 15 minutes.

6 **Assemble the tart:** Take the larger piece of pastry from the fridge. On a flat work surface, lay 1 or 2 pieces of plastic wrap large enough to roll out a 13-inch circle of dough. Place the disk in the middle of the wrap and flatten it with your hands. When it becomes too difficult to do by hand, cover everything with another layer of plastic wrap and use a rolling pin to finish the work. The dough should measure about 13 inches in diameter and ¼ inch thick.

7 Preheat the oven to 350°F.

8 Place the round layer of pastry in the bottom of a buttered 10-inch pie dish. Bring the dough that extends over the edges of the dish, up all around to form a ridge along the upper inside edges. Place the pie dish in the fridge. Roll the rest of the dough in the same way into a 10-inch-diameter circle and set aside as a lid for the tart.

9 Remove the pie dish from the fridge and pour in the walnut and honey filling. Cover the tart with the pastry lid, sealing the edges well. Brush the top with the beaten egg. Decorate the top crust with walnut pieces.

10 Bake the tart for 40 minutes, or until the pastry is cooked and golden.

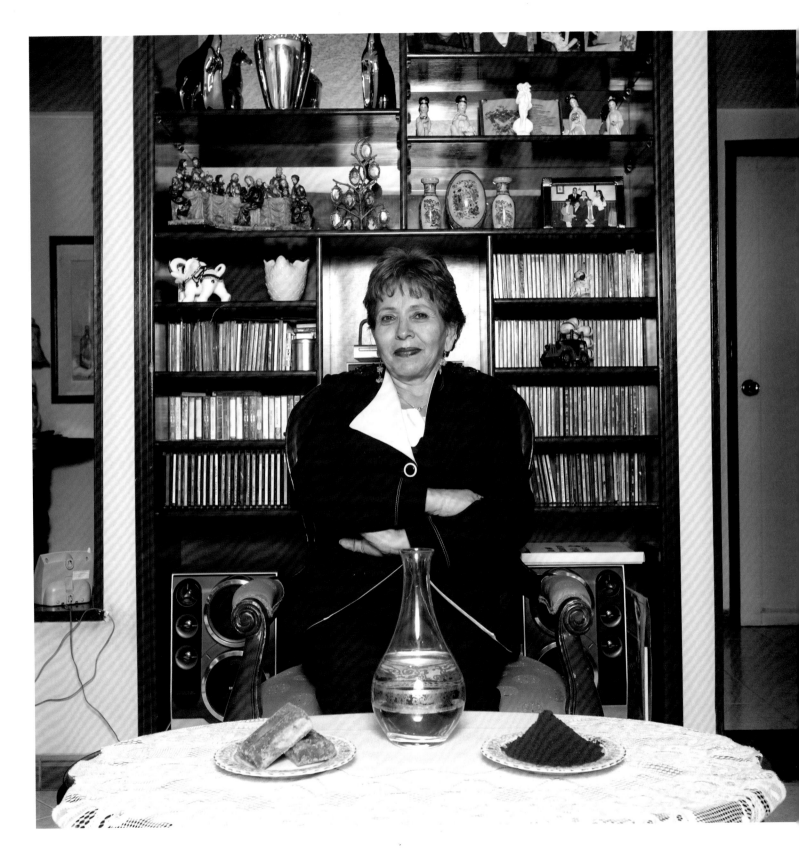

Maria del Carmen Pinzón

58 YEARS OLD

Maria was born in Cali, Colombia, but she moved to Bogotá with her family when she was very young and has lived there ever since. Her family is quite large—she is the sixth of nine children. She married at sixteen and one year later she gave birth to her first son. She eventually had three more children and now has seven grandchildren. For a period of her life she worked as an assistant to the manager of a building firm, but because of her husband's jealousy of her boss, she decided to quit. She never worked again and has instead devoted herself to her family. "I have never regretted my choice, even though at that time quitting was a difficult decision to make. But as soon as I realized the time I would gain to spend with my children, I understood that it was the right thing."

When I asked Maria to cook something typical from Colombia, she had no hesitation in suggesting: "A good coffee!" I couldn't think of a better way to bring closure to my travels than with a cup of coffee. So, here is how to prepare a great coffee in the Colombian style: If it is not sweet enough, you can add a spoonful of cane sugar, but make sure it is Colombian!

Coffee with Panela

SERVES 4

½ cup coarsely ground Colombian coffee

¼ cup finely chopped *panela* (unrefined cane sugar sold in hard, flat blocks)

1 Heat 2 cups of water. When the water comes to a boil, pour it into the carafe of a French press or into a heatproof container. Stir in the panela and let it melt. When the panela is completely melted, stir the coffee into the water, cover, and let brew for 2 to 3 minutes.

2 Now you need to filter the coffee to remove the remaining powder and grounds. You can use the plunger of the French press, a fine-mesh strainer, or even a piece of fabric to do it.

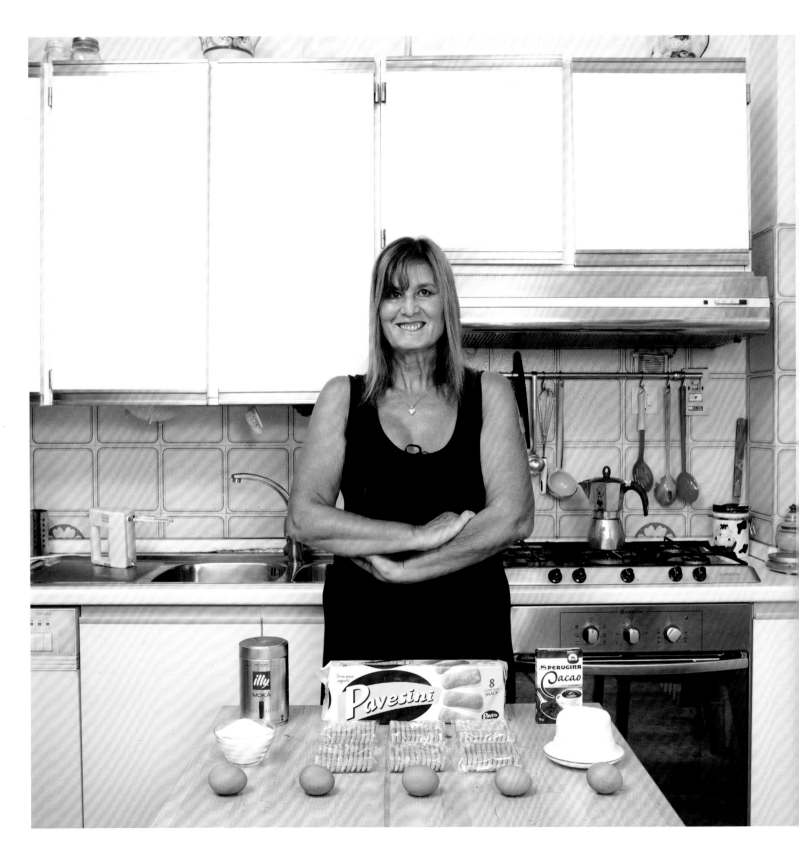

Paola Agnelli

59 YEARS OLD

The first time Paola fed me was thirty-seven years ago, a few hours after I was born. I don't remember much of that first meal, but among the many things I have consumed in my life, I know for sure it was the one she prepared with the greatest love and care. Paola is my mother. She has been a grandmother for only a few months now, thanks to my sister. My nephew, Matteo, will have to wait for a while to be able to enjoy his granny's desserts. Paola is a teacher in the elementary school of the small town where she lives. Every morning when she enters the classroom and starts her lesson, she faces twenty young pupils between six and ten who are not just her students, but like her own grandchildren; she gives them the same kind of love that she gives her family. This is why my mom is one of the most loved teachers in her school. But despite her great gifts in teaching, my mom is not the best of cooks. My dad has always cooked better than she, but there is only one thing he has never been able to make like she does: mascarpone, a Tuscan version of the famous tiramisù.

Tiramisù alla Toscana (aka Mascarpone)

SERVES 8 TO 10

5 large eggs

½ cup plus 2 tablespoons sugar

1 pound mascarpone cheese,
 at room temperature

10 ounces brewed strong coffee,
 at room temperature

1 package Pavesini biscuits
 (available in Italian markets)

Cocoa powder, for sprinkling

1 Separate the egg whites from the yolks into 2 bowls. Using a handheld mixer or a whisk, beat the egg yolks, adding the sugar little by little, until the yolks are thick and creamy. Add the mascarpone cheese, 1 spoonful at a time, mixing thoroughly.

2 In the other bowl, whisk the egg whites, using a handheld mixer or a whisk, until soft peaks form. Gently fold the egg whites into the mascarpone mixture.

3 Pour the coffee into a wide soup bowl. Dip the Pavesini biscuits, one at a time, very quickly (less than 1 second) in the coffee (they should be dampened, but not soaked) and lay them in the bottom of an 11-by-7-inch rectangular baking pan (other shapes are also fine, but the size has to be more or less this). Repeat until you have a single layer, one biscuit next to the other, in order to cover the whole surface of the pan.

4 Pour one-quarter of the mascarpone cream on top of the biscuits. Repeat with the remaining biscuits and cream until you've created 3 or 4 layers (depending on the shape and depth of your dish), finishing with a layer of cream. Place a star shaped stencil on top of the tiramisù and sift cocoa powder over the top.

5 Cover with plastic wrap and refrigerate for 3 hours before serving.

Tiramisù is certainly one of the most popular Italian desserts, ascribed to a head chef in Treviso. In the late 1960s, when he came back from a period of work in Germany, he tried to reproduce and adapt some of the recipes he had learned abroad and happened to create tiramisù. Traditional tiramisù uses Savoiardi biscuits, an Italian brand of ladyfingers. However, in Tuscany, and in the area of Arezzo in particular, tiramisù is made with Pavesini, another kind of biscuit, which, despite being similar to the original ingredient, gives a slightly different taste and thickness to the dessert.

Acknowledgments /

I WOULD LIKE TO THANK:

My grandmother and all the grandmothers in this book, my family, and all the families of the ladies photographed for this book

Arianna Rinaldo, Cristina Guarinelli, and all the people of *D la Repubblica*

Paolo Woods, Edoardo Delille, Claude Baechtold, Serge Michel, Pietro Chelli, my agents at INSTITUTE, and the Waxman Leavell Agency

Stefano Stoll and all my friends at Riverboom

GP&Catiello and all my friends in Val di Chiana, all my friends in Firenze, Elisa Paolucci, Catalina Jurado, Alia Bengana, Vanessa Peters, Chiara Amorini, Jennifer Delare, and Annina Truci

The gang at Via Vigevano, 9

All the people who hosted me and helped me during my long trip around the world

Studio Marangoni, in Florence; Festival Image, in Vevey; Cortona on the Move; Buckley Barratt; couchsurfing.org; Carlo Landucci; and occhidellasperanza.it.

Index